DRAWING
for
FANTASY ARTISTS

DRAWING
for
FANTASY ARTISTS

Socar Myles

Search Press

A QUARTO BOOK

Published in 2012 by Search Press Ltd
Wellwood
North Farm Rd
Tunbridge Wells
Kent TN2 3DR

ISBN 13: 978-1-84448-777-6

Conceived, designed and produced by
Quarto Publishing plc
The Old Brewery
6 Blundell Street
London
N7 9BH

QUAR.FABE

Project Editor: Victoria Lyle
Art Editors: Susi Martin and Emma Clayton
Designer: Karin Skånberg
Picture Researcher: Sarah Bell
Copyeditor: Sally MacEachern
Proofreader: Lindsay Kaubi
Indexer: Helen Snaith
Art Director: Caroline Guest

Creative Director: Moira Clinch
Publisher: Paul Carslake

Colour separation by Pica Digital Pte Ltd,
Singapore
Printed by Star Standard Industries Pte Ltd,
Singapore

10 9 8 7 6 5 4 3 2 1

CONTENTS

Contents continues

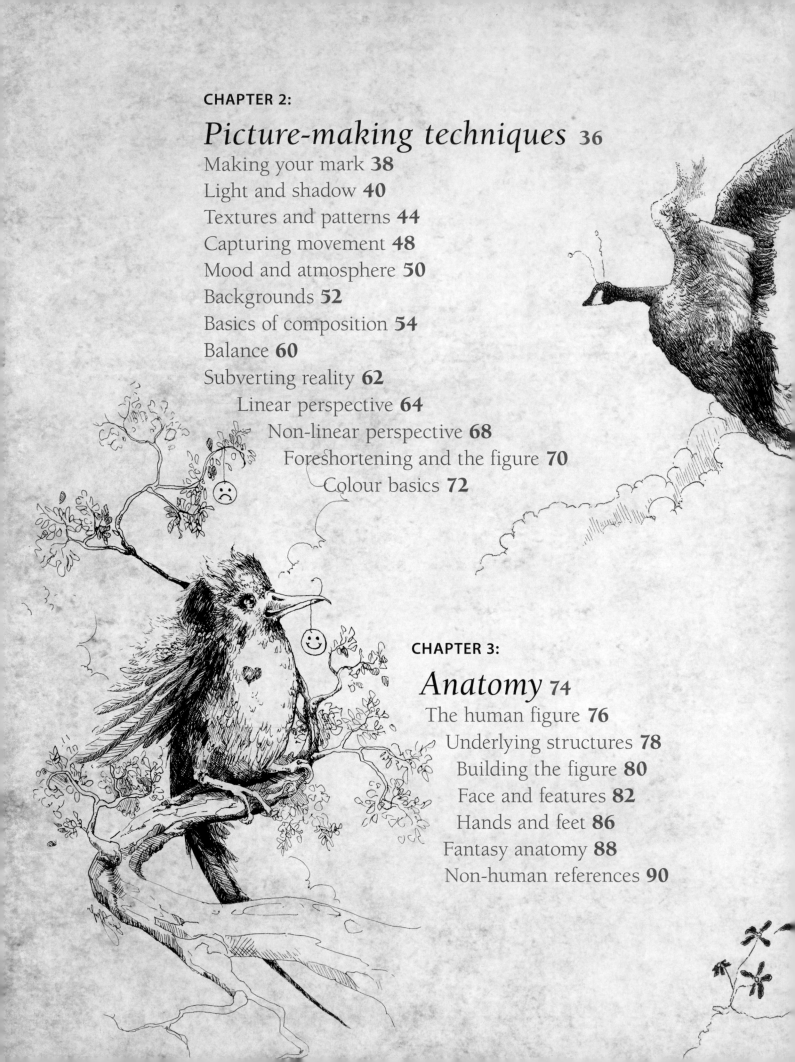

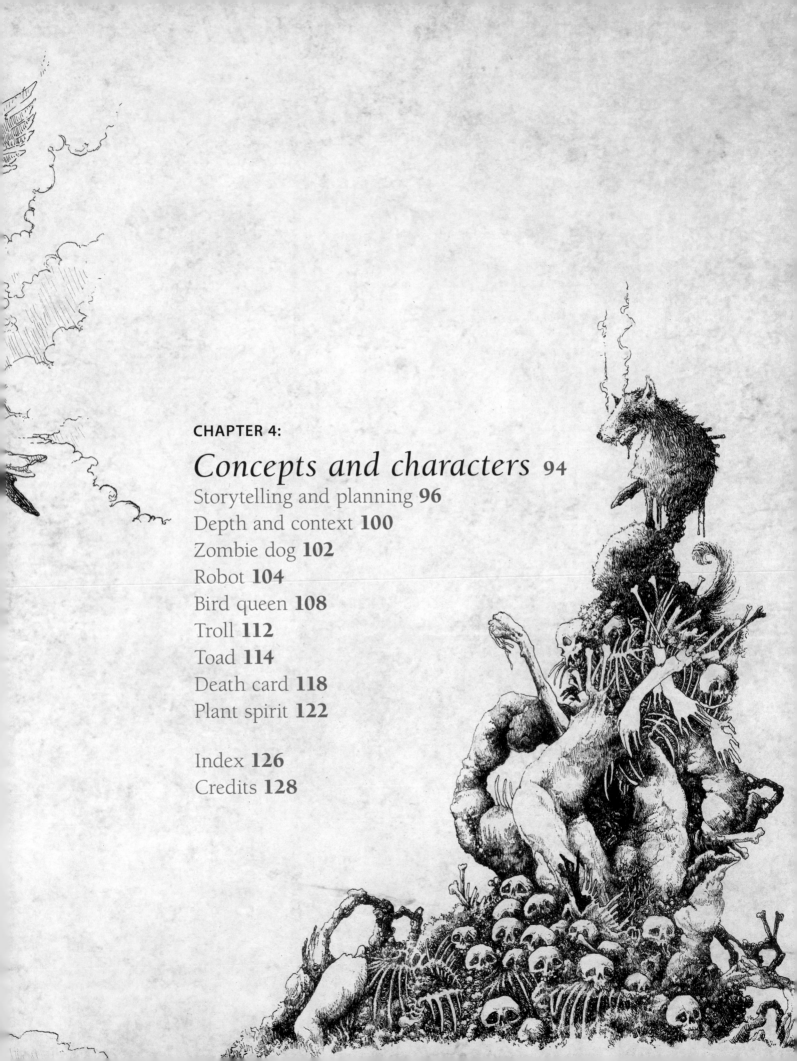

Foreword

I came late to fantasy art. Although I had grown up enjoying the illustrations of Michael Hague, Arthur Rackham and Gustave Doré, it didn't occur to me to turn my own hand to the fanciful until I was a broke student. I went online looking for a chance to hone my skills and line my pockets in one, and came upon a community of the friendliest people imaginable: fantasy art freelancers. They weren't making vast amounts of money, but they were having a good time, and supporting each other with tips, tutorials, and encouragement, which struck me as a thing worth doing.

This book is my way of offering something in turn to those who come after me on that path, whether with a career in mind, for the love of the craft or a combination of the two. Here is a guide to transferring fantasy from imagination to paper, intended to make the process accessible to anyone with a pencil and an idea: the beginner wondering where to start; the fantasy art enthusiast who'd love to give it a try; the budding illustrator looking for tips and ideas. Through lessons in basic draughtsmanship, explorations of materials and techniques, and exercises in translating ideas to images, an essential skill set may be developed.

About this book

Chapter 1: Starting to draw

This chapter examines the tools and materials you will need to start drawing. Although focusing mainly on the traditional media of pencil and pen on paper, digital tools are also covered. Practical techniques, such as mark making and stretching paper, are explained, as are topics such as inspiration and using references.

Chapter 2: Picture-making techniques

From light and shadow to composition and perspective, this chapter covers techniques for creating unique and striking pictures. How do you capture movement? How do you depict a complex texture? How do you realistically embed a figure in a scene? It's all explained here.

'Be a better artist' boxes suggest practical exercises for putting the theory into practice.

Annotated drawings visualise teaching points for clarity.

Tip boxes contain expert advice as well as pitfalls to avoid.

Through entertaining exercises and step-by-step tutorials, readers are guided through every stage of creativity: concept development, effective use of reference material, choosing a medium and shopping for supplies, basic drafting techniques, and the use of photography and digital media to supplement and enhance a traditional skill set. Emphasis is placed on experimentation, creativity and exploration of materials. Technical information is presented in a simple, straightforward manner, with plenty of illustrations, aimed at connecting concept with application.

The reader is encouraged to build upon what is learned here, as well as seek out alternate approaches. As an artist's confidence grows, so will his or her ability to take in lessons from a variety of sources, and work out which best suit his or her purpose.

Socar Myles

Chapter 3: Anatomy

This chapter provides a solid grounding in anatomy, in order for the fantasy artist to subvert this knowledge to create unreal, but believeable, creatures. Proportions, underlying structures and facial features are covered, as well as non-human references.

Chapter 4: Concepts and characters

Bringing together skills learned throughout the book, this chapter presents seven finished drawings of unique characters. Taking you through the conception and composition process step-by-step, it will encourage and inspire you to create your own artwork.

Key features of inspirational finished pieces are identified and explained in detail.

Sources of inspiration demonstrate the range of material that can be used as reference.

Each character is drawn in the round.

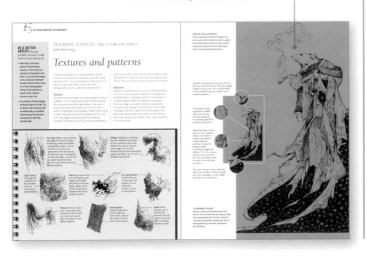

The concept for each character is described, showing the thought process and how it is possible to personalise generic types.

The development of the character is shown step-by-step, culminating with the finished drawing.

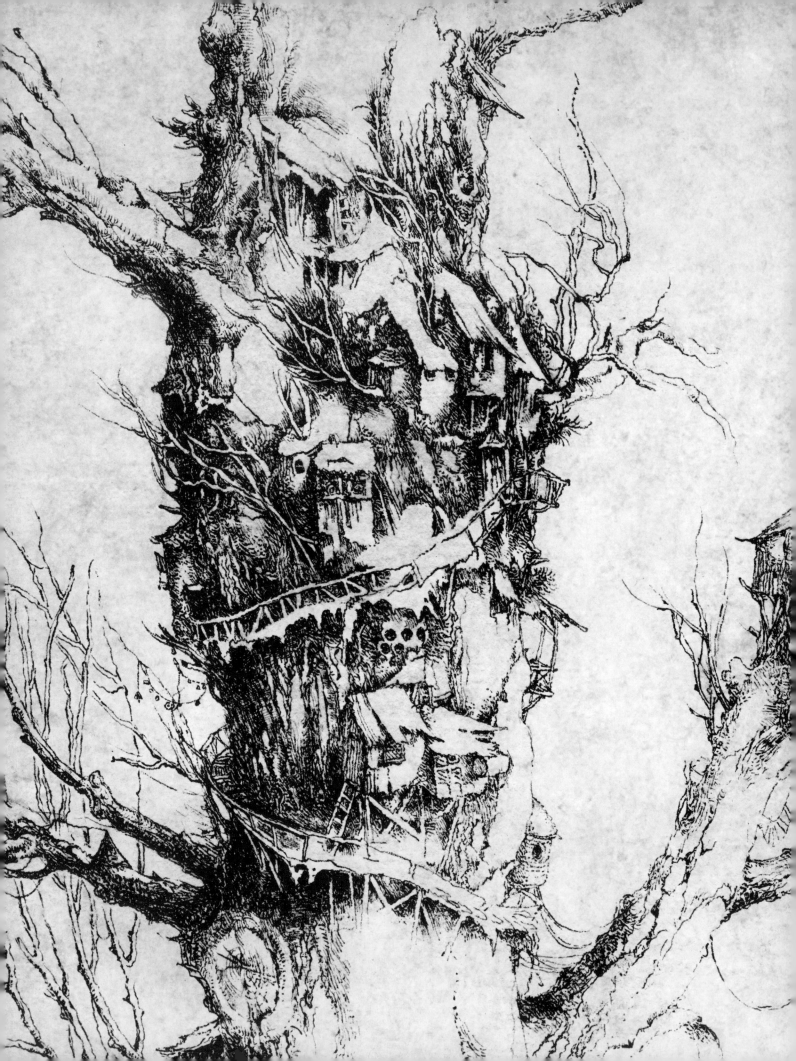

CHAPTER 1
Starting to draw

Will you use pencil or charcoal, felt-tip pen or brush, Mac or PC? Pen on vellum or a finger in the sand? Are you inspired by music? Fashion? Literature? Will you seek reference material in the wide world, or in the world inside your computer? However you choose to bring your fantasies to life, it pays to have a varied toolbox.

PENCIL DRAWING – How to get the most out of a humble pencil.

Pencil

Pencil is a good starting point for anyone learning to draw. It's familiar, affordable, portable and erasable, and it doesn't require a lot of setup or cleanup. You probably have a pencil near you right now. Pick it up and try it out. What kinds of marks can you make with it? If you're thinking about smudging some of those marks around with your fingertip, stop right there. Your finger is covered in oils that will damage your paper and make pencil marks impossible to erase. No matter what medium you're using, keep your skin off the paper at all times. Keep a blank piece of paper or a clean cloth close by to rest your hand on.

The insects on this page were drawn using pencil, graphite and charcoal.

MARK MAKING
Here are a few tips to help you make the most of your pencils and avoid a few pitfalls. Work left to right (or right to left if you are left-handed). If you have to rest your hand on an already-used section of paper, first lay another piece of paper over the drawing, so you won't smudge the graphite. Then spray your drawing with fixative when you're done. Graphite smudges and rubs away if left unsealed.

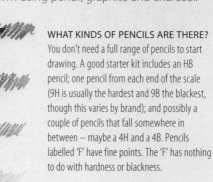

WHAT KINDS OF PENCILS ARE THERE?
You don't need a full range of pencils to start drawing. A good starter kit includes an HB pencil; one pencil from each end of the scale (9H is usually the hardest and 9B the blackest, though this varies by brand); and possibly a couple of pencils that fall somewhere in between — maybe a 4H and a 4B. Pencils labelled 'F' have fine points. The 'F' has nothing to do with hardness or blackness.

HOLDING A PENCIL
The way in which you hold your pencil will affect the type of line and marks you make.

STANDARD GRIP
Rest the long end of your pencil on the webby part between your thumb and your forefinger. Pinch it near the point, between your thumb and forefinger and the side of your middle finger, so that each of these fingers exerts equal pressure on the pencil. This allows for smooth and fine control.

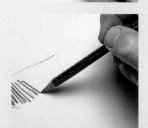

HIGHER
Holding the pencil higher up the shaft encourages you to work more loosely.

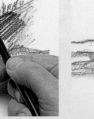

UNDERHAND
In this underhand grip, the pencil is held between the thumb and two forefingers.

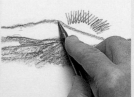

FOREFINGER CHANGE
Holding the pencil with your forefinger over the shaft allows firmer pressure.

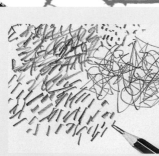

GRAPHITE PENCILS
Graphite pencils are graded by hardness and by blackness. The greater the proportion of clay added to the graphite, the harder the pencil. Pencils used for writing are usually HB and fall at the mid-point of the scale. An HB pencil will not make a black mark, no matter how hard you press.

SUBTLE SHADING
While dull pencils are useless for fine detail, they come in handy for subtle shading and areas of smooth or flat rendering. Going over the same area repeatedly and patiently with a blunt pencil yields a uniform patch of grey.

SHARP LINES
A freshly sharpened pencil yields sharp, clean details.

SMUDGING
Never smudge or smooth with your fingers. Use a twisted-up piece of suede or a cotton swab instead.

BE A BETTER ARTIST! *Now use your pencils to make quick sketches and experiment with surfaces.*

- Pencils are very portable, so take the show on the road. Get used to drawing on the go. Capturing fleeting moments needn't be solely the domain of the camera.

- Try out your pencils on various types of paper. How do the marks you get on a piece of rough watercolour board differ from those you make on smooth Bristol? Which do you prefer? Figure out which effects work best for the styles that interest you.

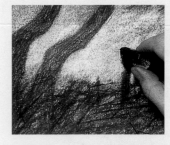

ERASERS
There are two main types of eraser suitable for using on your artwork. Gum erasers are soft and a little crumbly. They leave a fine dust after use, which absorbs graphite and allows it to be brushed off the paper. Kneaded erasers are made of putty and rubber. As the name suggests, they can be kneaded into fine points or soft edges, as desired. Applying your eraser in a dabbing motion lifts graphite marks gradually and is gentler on the paper's surface than back-and-forth scrubbing. Avoid using pink erasers, as these are hard and scratchy and will damage the surface of your paper. You can use erasers as a drawing tool; try adding highlights and white lines by removing graphite.

GRAPHITE STICKS
Standard drawing pencils are encased in wood, but graphite can also be bought as a thick stick without the outer covering. Graphite sticks, which are also produced in different grades, are ideal for drawings that rely more on tone than line. You can cover large areas very rapidly by using the side of the stick, breaking it into two or three pieces if necessary.

CHARCOAL
Charcoal, which is simply charred wood, is sold as sticks in various thicknesses and degrees of softness. It is a very 'forgiving' medium, as its soft, smudgy nature makes it easy to erase mistakes just by dusting down the paper. It is most often used for tonal drawings, or combinations of line and tone, but it is equally suitable for more linear approaches.

ADDING COLOUR – Wet or dry, coloured pencils can be used to create a vast array of marks and effects.

Coloured pencil

Most people will be familiar with coloured pencils and have probably used them in childhood, which is perhaps why they do not get the attention they deserve. But the inexpensive pencils supplied by schools or given as presents are very different from those made for artists and illustrators. These are a pleasure to work with and, because using pencils comes more naturally than working with brushes, they are one of the easiest mediums to try out.

Choosing coloured pencils

Coloured pencils can't be pre-mixed on a palette as paints are, and thus are made in a vast range of colours, but you won't need more than about ten to start out, especially if you intend to combine them with watercolours. The best course, therefore, would be to buy a small starter set and add more colours as needed. Most pre-packed sets contain a suitable basic colour range.

The main difference between types of coloured pencil is whether or not they are water-soluble. Working with a combination of both types of pencil provides an opportunity for a greater range of marks and layering of colour, although the variations may be slight.

The insects on this page were drawn using coloured pencils.

USING WATER-SOLUBLE COLOURED PENCILS

Water-soluble pencils are wonderfully versatile, as they can be used both wet and dry, or a combination of the two, in any one drawing, providing a high degree of textural variation.

TIP Whichever type of pencil you choose, it is recommended that you purchase a good-quality sharpener to keep the pencil tips in good shape and always spray completed pieces with a suitable fixative spray to stop any unwanted smudging.

BASIC NINE-COLOUR PALETTE

Hundreds of colours are available, but start with a nine-colour palette (see left) and build from there. Your basic palette should include one each of the three primary colours (red, blue and yellow) and a limited range of complementary colours (see Colour basics, page 72). Choose one very dark colour and white to complete your spectrum.

DRY COLOURED PENCILS

Dry pencils come in waxy and chalky varieties. Waxy pencils produce a rich, smooth stroke and can be sharpened to a very fine point, enabling the artist to draw in fine detail. Chalky pencils are more easily blended, creating some lovely, soft, dreamy effects. You can use hatching and crosshatching to build up areas of tone as you would in monochrome drawings. However, in coloured pencil work, these methods are also an effective way to mix colours or to modify them.

BLENDING WAXY PENCILS

To blend waxy pencils, it is necessary to work one colour into another, as they can't easily be rubbed together.

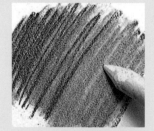

BLENDING CHALKY PENCILS

Lay down lines rather close to one another and rub them into one another with a paper stump or a cotton swab.

CROSSHATCHING

You can use crosshatching to mix colours optically; colours placed close together will mix when viewed from a distance.

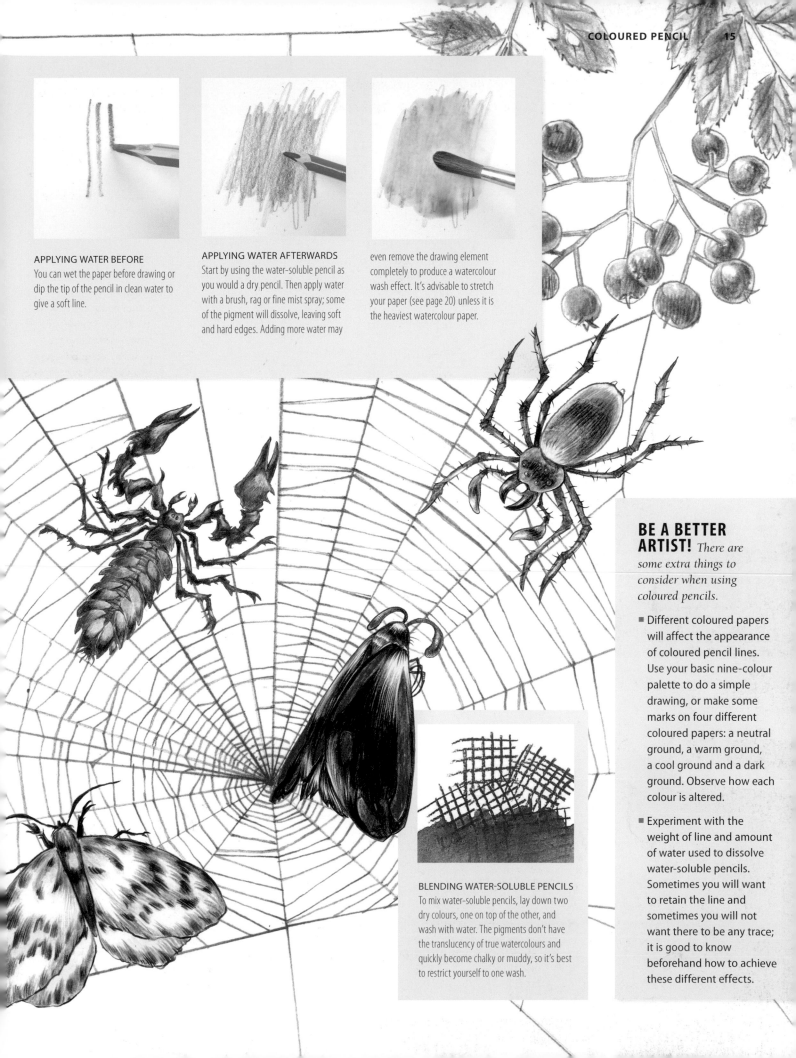

APPLYING WATER BEFORE
You can wet the paper before drawing or dip the tip of the pencil in clean water to give a soft line.

APPLYING WATER AFTERWARDS
Start by using the water-soluble pencil as you would a dry pencil. Then apply water with a brush, rag or fine mist spray; some of the pigment will dissolve, leaving soft and hard edges. Adding more water may

even remove the drawing element completely to produce a watercolour wash effect. It's advisable to stretch your paper (see page 20) unless it is the heaviest watercolour paper.

BLENDING WATER-SOLUBLE PENCILS
To mix water-soluble pencils, lay down two dry colours, one on top of the other, and wash with water. The pigments don't have the translucency of true watercolours and quickly become chalky or muddy, so it's best to restrict yourself to one wash.

BE A BETTER ARTIST! *There are some extra things to consider when using coloured pencils.*

■ Different coloured papers will affect the appearance of coloured pencil lines. Use your basic nine-colour palette to do a simple drawing, or make some marks on four different coloured papers: a neutral ground, a warm ground, a cool ground and a dark ground. Observe how each colour is altered.

■ Experiment with the weight of line and amount of water used to dissolve water-soluble pencils. Sometimes you will want to retain the line and sometimes you will not want there to be any trace; it is good to know beforehand how to achieve these different effects.

FROM BALLPOINT TO TECHNICAL – Get the most out of the numerous different types of pens.

Technical and fibre pens

Pen and ink is one of the oldest of all the drawing media. Both the implements and the inks can be made from a variety of substances. You will discover which type of pen suits you best by trying out the different types.

Fixed-width pens

Technical or fibre-tipped pens have nibs of a fixed width, so you'll need a selection of nib sizes to get a selection of line weights. However, these pens are still capable of producing a variety of techniques, such as stippling, broken lines and hatching, to create textures and interesting effects. They deliver the ink to the nib at a standard rate, allow you to draw quickly and are useful for outdoor work, as you don't have to carry ink with you.

The insects on this page were drawn using technical and fibre pens.

LINE WIDTH
Technical pens leave a smooth, clean line of constant width and are available in a range of sizes. Buy a variety to give yourself options.

TECHNICAL PENS
Like fountain pens, technical pens use ink cartridges, so remove them prior to storage. Clean technical pen nibs with a gentle soap-and-water solution every time they are used, or they will become clogged and begin to blot (or fail to work at all). Do not overfill the cartridge, or fill with metallic or acrylic ink. Technical pens produce smooth lines of uniform weight and blackness. They are excellent for drafting, architectural drawing and anything that requires neat, precise lines.

TIPS

- Avoid pushing your pen against the grain of the paper. If you encounter resistance, lighten your stroke to ride over the bump. Even felt-tips and technical pens can spatter if the tooth of the paper flicks the ink.
- Don't lift the pen from the paper more often than you need to. Where possible, a single line should be drawn in a single stroke. Points where the pen has been raised and put back down often bulge and thicken, leaving a trace of the artist's hesitation. If you must lift your pen mid-stroke, it's better to leave a small break in the line than an unwanted dot. This is especially important when you are using fixed-width pens, which leave very uniform lines.

ROLLERBALL PENS
Rollerball pens combine ball nibs with liquid ink delivery; unfortunately, they have a tendency to smudge. 'Smudge-free' inks are available, but remember that all ink may smudge or blot when wet. A smudge-free ink is simply one that dries quickly.

FIBRE-TIP PENS
Fibre-tip drawing pens have a fibrous tip of fixed width. Like technical pens, they leave a smooth, uniform line. They are less expensive than technical pens and are usually disposable.

WEDGE-SHAPED MARKER PENS
A wedge-shaped marker pen can be used to make thick or thin lines by using the pen either on its side or on its point. It is best used for covering large areas rather than depicting detail, however.

BE A BETTER ARTIST! *Go out and try some pens before you spend money on pens and inks.*

■ Make the most of your money. Don't waste your most expensive pens and inks on casual doodling. Buy similar types of pens in a range of qualities. That way, you can practise with the cheaper ones to get the feel of how they work and save the good ones for more important projects.

■ Experiment with new pens as soon as you get them. Get a feel for how long the ink takes to dry on various types of papers, how uniformly it flows and any quirks you might want to be aware of (or take advantage of).

BALLPOINT PENS
Ballpoint pens come in both refillable and disposable varieties. They use viscous, oil-based ink that coats the ball nib and transfers, with pressure, to the paper. When shading lightly with a ballpoint pen, wipe the nib from time to time, as the ball keeps turning even when the ink is not being properly deposited and globs can form around the edges. This ink is generally not of a particularly high quality and it is better suited for writing than for drawing, or for sketching on the go.

TIP Try not to be in a hurry when you ink. Even when neatly contained in the barrels of pens, ink is a wet medium that has a way of getting where you don't want it to be. Just as you would when you're drawing in pencil, always have an extra sheet of paper or a piece of cloth ready to rest your hand upon. This prevents harmful skin oils from soaking into your drawing, and it also keeps fingerprints and smudges to a minimum.

BRUSH PENS
Brush pens are fibre-tipped pens with a brush-like nib shape that yields lines of variable width, depending on the angle of application. The tip is fine and leaves a light line; the side can be dragged across the paper for a heavier line. Brush pens come with various types of inks: translucent watercolour ink that can be further manipulated with water washes, permanent and water-soluble drawing inks and pigment-rich acrylic ink. They are a neat and portable alternative to standard pen-and-brush techniques. Don't press down too hard when you are using brush pens. Unlike brushes, split or damaged nibs can't be reformed into neat points.

INCREDIBLE INK – *Discover the versatility and possibilities of using ink from a pot.*

Nibbed pens and brushes

Once the nib of a felt-tip pen becomes worn or damaged, the pen is done. With a dip pen, a damaged nib can be removed from the holder and replaced with a new one. Handle your nibs gently, especially when securing a new one in the holder; nib tips are split into two tines, which are easy to squeeze out of alignment. Examine your nibs before you buy them to make sure that they aren't damaged. If you look at a nib side-on and the tines are pointing in different directions, don't buy it. New nibs should come to a neat, uniform end.

The insects on this page were drawn using nibbed pens and ink.

Pointed nib

Broad nib

Steel nib

Copper nib

NIBBED PENS
Nibbed pens are ideal for drawing, as they give a sensitive and variable line, although the drawing process is slower as you have to keep recharging the nib. A broad-nibbed pen uses more ink than a fine one, thus limiting the length of the line that can be achieved with one stroke.

POINTED NIBS
Pointed nibs are more flexible than broad nibs and have a pointed, not flat, tip. Line weight is regulated by pressure. When the nib is pressed to the paper, the halves splay apart, allowing ink to flow between them. This only works when you are pulling the nib towards you. Attempting it on an upstroke will cause the nib to catch on the tooth of the paper and spatter ink everywhere.

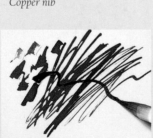

BROAD NIBS
Broad or chisel-edged nibs are rigid with flat, wide tips. Fine lines are achieved with sidelong strokes and broad lines are formed by pulling the nib directly towards you.

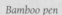

Bamboo pen

INK WASHES
Ink washes can be used to apply a background colour, or texture across an entire sheet of paper, or to create discrete areas of tonal gradation.

Step one: Mix ink with water to prepare it for washing. Artist-grade acrylic inks and permanent black inks tend to contain a lot of pigment. Start with only a drop or two in a quarter cup of water. You can add more pigment to your wash if it isn't dark enough.

TIP
- Wipe away excess ink on a scrap piece of paper after each dip in the inkwell. This prevents blots and drips.
- Never dip your pen beyond the nib. Dipping the holder into the ink allows ink to get into the holder itself. When it dries, it will glue your nib in place.
- Wipe your nib clean every so often. When ink dries on the nib it can glue the tip together, which will cause ink to drip and spatter when you try to bear down on the nib for a thicker line.
- Clean your nibs and penholders after use with an ink cleaning solution designed for the purpose. Do not let ink dry into your equipment.

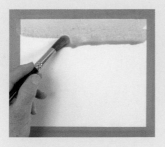

Step two: Stretch your paper (see page 20) to avoid curling and warping. Apply ink with uniform horizontal strokes of a brush or sponge.

Step three: Continue down the paper quickly, not allowing the ink to dry between strokes. Work back over uneven lines if necessary to even out any discrepancies in the wash.

Step four: Here, the ink has been applied to create a flat, even finish. Graded washes can be achieved by applying further layers of wash to the areas you want to be darker.

BE A BETTER ARTIST! *You get what you pay for when it comes to inks.*

- Don't waste money on student-quality acrylic inks. These are often not lightfast or colourfast and use low concentrations of pigment. This means you'll end up having to go over lines repeatedly to get the intended intensity. And, once you get the effect you want, it will degrade over time.

- Note whether the ink you are buying is permanent or water-soluble. Some permanent inks will hold fast when washes are applied on top of them; some will not. If you want to use a wet-on-dry technique, test it out first, using the ink and paper you intend to use for the final drawing.

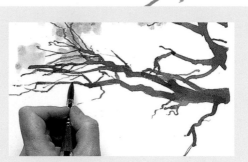

COMBINING TECHNIQUES
The larger branches in this piece were drawn using a thin brush, flooding in more ink in places. The smaller branches were added with a nibbed pen. Then an ink wash was added with a large brush to the background. This combination of techniques creates a multi-layered and multi-textured effect.

Chinese brush

BRUSHES
If you have only ever worked with the point media (pencils and pens) drawing by dipping a brush into ink and letting it glide across the paper gives a wonderful sense of freedom.

Medium paintbrush

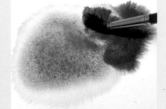

BRUSH TYPES
Good drawing brushes allow for strokes as fine as a hair's breadth (the tip of the brush should taper to a single hair), or as wide as the entire tip laid on its side. By altering the angle of the brush, it's possible to go from one extreme to the other in a single stroke.

WET-ON-DRY
This means working fresh (wet) ink over a layer of ink that has already dried. When using water-soluble inks, applying wet ink can cause dried marks to remoisten, causing some mixing of colour to take place. Be aware of whether your inks are water-soluble or not: this effect is not always wanted.

WET-ON-WET
Laying down water with one brush and ink with another, wet-on-wet, will cause your ink to spread out on the page, following the spread of the water. This can create some beautiful liquid effects. Avoid using too much water, as it will warp your paper and your ink will take forever to dry.

*CHOOSING PAPER – Learn about paper types
and how to match your paper to your drawing.*

Paper

Papers can be handmade or machine-made. Handmade papers are the most expensive. Papers vary in quality and thickness, or weight.

When selecting your paper, the first question to ask yourself is: 'What am I going to draw on it?' Paper can be expensive, so there's no point in wasting pricey archival watercolour stock on 30-second gestural drawings when a roll of newsprint or the backs of used sheets of printer paper will serve you just fine.

When choosing paper for drawings you'd like to preserve, look for the words 'acid-free' and 'archival'. Acids found in wood pulp cause paper to degrade over time, so you'll want paper that has a neutral pH for your best work. The most durable papers are made of cotton rag, but most drawing papers are wood pulp-based.

STRETCHING PAPER

If you are using a technique that incorporates a fluid medium, such as ink and wash (see page 18), you may need to stretch the paper to prevent it from buckling.

Step one: Cut the tape into the correct length before wetting either it or the paper.

Step two: Wet the paper on both sides with a sponge (or soak it briefly in a sink or bath).

Step three: Wet the sticky side of the tape, then turn it over and stick it all around the edges of the paper, smoothing it with the sponge. Leave to dry naturally.

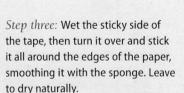

INGRES
Ingres paper, named after artist Dominique Ingres, is a light- to medium-weight paper with a prominent tooth, excellent for charcoal and pastel work. It is not as good for fine pen-and-ink work, or pencil work involving a lot of small details, because of its woven texture.

WATERCOLOUR PAPER
The heaviest papers are usually used for painting, rather than drawing. Watercolour paper, like drawing paper, can be rough or smooth and also works well for inks applied with a brush. It's not so good for inks applied with a nib or felt-tip pen, as the fibre of the paper will damage your pens.

TRACING PAPER
Tracing paper is your best friend when you're working on a complicated piece and you're not sure what should go where. Sketching the elements of your composition on to scraps of tracing paper allows you to balance your composition without having to start again from scratch. This might seem like a lot of extra work, but you'll find that it saves time, as you won't have to erase and recreate entire sections of your drawing to fix an ailing composition.

DRAWING PAPER

Drawing paper is medium-weight, often available in archival quality and suitable for finished work in pencil, charcoal, pastel and ink. This type of paper is not suitable for watercolour paintings or wet-on-wet ink work but will support ink washes. Drawing paper, like sketching paper, varies in texture and is also available in a variety of colours.

COLOURED PAPER

Paper comes in a range of colours, from neutral browns and greys to vivid hues. Choosing a toned paper with a mid-range value makes it easy to create the illusion of a full-value range using only black-and-white ink, whereas, by choosing a paper that contrasts with the dominant colour in the drawing, you can exploit interactions of opposites (see Colour basics, page 72).

BE A BETTER ARTIST!

When you feel sure of your techniques, try drawing on different types of surface.

- Try out some speciality papers, such as rice paper, handmade paper or lambskin paper. Each has its own properties and uses. Find the ones that suit your purposes best.

- Try drawing on things that aren't paper. What happens when you draw on a banana skin with a ballpoint pen and leave it out in the sun?

- Never try to draw a complicated picture in one go on a single sheet of paper. You'll get bogged down, trying to make every detail perfect and lose all semblance of looseness and spontaneity. Once you become confident, you may choose to abandon this rule.

PAPER TEXTURE

Artists often choose a textured surface for their drawings, as the paper grain breaks up the strokes or areas of tone to produce an attractive broken effect that can add extra interest to drawings. A more practical advantage of textured paper, especially for colour work, is that it allows you to lay on more layers of colour. If you work on too smooth a surface and with too much pressure, the paper can quickly become clogged, resisting futher applications of colour. With watercolour paper, it is nearly impossible to fill the grain of the paper fully, so the surface will remain workable for several subsequent layers.

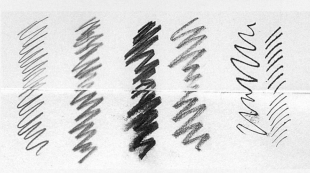

Marks made on shiny paper (top) and standard drawing paper (bottom) with (from left) 3B pencil, coloured pencil, willow charcoal, charcoal pencil, pen and ink.

GRAPH PAPER

This is a lightweight paper, useful for technical drawings, architectural work, precise copying or anything where measurement is important.

BRISTOL BOARDS

Ink-and-brush drawing works well on Bristol board, although the ink may form bubbles if applied too heavily; watercolour and wet-on-wet ink work do not, as it warps easily and allows water to pool and bead on the surface. Heavy stock is durable, thick and unlikely to allow inks or paints to bleed through to the other side.

HEAVY DRAWING PAPERS

Heavy drawing paper comes in a variety of textures and colours and supports a range of dry and wet media. If in doubt, with regards to bleed-through or durability, test the medium you'd like to use on a small section of paper before committing your masterpiece to it.

CARBON PAPER

Tracing paper can be used in conjunction with carbon paper to transfer drawings from one sheet to another. Graphite paper is an erasable alternative to carbon paper, but try it out before you use it to transfer something to an expensive piece of paper. Some brands are more erasable than others.

SKETCHING – How to get best value out of your sketchbook, from choosing one that suits you to what you put into it.

Your sketchbook

A good sketchbook serves as both testing ground and idea repository. Never ever worry about 'messing up' your sketchbook – that's what it's there for. Your sketchbook is where it's acceptable to make mistakes, try new techniques, experiment with subject matter and repeat the same thing over and over until you get it right. You can tape things into it, tear pages out of it and even press flowers in it, if so inclined. The only thing you shouldn't do with your sketchbook is treat it like a precious work of art. You'll never be able to get the most out of your sketchbook if you're afraid to make mistakes. If anything, consider your sketchbook a journal reflecting your progress – and remember, there wouldn't be any progress if you were perfect right from the start.

Remember that what you sketch is less important than making sure that you sketch. Hone your observational skills and engrain the intricacies of the visual world into your memory.

Selecting a sketchbook

Buying a sketchbook may seem like an easy thing to do, but there are a lot of aspects to consider before you hand over your money.

Size

Choose a sketchbook that suits your sketching style. If you plan on doing a lot of studio work – life drawing, for example – a big sketchbook makes sense. You'll want to be able to do both loose gestural drawings and long, detailed studies, both of which work better on a larger area. If you're more into sketching on the go – nature walks or portraits of people on your morning commute – a smaller, notebook-style sketchbook is for you.

Quality

What are you going to do with your sketchbook once you're finished with it? Do you tend to gear your sketches towards a specific project and then never look at them again once that's complete? If so, you don't need to hang on to your sketchbooks; indeed, you may not need a sketchbook at all. Don't waste money on expensive acid-free paper if you don't need your sketches to last. Scrap paper will do just fine. If you use your sketchbook as a journal or to furnish reference for undetermined future projects, look for paper that is of archival quality.

FOR WHEN YOU'RE ON THE GO
Sketchbooks come in all sizes! A little notebook, small enough to slip into a purse or pocket, can come in very handy. Always have paper on hand to jot down those fleeting ideas.

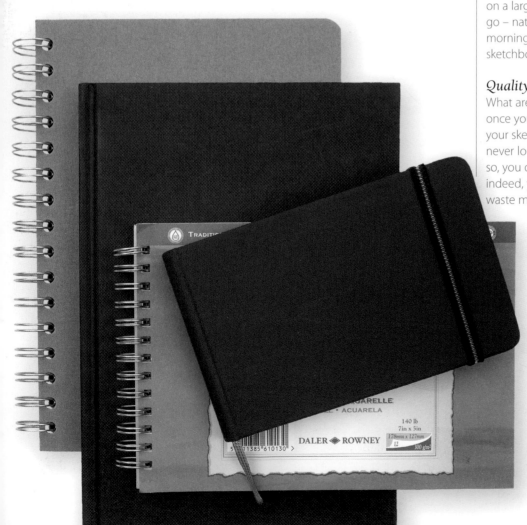

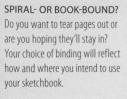

SPIRAL- OR BOOK-BOUND?
Do you want to tear pages out or are you hoping they'll stay in? Your choice of binding will reflect how and where you intend to use your sketchbook.

Paper surface

Do you use a lot of fine detail in your sketches? Or do you prefer to work loosely and take advantage of the paper's natural texture? If you like to produce work that is small and detailed, with a lot of precision, look for a smooth paper, without much tooth. If you prefer drawing something that'll let the paper's qualities shine through, look for a toothy surface.

Paper weight

The weight of a paper refers to its thickness. If you want to sketch in ink, you'll want a sketchbook with a paper weight of at least 100 gsm (70 lb), otherwise the ink may bleed through to the other side or be distinctly visible. It's a waste of money if you can only use one side of each page, so keep an eye on paper weight. If you want to paint in your sketchbook – for example, if you enjoy *plein air* watercolour sketching – choose a paper weight of at least 260 gsm (120 lb).

Binding

How much do you want to abuse your sketchbook? Spiral-bound sketchbooks are generally the cheapest, but they won't stand up to much abuse and dog-ear easily. Although pages are easy to remove, they're also easy to damage in the process. Tape-bound sketchbooks are best if you want to tear out a lot of pages, as the paper is held in only with a gummy adhesive, which is designed to give way easily. If you want a sketchbook for heavy use, go for a book-bound one. These are bound like hardback books, with sturdy spines and covers, and the pages are sewn in securely and not designed for removal.

Digital alternatives

The sketchbooks pictured here are made of paper, but yours doesn't have to be. Tablet computers, like the iPad, are great for sketching on the go. Even a smartphone with a touch screen can be used.

TIPS

- Reserve the first page or two of your sketchbook for a table of contents. This doesn't have to be a difficult undertaking. Simply note the date, the pages used and what you sketched each time you use your sketchbook. This will mean that you can find it easily at a later date. Number the pages on their outer top corners, so you can search them without trouble.
- Carry your sketchbook in a waterproof bag with a zip seal. You never know when the heavens will open.

HARDWARE AND SOFTWARE – How computers can supplement your drawing skills and trditional media.

Digital media

With the wide range of options and abilities the computer offers, it is important not to forget that the computer is really a 'dumb box'. It will do what you tell it to and do it well, but if you don't know how to draw or if you do not understand light, perspective and composition, then the computer will faithfully execute your poor ideas and generate poor images – skill and imagination are still required.

That said, computers have transformed the commercial art world. Just a decade ago, art created using a computer was unusual; now it is commonplace and fast becoming the standard. Even work created using traditional media becomes digital before publication, because almost all printing processes are now digital. And in your private practice you may find that there are some useful or exciting things you can do on a computer, such as inking linework and adding colour.

Choosing the right computer

Your choice of computer is down to your operating system preference, which will be either Mac OS or Windows. Macintosh is the preferred system in the creative world, but most of the industry-standard software is available on both platforms and files can be easily transferred between them. Also, consider your budget. It is nice to have the latest digital equipment, but if your budget is limited, buying a used computer can be a good idea. Ensure you buy the highest-quality monitor, however, at the largest size you can afford. It will make working easier and will give you the most accurate colour image, which is essential. Finally, when buying a computer, always purchase as much RAM as you can afford since graphics applications can often require a lot of memory.

BE A BETTER ARTIST! *Spend some time experimenting with different software programs in order to get used to them.*

- Photoshop is a dense program. Take one image and manipulate it into 10 or 20 versions, using every tool available – it's the best way to learn the program.

- Painter offers incredible flexibility in the choice of brushes and effects, so spend a few days creating various paint swatches.

COMPUTER
Whether you choose a Mac or a PC and a laptop or a desktop computer will depend on your personal preference and working habits. When it comes to monitors, size and quality are critical. Make sure that the monitor is properly calibrated so that colours are displayed as accurately as possible. A larger monitor can be attached to a laptop if required. Nearly all computers come with CD/DVD burners, which are indispensible for making back-ups, although a second external hard drive is also advisable for this purpose.

STYLUS AND TABLET
Drawing with a mouse can be awkward and clumsy because it is held quite differently from a pencil or pen; a stylus replicates the natural drawing movement. As a tablet is pressure-sensitive, you can emulate working with real pencils and brushes. Tablets come in a range of sizes, with commensurate differences in price, but smaller ones are well within the budget of most artists.

SCANNER
Whether you wish to scan a sketch as a starting point for a digital painting or to digitise an artwork for printing, a scanner is essential. Most scanners have high optical resolutions that are more than adequate for scanning line work. Achieving high-quality colour scans may be more difficult, however, and if you have hand-painted your images, you may be better off getting them scanned professionally, particularly if they are going to press.

CHOOSING THE RIGHT SOFTWARE

The program you choose will depend on personal preference and the style of art you are producing. You can often download free trial versions from the manufacturer's website, so you can try several and decide which you prefer before buying. There is also lots of alternative software, such as Shareware and Open Source, that is cheaper than the major commercial packages and will still do the job.

Images produced with vector programs are more hard-edged than pixel-based ones, so this is an excellent choice for fantasy comics, especially if you use large areas of flat colour.

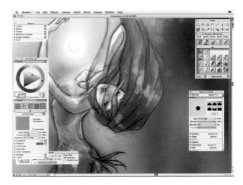

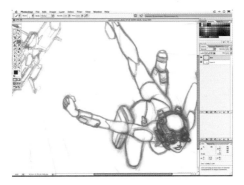

PAINTER

Painter excels at emulating traditional media and the sophisticated painting engine gives you almost limitless possibilities when creating your own brushes and effects. There is even a palette on which you can mix colours. Painter is popular with digital artists who come from a traditional paint-on-paper background, but is suitable for all levels of expertise.

PHOTOSHOP

Photoshop is the longest-established and best-known digital art software. A simple yet powerful set of drawing and painting tools is complemented by a versatile, comprehensive suite of image adjustment tools, making this the first choice for many professional artists.

ILLUSTRATOR

Vector illustration software, such as Adobe Illustrator, uses mathematical equations and PostScript language to produce drawings. As a result, very small files are created, which contain images that can be enlarged to any size without loss of quality. Therefore, vector software is ideal for turning a sketch made with natural media into a simpler digital image that can be viewed at any size.

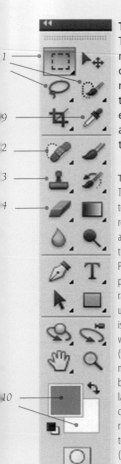

TOOLBARS, MENUS, PALETTES

There are various ways for you to control your work. The main toolbar contains all the principal tools, including ones for selection, drawing and cloning. The other menus, palettes and swatches give you mastery over all the tools in the toolbar. Your control over colour and the effects that you can create are an important part of your artistic repertoire. These panels show a sample of the tools, layer and brush options available in Photoshop.

TOOLBAR

There is a range of standard tools in the toolbar, including tools for selection (1), retouching (2), cloning (3), erasing (4) and more. Having selected your tool there are three ways to select colours in Photoshop: selecting from a standard or personalised grid (5), picking from a rainbow colour bar (6) or mixing colours using sliders (7) and a rainbow bar (8). It is also easy to match a colour in your work by clicking on the eyedropper tool (9) and then on the colour you wish to match. The foreground and background boxes (10) in the toolbar used with the large colour picker window (11) give you control over areas of colour. There is a range of standard brushes and drawing tools and options for customising them (see Brushes).

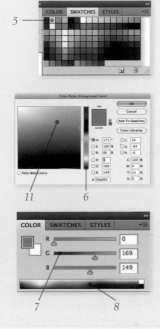

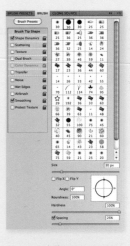

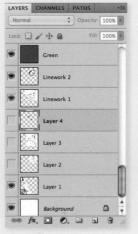

BRUSHES

Any software designed for drawing and painting will provide a range of tools — from pens, pencils, pastels and coloured pencils to various brushes. In Photoshop, you can set the type of brush and size in the brush toolbox.

LAYERS

Most drawing, painting and photo-editing programs allow you to experiment with different effects and compositions by using layers. Layers can be visualised as pieces of transparent film stacked on top of one another. When you make a drawing or scan in a photograph, it appears as the background layer called the canvas. If you create a new layer on top of this, you can work on it without altering the underlying image, because the layers are independent of each other. Similarly, you can work on the canvas without affecting images on other layers.

SCANNING YOUR DRAWINGS

To get your hand-drawn artwork on to a computer, you will need to scan it. Always scan at the highest optical resolution that your scanner permits and never below 300 dpi. There is a choice of three scanning modes: line (bitmap), greyscale or colour. Line or greyscale mode is best for scanning line art. Colour mode may be useful if you do your sketches with coloured pencils. If you want to scan hand-coloured images, it is usually best to get them scanned professionally, particularly if you intend to use them for print.

TIP

If there is artwork visible from the other side of the paper ('show through'), you can reduce this by placing black card over the back of the paper.

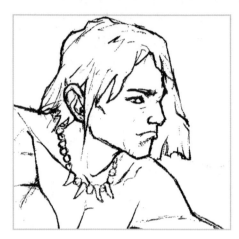

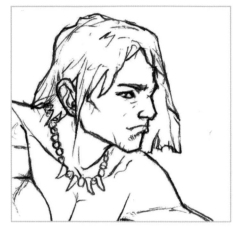

LINE MODE

Choose line mode for scanning black-and-white, inked images; use a resolution of not less than 600 dpi for this mode. Line mode ignores any lines that are less than about 50 per cent black, so any light pencil lines will disappear.

GREYSCALE MODE

Choose greyscale mode for scanning pencil drawings, because it will capture the full tonal range of the pencil and retain the subtle detailing in the strokes.

Original scan

CLEANUP SCAN

Clean up the scans if necessary; for example, remove any nearby sketches or notes. Start by cropping out as much of the unwanted areas as possible, then use the various selection and eraser tools available in your particular program to delete any remaining areas until you have a clean line drawing on a white background.

IMPROVE LINEWORK

Adjust the quality of the linework if desired. For example, you can make the lines appear crisper by increasing the contrast of the scan, or vice versa; you can do this using either Levels or Curves in Photoshop, for example.

Contrast increased

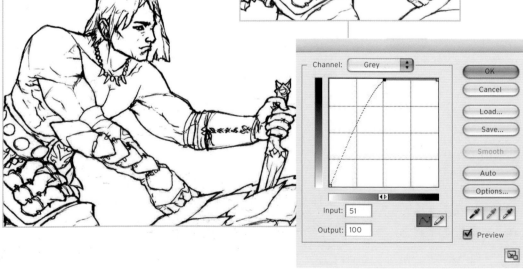

INKING

It is common for fantasy artists to draw in pencil and then work over their lines with ink. This provides consistent black lines that add depth to the drawing and help it stand out on the page when printed.

Inking can be done digitally, ideally by drawing over the lines using a stylus and graphics tablet rather than a mouse. Digital inking takes practice, but you do have the luxury of an Undo command. Make sure that you draw the ink lines on a separate layer, so that you can return to the original scan if necessary.

ADDING COLOUR

One thing you may want to do to your drawing once it has been scanned into your computer is add colour. There are numerous ways of doing this in each software program. This step-by-step sequence, written by Anne Stokes and done in Photoshop, is intended to show you how simple it is and to encourage you to experiment in your own program.

Step one: Scan drawing This beast has been drawn by hand and then scanned into Photoshop. The dragon has been cut out from the white background. The background was selected using the magic wand tool. The image of the head has been placed on a separate layer (see page 25) so that future functions will affect the head only and leave the background white.

Step two: Block main areas of colour By altering the levels in the Hue/Saturation function, the whole head has been shaded dark pink. The main areas that are to be different colours have then each been selected using Photoshop's lasso tool and individually coloured using the Hue/Saturation function.

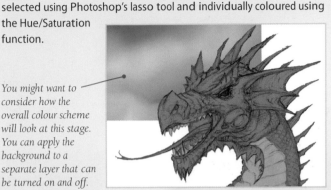

You might want to consider how the overall colour scheme will look at this stage. You can apply the background to a separate layer that can be turned on and off.

Step three: Add shadows Using the burn tool, shadows have been put on to previously flat areas of colour.

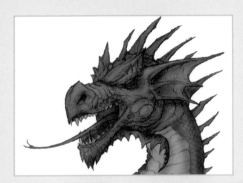

Step four: Add highlights With the dodge tool, highlights have been added. The edges have been cleaned up using the eraser and smudge tools.

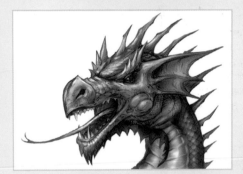

Alternatively, you can skip straight to step five and add the shadows and highlights with the brush tool.

Step five: Add different colours Using the brush tool with 20 per cent opacity, different colours have been added over the top of the image to give more variety of colour. The head has been 'selected' so it does not affect the surrounding area. More smudging and further use of the dodge and burn tools on a small brush setting give the details.

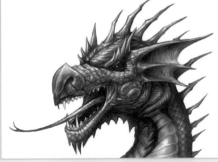

Step six: Add background A background has been added to complete the picture. The separate white background layer is behind the dragon's head and therefore can be altered without affecting the dragon itself. Various shades of orange have been sprayed on with a large-setting brush to create the volcanic cloud effect. The colours have been picked from the Swatches box, which you can access by going to Window and clicking on the Swatches option. Whichever swatch of colour you click on will be selected for use with the brush.

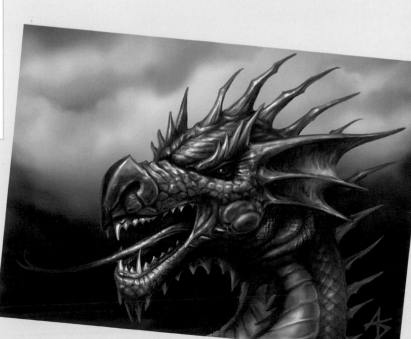

FINDING IDEAS – Learn how to find inspiration from a variety of sources.

Inspiration

Ideas can come from anywhere – from the work of other artists, from the grandeur of the natural world, from the tangled lines of hairs in the bathroom sink. An artist's bank of inspiration might be filled to the brim with books and poems and interesting phrases culled from late rent notices, with faded and personally slanted memories of cherished (or hated) eras, with postcards, with magazine clippings – with just about anything, really.

A fantasy artist may seem to be at a disadvantage, as no direct reference exists for your subject matter – only the fruits of other imaginations. But nothing's more open to interpretation than the non-existent. Look at the many faces of gods and dragons, fairies and imps, demons and trolls. As a fantasy artist, you can pull ideas from virtually anywhere and set them to work in a world of your own construction.

▶ MICHAEL HAGUE
This watercolour by Michael Hague illustrates 'Fairy Song', by Sir Walter Scott and was first published in *The Book of Fairy Poetry*.

BE A BETTER ARTIST! *Now it's time to turn your surroundings into fantasy art.*

■ What gets your creative juices flowing? Pin your favourite pictures up around the studio and keep a bookmark folder of inspiration on your Internet browser. Try reading for half an hour before you start drawing, or leafing through your sketchbooks.

■ Music is tied strongly to memory and emotion. When you want to get a particular atmosphere into your work, try listening to tunes that put you in the mood.

■ Try to learn something from every piece of art you see – even the bad ones. Figuring out what went wrong can be a valuable exercise.

drew the viewer into an unpleasant world of zombies, ghouls and old witches.

- The Internet is full of art of all themes and skill levels. Aspire to match the best – but look at everything, from the amateurs to the masters. It can be especially helpful to look at the work of a single artist as it has evolved over the years. Posts to Internet galleries are often dated, so you can track people's progress without difficulty. Try to figure out what they learned and when – and how you can apply the same lessons to your own art.

Video games

Modern games feature lush environments and a wide array of creature and character designs to draw upon. Wandering through the worlds of *Final Fantasy XII*, *Star Ocean: Till the End of Time* or *Shadow of the Colossus* can be breathtaking.

◄ ARTHUR RACKHAM
This dreamy and surreal illustration depicts the Pool of Tears from Lewis Carrol's *Alice in Wonderland*.

▼ GUSTAVE DORÉ
This engraving by Gustave Doré shows Satan and his followers being cast out of heaven.

Other art

Other art is an excellent source of ideas and you should look at as much of it as possible. Admire it, but try to look with a critical eye as well. How did the artist achieve these effects? Why is this approach effective? What attracts you to this image? And what, if anything, would increase its appeal?

- Gustave Doré uses strong lighting and energetic lines to create drama. His illustrations for *Paradise Lost* bring the fantasy worlds of heaven and hell, and the characters therein, to life.
- Arthur Rackham uses soft light, flowing lines and muted palettes to evoke a dreamlike fairyland – a world that drifts out of focus if you try to touch it or come too close.
- Michael Hague's bright, translucent colours imbue his paintings with equal parts cheer and otherworldliness. They appeal to children and adults alike.
- Yoshitaka Amano, like Arthur Rackham, uses free-flowing lines and washes of colour to create a sense of the unknown and fantastic. He draws on elements of design, architecture and fashion to add richness to his creations.
- 'Ghastly' Graham Ingels did horror like no one else for EC Comics. Bold lines, stark contrasts and crude shapes and forms

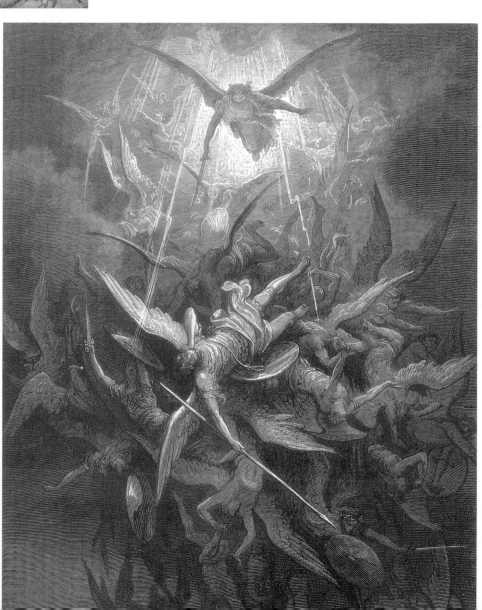

HAUTE COUTURE
This tiered lace dress with horned headpiece by Alexander McQueen is beautiful, unusual and inspiring in equal measure.

Look at your games with a critical eye. Do the people and creatures you encounter look like they belong in their environments? Are they dressed appropriately for the weather? Prepared to handle the terrain? Could the local ecosystem support all those big, red dragons you keep encountering? Maybe it's the same dragon every time, picking itself up and swooping in for another bite at you.

Older games weren't so strong on the visuals. Imagination filled in the blanks left by low-resolution displays. How did you picture the worlds of *Pitfall*, *Paperboy* and *Below the Root*, as you sat hunched over your Commodore 64? What about *Asteroids*? You weren't standing in the arcade with visions of angry triangles dancing in your head, were you? How did you picture that spaceship? The asteroids? The annoying little fellow in the UFO, who'd fly by and take shots at you?

Fashion

Haute couture lines often feature impractical, extravagant creations, equally suited to the court of the Fairy Queen or a deck of the alien mothership. These designs are intended to show off the designer's skills, rather than attract the average consumer, and are, themselves, works of art. Hints of the fantastic can also be plucked off the rack. Echoes of Nicole Miller's colourful, geometric patterns might spice up your sci-fi, while nothing says ethereal like a ballgown from Oscar de la Renta.

Jewellery

From the antique to the cutting-edge, from the fancy to the funereal, there's a rich history of design and symbolism to draw upon. Gemstones have often been assigned symbolic significance. A single, gleaming South Sea pearl might suggest purity, innocence or mystery, whereas strands and strands of them lean more towards opulence or greed. Diamonds are hard; rubies are fiery; opals are brittle; emeralds are green, associated with grass, new growth and, in *The Wizard of Oz*, money – or, at least, the illusion of it.

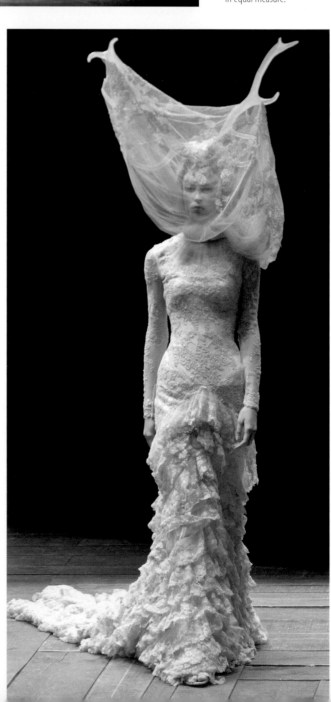

Books

Read a lot – and not just fantasy! Remember, if all you ever read is other people's flights of fancy, anything thus inspired will already be filtered through the lens of somebody else's imagination. Read gardening books, history books, books about angry Scotsmen who hate their jobs. Read comics. Read the paper.

- Read *Crime and Punishment* by Fyodor Dostoyevsky. It'll make you want to draw horrid, tormented souls, all hollow-eyed and sleepless. And you can tell people you've read *Crime and Punishment*!
- Read *The Overcoat* by Nikolai Gogol to get in the mood for eerie things, pathetic creatures and unsatisfying acts of vengeance. Whoever invented poisonous toads had probably just read *The Overcoat*.
- Read *The Wind in the Willows* by Kenneth Grahame. It'll inspire you to spend more time outdoors and on boats.
- Read the comics *Tales from the Crypt*, *Vault of Horror* and *The Haunt of Fear* – especially 'For How the Bell Tolls', found in *Vault of Horror*, January 1953. Talk about going out with a bang!

- Read other people's diaries. It's not nice to sneak into your brother's room and read his, but this is the digital age. Online diaries furnish all the voyeuristic enjoyment, with none of the pangs of conscience. What do mundane personal musings have to do with fantasy art? Good fantasy rings true on a human level. Characters we recognise in worlds we don't: That's the winning formula.
- Read *Gormenghast* by Mervyn Peake. It has man-eating owls, the king of all castles and a delicate musing on tooth decay that gains more and more painful personal relevance as the years pass by.
- Read road signs. Although the wonderful Burma Shave billboards are a thing of the past, there are still some gems out there. Here are some peculiar examples: Ball of String, 5 miles (left); Warning: Dead Zone; Toad Migration Area; Medicine Hat.

PLACES, PEOPLE, THINGS

Inspiration can strike anywhere. Keep a notepad and a mobile phone camera with you at all times, so you can keep records of interesting things people say, striking lighting conditions, unusual architecture, flowers you've never seen before, funny-looking animals and anything else you might want to incorporate into your work.

USING REFERENCES – How to use the reality around you as a source for fantasy.

Sourcing and using references

Fantasy art involves lots of imagination, but a solid understanding of reality is also essential. It's in the small, familiar details – the eagle-like wing of a griffin, a kirin's leonine mane, the nictitating membrane on a dragon's eye – that your creation comes to life.

Simplification

When you draw from the imagination, you base the drawing upon experience. Experience tells us that an eye is an almond shape, with a circle inside; that a mouth is a line with a dimple at each end; that a nose is a bump with two holes in it. Our brains simplify what we see, codifying visual input for fast interpretation. This is great when you're bowling along the motorway at high speed. It's not so helpful when you're at home, later that evening, trying to draw the interesting tree you noticed on the drive. Using reference interrupts automatic simplification, helping you to observe, record and correct in a more orderly fashion.

Reference material

Reference material can take the form of a live model, a view from a window or balcony, a photograph or even a scale model. Having something to work from is a great tool for breaking out of the habit of oversimplifying. When you draw from life, or from a photograph, don't rush to draw what you think you see. Take your time. Study your reference material. What do you really see?

PHOTOGRAPHS
Take a small camera, such as a mobile phone camera, everywhere you go to take reference photographs of the things that inspire you – large and small.

BE A BETTER ARTIST! *Start gathering reference to use in your fantasy art.*

- If you see something interesting, take a photograph of it. Organise your pictures by subject matter, so they'll be easy to find when you need them. Other ways to gather reference include sketching; taking written notes, picking up pamphlets, postcards and brochures; pressing flowers; and browsing stock photography sites. When using stock sites or any material you did not create yourself, make sure you respect the original creators' rights and terms of use.

- Take a photography class, or at least read the manual that came with your camera. Knowing how to get a clear, crisp, well-lit photo is very helpful.

- Even when you're drawing familiar subject matter, it never hurts to check out some reference. A good artist is constantly observing and building a visual vocabulary. The more you look, the more you notice – and the more you remember.

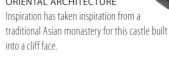

ORIENTAL ARCHITECTURE
Inspiration has taken inspiration from a traditional Asian monastery for this castle built into a cliff face.

CONSIDER THIS!
You can gather reference material for anything, from textiles to plant and rock textures. Reference can even take the form of written material; when you're drawing historical fantasy scenes, it's great to know what types of tools, animals and buildings might have been around at the time.

APPLYING WHAT YOU'VE LEARNED

The first thing to do is figure out what you can use as a basis for your creation. If you're drawing a griffin, gather pictures of lions and eagles. If you're drawing a dragon, try snakes, lizards or even birds. For a fairy or goblin – or any humanoid creature – use a person. In this exercise, you're going to draw the same subject twice: once entirely from the imagination and once with reference.

Step one: Unreferenced sketch This fairy princess has been drawn from a straight-on angle. The facial features have been described in a fair amount of detail, but the rest of the figure is only hinted at. Although a lot of care has been lavished on the hair and the fabric of the costume, the extremities have been avoided. Hands and feet are difficult for most beginners, as they're complicated forms with a lot of subtle details, so it's tempting to gloss over them entirely.

Step two: Gather your reference Ask somebody to sit for you. Or, if you're going to work from photographs, make sure you take several. Try out several poses, angles and lighting directions. Once you start sketching, you'll see that some translate better into drawings than others.

Unless you are specifically interested in costume reference, it's best to shoot your model in the nude, or in tight-fitting clothing, so you can get a good, clear look at her anatomy. However, in this case, the fairy queen's clothing is important – most notably, her boot – so it's been included.

Work from black-and-white photos, where possible, as it's easier to concentrate on value and form when colour information is not present. We interpret some hues as 'darker' or 'lighter' than others, even when this is not the case. Blue, for example, will read as 'darker' than yellow, even when the yellow has a deeper value.

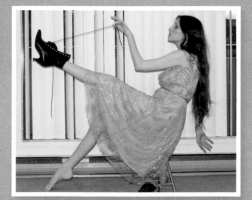

Step three: Adapting reference Try to stay close to your reference material while learning to observe, but don't be afraid to make editorial decisions! Your reference may be flawed, but your art doesn't have to be. In this case, an awkwardly placed hand has been left out and the costume has been altered to reveal the lines of the legs.

Now try it from the imagination again. As you work, try to remember the shapes, textures and lighting effects you observed while working from reference. When you compare the finished product with your first try from the imagination, you should see some more sophisticated forms emerging!

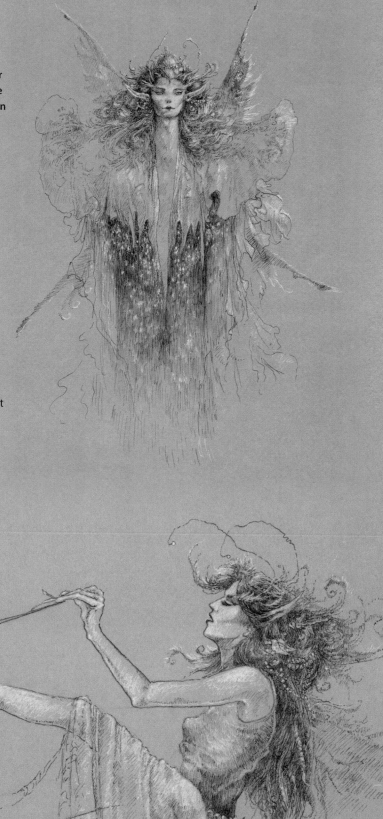

- Human models may be self-conscious and try to choose flattering poses. Animals will position themselves however they like and are therefore ideal subjects for action and gestural drawings and for studying natural poses. Try sketching in your local dog park or zoo. Animals are also convenient subjects in that you don't need their permission, but they may not hold a pose long enough for you to draw it.

- Give yourself freedom. Do a life drawing session with materials that will not last. Do gestural drawings with your finger in sand and longer poses in soy sauce on napkins. Or use washable children's paints on a white wall and scrub them off when you're done. Knowing that all your work will be lost removes any pressure to create a masterpiece and frees you up to experiment.

- Plan your life drawing sessions with your next fantasy drawing project in mind. If you want to draw a barbarian swinging a sword, bring a toy sword for your model to hold. If you want to draw a fight on a flight of stairs, have your model pose on steps.

GETTING TO GRIPS WITH LIFE DRAWING – It's easier than you think to draw from life, as these tips reveal.

Drawing from life

When you draw from a photograph, the subject has already been flattened and simplified and is one degree removed from reality. You are translating one two-dimensional medium into another. This is not without value, but you'll also want to be able to do that conversion from 3D to 2D yourself. Drawing from life allows this. Furthermore, it enables you to observe and record movement, which is essential to understanding how everything fits together and why the body looks the way it does from any given angle.

DRAWING WITH A MODEL
Start your life drawing session with some action drawings and gestural drawings to loosen up. If you are using a human model, ask him or her to move around naturally for five minutes or so, then do a series of 30- to 60-second action poses. If you are using an animal, it will probably move around on its own.

▼ ACTION DRAWINGS
Action drawings have to be done very quickly. Don't worry about details – these drawings are less about what is there and more about how it is moving. Concentrate on lines of tension and movement and on visually representing the transition from one state or pose to the next. Is your model twisting? Turning? Putting strain on one particular muscle or muscle group? Try to capture that. An action drawing can be as simple as the principal line of tension on a moving body – often across the arms or down the spine, but not always.

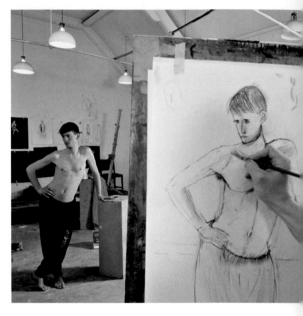

▲ LIFE DRAWING CLASSES
Life drawing classes are a great way to get access to an artist's model and a professional critique of your drawing at a reasonable price.

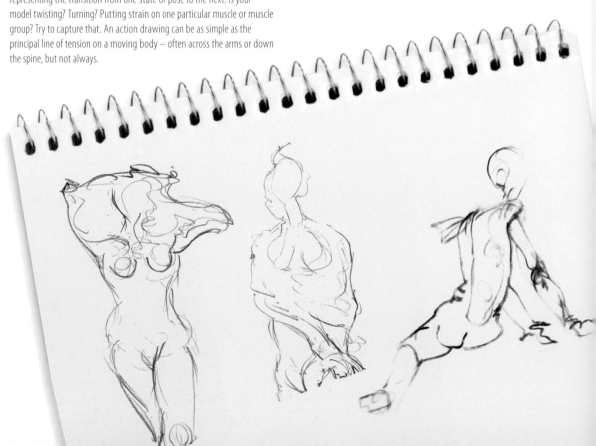

FINDING A MODEL

- Hiring an artist's model or joining a life drawing class is the least awkward way to get life drawing experience. Professional models know what is expected of them and are comfortable posing both clothed and in the nude.

- A professional model may not always be available or practical. If you ask a friend to pose for you, get him or her to wear something comfortable, but not so bulky as to hide the contours of the body. A T-shirt and shorts work well, as does a swimming costume.

- If you want to sketch a stranger, ask first. Some people will say it's fine but then ask to keep the drawings. It's a nice gesture to agree to that. The value of life drawing is in learning to observe and interpret your subject, not in the drawing itself.

TIPS

- Be reasonable in your posing requests. Most models cannot stand on one foot, for example, for more than 60 seconds without strain. If your model becomes stressed or unbalanced, he or she will move to correct the pose, voluntarily or involuntarily, and you won't capture it well anyway.

- Always be conscious of safety when asking someone to pose on uneven footing or with a heavy object. Don't ask them to hold such poses for more than a couple of minutes.

- If there's a difficult or stressful pose you'd like to study at greater length, ask your model if you can take a photograph. When hiring a model, it's a good idea to find out in advance if photography is allowed. Extra fees may be involved.

- Ask your model to pose with various objects. Professional models may bring sticks or poles, or scarves or drapery with them, as these are popular choices.

◀ GESTURAL DRAWINGS

Gestural drawings are similar to action drawings. They should be done quickly and without getting caught up in details. As with your action drawings, you'll want to pay attention to tension, movement and transition — but this time, try to relate that to the nature of the subject. Also consider its weight, its relationship to its surroundings and where and how it is balanced.

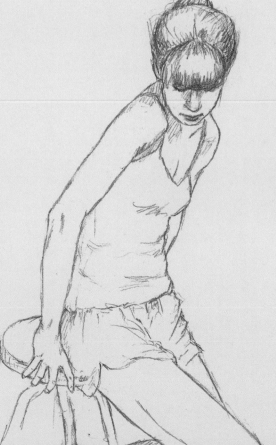

▶ LONGER POSES

Once you've got into the groove, have your model strike some longer poses of two to three minutes each. This should be plenty of time to sketch in the large forms of the body, as well as some finer details, such as facial features, hands and feet and areas of deep shadow.

Try to discover a focal point in each pose. What interests you when you look at your model? Draw attention to that area by spending more time there than on the rest of the body. Feet, hands and faces are often centres of interests. So are places where the bone pushes up against the skin and regions of gathered or wrinkled skin.

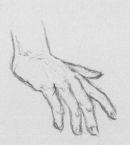

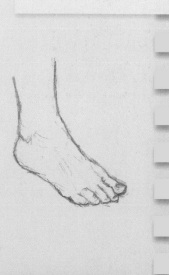

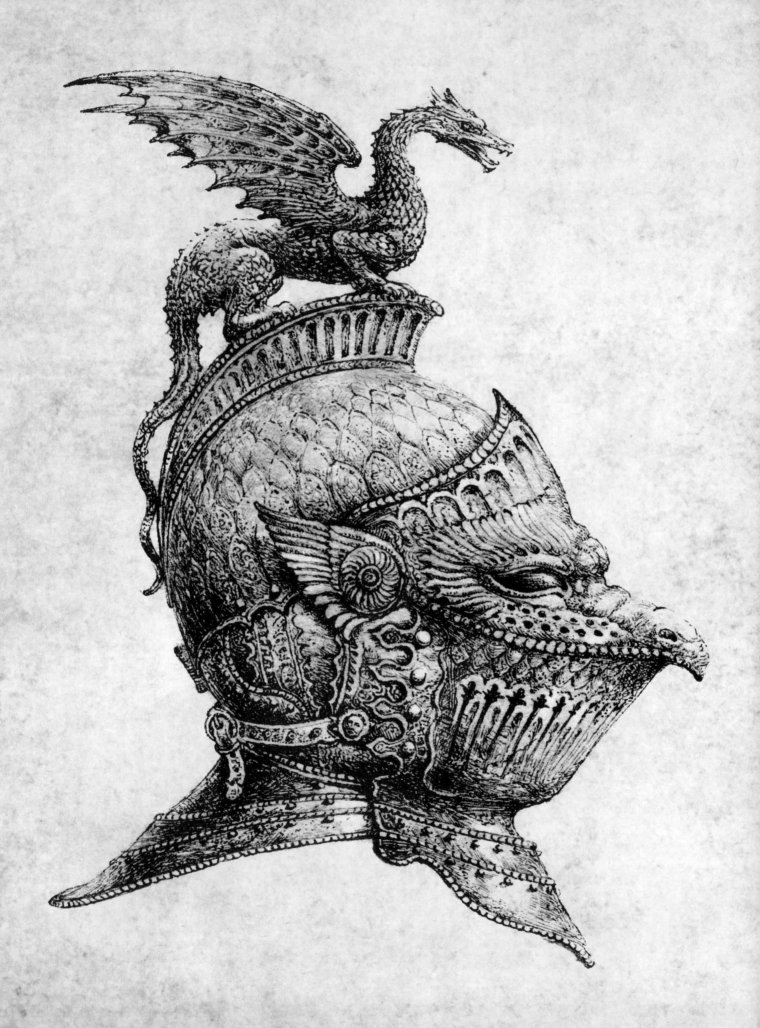

CHAPTER 2
Picture-making techniques

Learn to understand the world in terms
of light and shadow, texture and pattern,
shape, form and perspective. Once
you've put aside what you think you see,
in favour of what's really there, you can
set to work hanging the trappings of
imagination on the framework
of reality.

GET COMFORTABLE WITH LINE – How to use a variety of line types and mark-making techniques to describe an object.

Making your mark

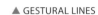

▲ CONTOUR LINES

The most straightforward type of line is the descriptive or contour line, which is used to denote an edge or form. You can also use a descriptive line to mark the transition between one object or plane and the next. Here, contour lines carve the little rat from his surroundings, outline the spots on his back and draw attention to changes in plane within his body (such as the edge of his flank and the wrinkles under his neck).

Before you continue reading, take 20 seconds and draw a man in bed counting sheep. Don't think about it too much. Draw as fast as you can.

Edges

Given the short time allotted, you probably took the most direct route and drew the outlines of objects: a circle for the man's face; lines beneath, where the covers come up to his neck; maybe a thought bubble above his head; a jagged line for the top of the fence; a cotton-puff sheep sailing over it. Nothing wrong with that; line is the simplest way to describe an object visually. However, describing the edges of things is only the beginning. Lines can also be used for shading, building up texture, suggesting movement, attracting the eye to key areas, creating emphasis and pure embellishment.

Doodles

You're probably already more comfortable with line and mark making than you realise. Think back to the last time you were talking to somebody dull on the telephone, doodling as you pretended to listen. Did you use long, elegant lines to make a series of stick figures jump and dance across your notepad? Maybe you used short, sharp marks to show the movement of fleas jumping off a dog's head? Or a mass of squiggles to describe grandma's messy hair? Or maybe you kept it simple and sketched the outlines of flowers and vines around the edges of the paper? Even these quick and casual strokes require a basic understanding of line and its functions – so you're off to a good start!

▲ GESTURAL LINES

Draw gestural lines quickly and energetically to imply movement, or to indicate how the object might relate to the space it is in. Here, gestural lines describe a bird as it prepares to land. Heavy, curled lines in the feet suggest tension, whereas light, fluttery, erratic lines in the wings suggest frenetic motion. Even the lines used for shading radiate outwards from a roughly central point, suggesting that the bird's body is at the centre of an explosive flurry of activity.

◄ IMPLIED LINE

An implied line is one that is not drawn, but can be assumed to exist. It may be suggested by the juxtaposition of light and dark areas, or by a line that would be solid and continuous but is missing some non-essential segments. Here, the nostrils, shape of the face and chin are depicted with implied lines.

► DECORATIVE LINE

Decorative lines do not attempt to describe a three-dimensional object; instead, they form two-dimensional patterns and decorations, acknowledging the picture plane itself. In this sketch, the suggestion of dimensionality is abandoned below the man's neckline and replaced by a flat, decorative pattern.

EXPERIMENT WITH LINE

Lines can be used to suggest anything, from the rough texture of a carpet to the dappling of light on a tabletop. Experiment with different tools and movements to see what kinds of line you can generate. Try to think up uses for each type of line.

HATCHING
Lines can be used to suggest lighting and weight. Parallel lines, placed either closely together or far apart, create the illusion of shades of grey. This is called unidirectional hatching.

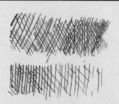

CROSSHATCHING
Crosshatching uses two or more sets of lines laid over one another at opposing angles. It creates a darker, denser shadow than single hatching. Because it does not follow the contours of the object you are shading, crosshatching can have a flattening effect.

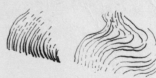

CONTOURED HATCHING
Contoured hatching uses curved lines instead of straight ones and is especially effective when the contours of the hatching conform to the topography of the object being shaded. Try varying the weight of the lines, along with their direction.

RECOGNISING LINES

See if you can find examples of descriptive, gestural, implied and decorative lines in this complex image of a fantasy creature.

Look for implied lines in the areas where form is lost to shadow and where the press of bone or muscle beneath the skin is partially described.

Gestural and decorative lines show the creature's feet dissolving into a sea of smoke and birds.

Contour lines circumscribe most of the figure.

The line of the spine and buttocks, which forms the basic shape of the composition, began as a continuous gestural line but became a series of implied and descriptive lines later in the sketching process.

The text wrapped around the creature's back is a decorative line because it does not obey any rules of perspective or foreshortening; it appears to be written on the picture itself, rather than on the floor within the picture.

Contour lines appear at the edges of muscular and skeletal structures to show subtle changes in plane.

Hatching, mostly unidirectional, describes areas of shadow and areas where the flesh would weigh heavily on the bones.

BE A BETTER ARTIST!

Now it's time to try out some line-making techniques in your fantasy art.

- Create an image using different types of line. Use solid, broken, heavy, light, curly and straight lines.

- Try a gestural drawing of a phoenix rising from its own ashes. Instead of drawing the outlines of its wings, or specific details such as feathers, draw their motion. Consider how every part of its body would move as it bursts forth in flames. Use marks that simulate these types of motion. Don't worry if it doesn't look realistic. Gestural drawings are about energy and spontaneity, rather than strict representation.

- Think of as many fantasy creatures as you can: dragons, unicorns, trolls, snake people – whatever you can conjure up. Use a variety of line types to reveal the defining characteristics of each creature. Consider its texture, shape and nature. Is the creature weak or strong? Slow or fast? Peaceful or hostile? Be creative!

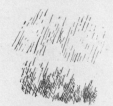

SCATTERED HATCHING
Scattered or broken hatching uses a series of short, rough marks, rather than longer, cleaner lines. Single hatching, crosshatching and contoured hatching can all be done in this fashion.

BROKEN LINES
You can use broken lines to highlight areas of high tension, strong lighting or movement. Remember, if the underlying structure is right, the human mind will fill in a lot of blanks. You don't have to draw everything for the viewer to know it is there.

SCUMBLING
A series of wriggly, scribbly marks creates a rough and interesting texture.

COMBINATION OF LINES
You will often use a combination of lines to create the effect you want. Weight, thickness, direction and density will all affect their appearance.

VALUE AND FORM – How to use lighting to create the illusion of depth and form.

Light and shadow

Value refers to the darkness or lightness of an area, independent of hue. Black is at the lowest end of the value scale and white at the highest, with shades of grey in between.

Value range

Value range, or tonal range, refers to the difference between the highest and lowest values in your drawing. A drawing with a wide tonal range is referred to as 'high key', whereas one with a narrower range is 'low key'. Many drawings will have elements of both. A figure drawing, for instance, might have the high-key contrast of black hair against white skin, as well as the more subtle play of morning light, cast through Venetian blinds, on the skin itself.

Perceiving and rendering light

Unless something gets in its way, light travels in a straight line. But rendering lighting effectively is not as simple as drawing straight lines from your light source to your illuminated object. Knowing where the light falls is only half the battle; there's also the matter of how we perceive light, shadow and form. The human mind has a tendency to condense and simplify. This is how we're able to recognise objects at a glance, rather than wasting time analysing every quirk and subtlety. When you draw a subject that's not moving (or, better yet, captured in a photograph, so that it won't move), it's easy to get lost in detail and forget the larger shapes our brains are trained to see. When rendering light and shadow, always work from simple to complex, from rough to refined. Stop frequently, to make sure your scene still reads clearly, at a glance.

▲ GREYSCALE
Even in a black-and-white drawing, you can make use of the full greyscale. The brain interprets heavy or dense hatching as dark grey and light or sparse hatching as light grey. Using mid-tones effectively brings realism and subtlety to your renderings. Try creating your own greyscales, from black to white, using different types of shading to render the greys in between.

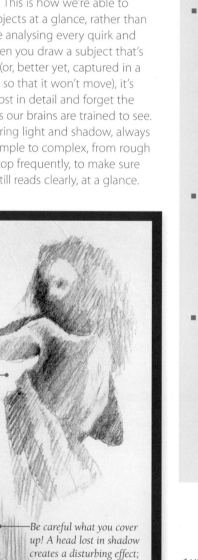

Bright light from above and to one side reduces the human form to simple, dramatic areas of light and shadow.

Heavy shadows create a sense of drama – here, a half-hidden face suggests a mystery to be uncovered.

Be careful what you cover up! A head lost in shadow creates a disturbing effect; is it there at all?

◄ USE SHADOWS TO IMPLY FORM
Next time you draw from life, observe where and how the shadows fall. Try to use shadow to imply form and mass. How simple can you go, while still creating recognisable figures?

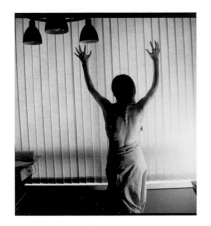

◄ REFERENCE IMAGES

When you take reference photographs, try to add a little extra drama to the lighting. Large, easily defined areas of light and shadow make for good reference points when building up form and dimension and can also be valuable compositional tools. Shooting reference photos in black and white lets you concentrate on value, without the distraction of colour.

◄ REALISM OR DRAMA

Complex subjects, like the human figure or clothing with lots of folds, create shadows with equally complex patterns. It's tempting to copy these faithfully – and doing so is a good exercise in observation. But remember, your pen is not a camera. You're free to do more than observe. Here, tiny gradations of shadow add to the disturbing effect of the monster's bony hands and protuberant spine, but detract from the impact of the image as a whole. There is no clear focal point; the eye doesn't know where to go first.

▼ GROUPING SHADOWS

Grouping shadows together makes your drawing easier to read; the eye interprets simple forms more readily than complex ones. Once you've grouped your shadows, you can reintroduce subtle gradations within your groupings. Feel free to play with the shapes of the shadows to emphasise or minimise particular areas. Although most of the detail in the monster's hands, arms and head is now lost, the structure of its torso stands out, as do the tentacles peeping from beneath its drapery.

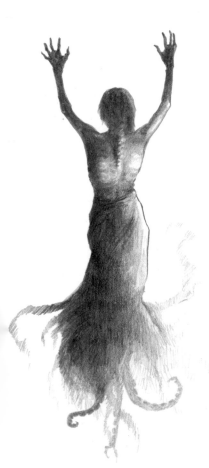

► LOST EDGES

Lost edges, where the boundary of an object is obscured by light or shadow, help make an object look like part of the scene it's occupying, rather than something pasted on top. Here, the value of the cloth draped around the model's torso is, in places, the same as the value of the torso – and so the edges cannot be seen. Concentrating detail in areas of high interest serves to lead the viewer's gaze to your intended focal points. Grouping shadows together and making judicious use of lost edges allows you to emphasise important areas, while leaving less significant ones to the imagination.

TIPS

- Even if something's black in real life, think twice before slapping down the ink! Tattoos, for example, are often executed in black ink, but the light that falls on undecorated skin also falls on the tattooed areas, so your drawing needs to reflect this with varying degrees of tone. Drawing tattoos as flat black designs gives them a hole-in-the-skin appearance. The same goes for things that are white; a sheep's back is not a blank puff of nothing. Shadows will create areas of grey where the wool bunches up.

- Start planning value early on. Don't get caught up in tiny lines and details before you've decided where your lighting will fall and with what intensity. Some areas may be washed out by highlights, or obscured by shadows, so you won't have to bother adding fine detail to them.

- Assigning different value ranges to your foreground, middle ground and background helps create an illusion of depth. Usually, you go either from light to dark or from dark to light, with the mid-tones in the middle ground. It's unusual to put either the brightest or darkest value range in the middle ground.

- Some surfaces absorb light; others reflect it. Dark-coloured and matt surfaces reflect less light than light-coloured and shiny ones. Where an object rests upon, or sits close to, a reflective surface, you'll see reflected light cast upon it. Reflected light can create some subtle and beautiful effects, such as rippling patterns from nearby water; gentle points of illumination from glasses or mirrors; and soft glows from smooth, shiny surfaces.

LIGHTING AND ATMOSPHERE

Lighting creates atmosphere. Make sure that you choose the right type to make the most of your subject.

▶ BRIGHT LIGHT

Bright light works well for pastoral scenes and scenes where you want a lot of detail to show. Use focused light to draw attention to a particular part of a picture – a glowing sword being extracted from a magic stone or the fiery halo of an angel. Use diffuse light to spread the focus around – gentle sunlight in a mystic forest, brilliant light making the knights' armour gleam at a jousting match.

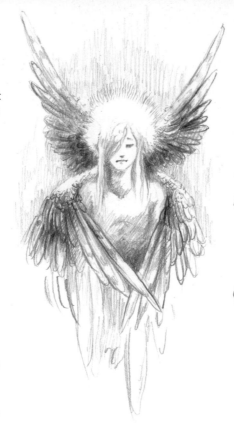

▲ COMBINATION LIGHTING

Combination lighting is effective for creating contrasts within the same picture. Here, the mellow candlelight from within creates an entirely different atmosphere from the creeping darkness around the tangle of roots.

◀ DIM LIGHT

Dim light is perfect for the creepy, the brooding and the sinister. For example, when you draw a troll under his bridge, or a massive spider lurking in a hole, plenty of lost edges and smoky shadows can make the monster's exact size and power uncertain – and thus, more frightening. Keeping the value range narrow in all but the most interesting areas heightens that sense of uncertainty.

▲ BACKLIGHTING

Backlighting is great for creating drama. Don't be afraid to indulge in a spot of artistic licence; all foreground detail tends to be lost in a harsh backlight, but picking out a few points of interest will draw the viewer's eye right where you want it. Backlighting works equally well for depictions of heroes and villains – any time you need a spot of awe and majesty, really.

CHECK FOR FAULTS

If your drawing does not look right, check to see if you've committed any of these common faults.

◀ STRONG OUTLINES

Too much outlining can make objects look like they're been pasted on to the picture plane, rather than occupying it. If you want to make something stand out, strong lighting is a better bet than strong outlining.

▶ TIMID SHADING

Nervousness can lead to wishy-washy shading that doesn't serve much of a purpose. If your drawing would no longer make sense with all the outlines erased, you may be suffering from timid shading.

▶ MULTIPLE LIGHT SOURCES

Unless you have a specific reason for including multiple light sources – streetlights competing with light from a window, for example – pick a direction for your lighting and stick to it.

◀ PILLOW SHADING

If you apply dark shading to the edges of each form and keep highlights to the middle, your drawing will looks like a collection of puffy pillows.

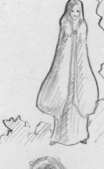

◀ MID-RANGE VALUE

If all your shading falls squarely in the mid-range, your drawing will appear soupy and lacking in depth. Don't be stingy with the deep shadows and sharp highlights.

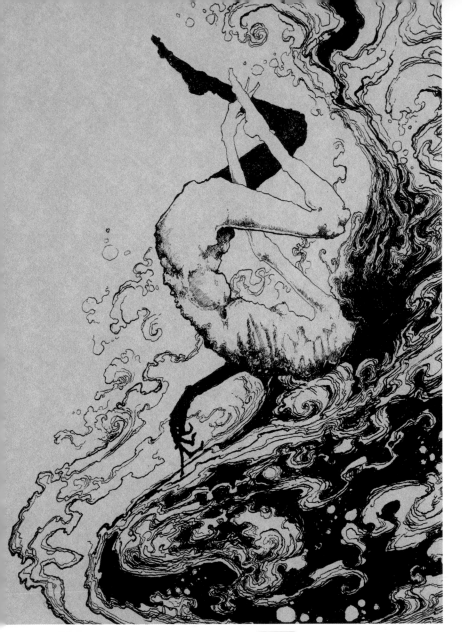

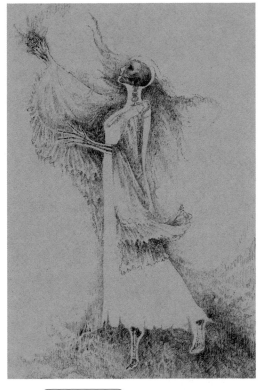

▲ CREATING MYSTERY

The narrow value range creates an eerie atmosphere. Edges are lost on the light and dark ends of the value scale, making the outline of the figure ambiguous. You can use narrow value ranges and soft, bright lighting to express feelings of impermanence, mystery, instability or fragility.

▲ CREATING DRAMA

A high-key image, with few intermediary shades between the blackest shadows and the brightest highlights, can suggest harsh or flat lighting conditions, such as moonlight, the glare of streetlights or the high-watt lamps of an operating room. Here, harsh lighting has been used to create drama. The lost edges, where the shape of the head merges with the water, indicate that the creature is drowning and will not resurface.

USING THE GREYSCALE

These drawings show how different levels of tone can be used to create different effects.

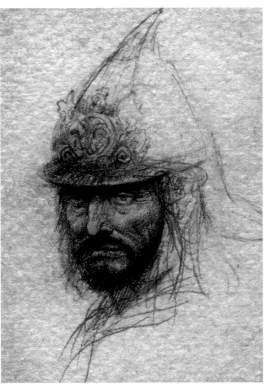

▶ CREATING CHARACTER

This image also uses tones at the far end of the greyscale, but the quality of line creates a very different effect to the image above. Even on a bright, sunny day, this knight's face is cast in shadow. Is it the shade from his helmet, or a shadow on his soul?

BE A BETTER ARTIST! *Use lighting to describe the personality of your fantasy creature.*

- Illustrate a scene from your favourite book or fairy tale. Use lighting to bring forth the mood you associate with that scene.

- Draw some of your favourite fantasy creatures and characters. What sort of lighting fits each one's personality best? What sort of lighting would they not appreciate? Use lighting to illustrate some aspect of each one's character.

DESCRIBING SURFACES – How to make your surfaces look interesting.

Textures and patterns

Textures and patterns are everywhere! Getting started can be daunting, especially with the more complex ones – but remember, just like everything else, you can break them down into their component parts to understand them better.

Texture

Textures can be thought of as topographic maps of surfaces – all the ridges and nubs and sticking-up bits that make materials identifiable. One way to break into drawing textures is to think of them in terms of highlights and shadows. Rather than trying to draw the surface, draw the shadows on it. Start with the biggest ones and work towards the smallest. The idea of drawing a thousand blades of grass is a daunting one, but it's not so hard to draw the patterns of light and shadow that make up the clump. Then add a few individual blades for emphasis.

Patterns

Patterns, unlike textures, are not three-dimensional and don't cast shadows. Instead of using lighting to break down a complex pattern, concentrate on its basic shapes. Work from general to specific. If, for example, you want to draw an elaborate brocade coat, instead of starting with a tiny spray of foliage near the collar and working down, first draw the general lines that those curls of flowers and vines are going to follow. Then, start sketching in the blossoms.

Tree bark *Different types of stroke imply different textures. Broken, meandering strokes work well for unpredictable surfaces, such as tree bark. Try a variety of approaches to the same texture; the bark of an oak is nothing like the bark of an alder, and even the same patch of oak bark looks different in soft, harsh and limited lighting conditions.*

Foliage *Stippling is a technique that uses hundreds of tiny dots of ink to build up texture and shadow. You can use it for an entire image, or as a more localised technique for representing clouds, tiny leaves, stucco-sided buildings and so forth.*

Light *Wobbly, curving forms combined with deep shadows create an impression of dappled lighting.*

Water *Experiment with loose, flowing lines and choppy areas of light and shadow to describe ripples, eddies, waves and the sharp play of sunlight on the surface of agitated waters.*

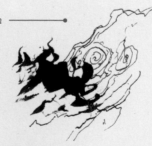

Fur and feathers *Combine lines of various types and weights to create interesting textures, such as fur and feathers.*

Drapery *Throw a winter coat, a satin gown and a cotton sheet over the back of a chair; each type of fabric will drape in a very different fashion!*

Knitted fabric *Study the differences between light and heavy cloths, stiff and silky cloths, textured knits and flat weaves.*

Scales *When drawing scaly or leathery skin, remember that the surface texture will follow underlying folds and crinkles.*

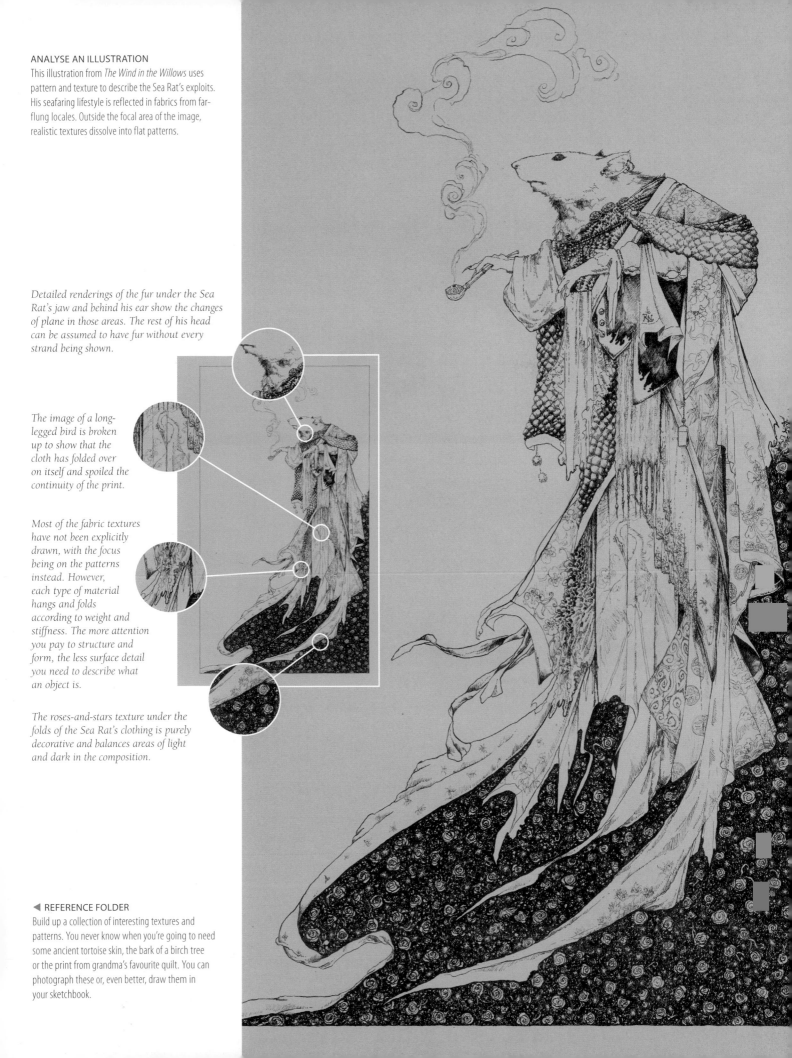

ANALYSE AN ILLUSTRATION
This illustration from *The Wind in the Willows* uses pattern and texture to describe the Sea Rat's exploits. His seafaring lifestyle is reflected in fabrics from far-flung locales. Outside the focal area of the image, realistic textures dissolve into flat patterns.

Detailed renderings of the fur under the Sea Rat's jaw and behind his ear show the changes of plane in those areas. The rest of his head can be assumed to have fur without every strand being shown.

The image of a long-legged bird is broken up to show that the cloth has folded over on itself and spoiled the continuity of the print.

Most of the fabric textures have not been explicitly drawn, with the focus being on the patterns instead. However, each type of material hangs and folds according to weight and stiffness. The more attention you pay to structure and form, the less surface detail you need to describe what an object is.

The roses-and-stars texture under the folds of the Sea Rat's clothing is purely decorative and balances areas of light and dark in the composition.

◄ **REFERENCE FOLDER**
Build up a collection of interesting textures and patterns. You never know when you're going to need some ancient tortoise skin, the bark of a birch tree or the print from grandma's favourite quilt. You can photograph these or, even better, draw them in your sketchbook.

TIPS

Here are some of the do's and don'ts of pattern and texture.

DO exercise restraint when rendering complex textures. There's no need to draw every strand of hair, every wrinkle, every puff of down. Concentrate on the forms underneath: locks of hair, folds of skin and groups of similar feathers. The hints of detail you put in the shadows and in areas of focus will imply the details found across the whole object.

DO pay attention to whether the surface you're drawing is matt or shiny, rough or smooth, hard or soft. Hard, smooth and shiny surfaces tend to have sharper, brighter highlights and reflections on them than rough, soft or matt surfaces.

DON'T apply textures and patterns like wallpaper, unless you want the underlying objects to appear flat.

DO add little hints of texture wherever a change of surface occurs. Although this creature's eyes are in a bright area, drawing the smaller scales around them creates visual interest.

DO pay attention to the contours of the underlying object. Stretch and adapt the texture to follow wrinkles, folds and areas of tension.

DO put your most detailed textures in areas of shadow when working in black and white. Although in real life texture would be most visible in highlighted areas, every mark you make affects value, so you don't want too many in bright areas.

INCORPORATING PATTERN AND TEXTURE

Let's try a drawing that's all about rich textures and patterns. The aim of this figure drawing is to make natural and man-made materials intertwine elegantly. But contrast can be just as interesting as harmony. Imagine how this scene would look with a golem, or a crashed hovercraft.

▶ *Step one:* The first stage is collecting reference. Don't worry about finding textures that match the vision of your mind's eye exactly. The idea is not to copy reality, but to get inspired by it. The forest is full of complex forms and intricate textures. Lacy skeleton leaves and many-fingered oak leaves inspire a delicate background.

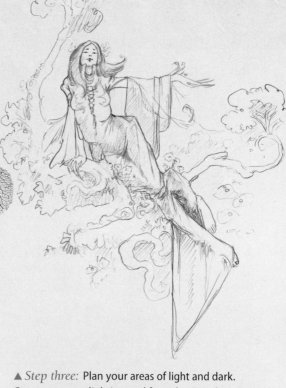

▶ *Step two:* Practice sketches can help you figure out where you want everything to go. Note which textures lend themselves best to shadowed areas and which fare well in bright light. You'll want to keep this in mind when you're working out your composition later. Pay attention to your edges! Notice how the bark gives the tree trunk a knobbly appearance on the sides. Textures are three-dimensional and thus affect shape.

▲ *Step three:* Plan your areas of light and dark. Concentrate on lighting and form, leaving the surface details for later. If you want a stylised effect, using flat areas of pattern rather than realistically shaded cloth, it's still possible to create the illusion of dramatic lighting. Strategic placement of shining ornaments, bared skin or less densely patterned swatches of fabric can create artificial highlights.

DON'T apply texture too heavily; a dense texture applied over a large area can turn into a 'hole' in the picture.

▶ **DETAIL THAT REVEALS AND CONCEALS**
Like the sequence below, this drawing took the forest and the innumerable textures found there as its starting point, but to a very different effect. Cleverly applied and highly rendered textures across the entire picture plane camouflage human features, creating an eerie atmosphere where the viewer has to look carefully to be sure of what they are seeing.

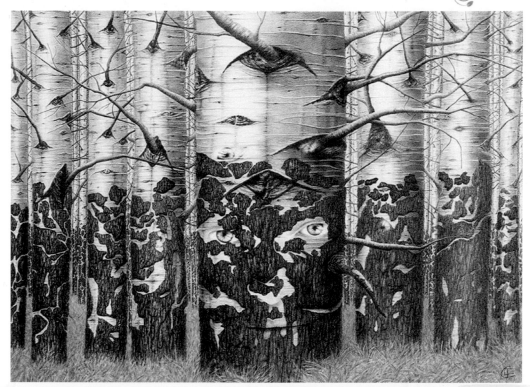

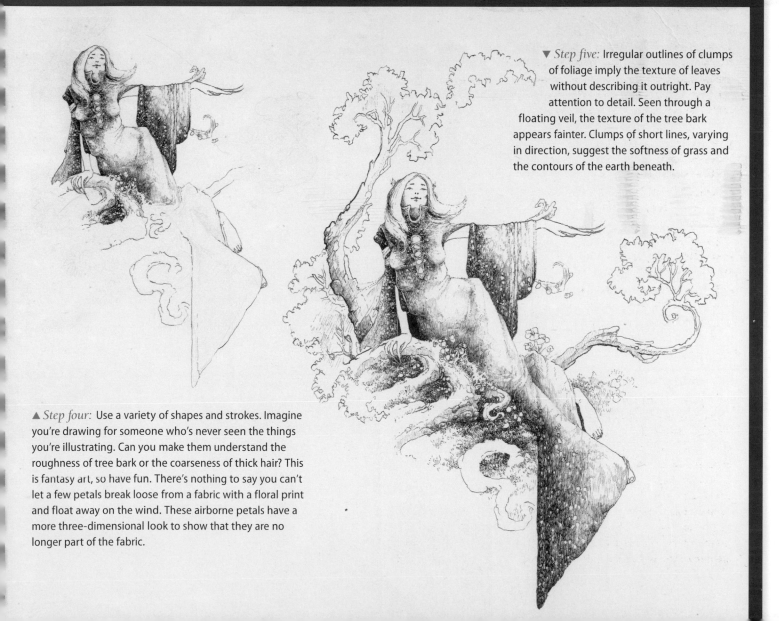

▼ *Step five:* Irregular outlines of clumps of foliage imply the texture of leaves without describing it outright. Pay attention to detail. Seen through a floating veil, the texture of the tree bark appears fainter. Clumps of short lines, varying in direction, suggest the softness of grass and the contours of the earth beneath.

▲ *Step four:* Use a variety of shapes and strokes. Imagine you're drawing for someone who's never seen the things you're illustrating. Can you make them understand the roughness of tree bark or the coarseness of thick hair? This is fantasy art, so have fun. There's nothing to say you can't let a few petals break loose from a fabric with a floral print and float away on the wind. These airborne petals have a more three-dimensional look to show that they are no longer part of the fabric.

THE ILLUSION OF MOVEMENT – Objects stop moving when you put them on paper, but you can still make your drawings dance.

Capturing movement

Drawing is a static medium; once you've committed something to ink, it's not going anywhere. So what do you do when you've only got one picture, one chance to tell the world what's just happened, what's happening now and what's about to happen? How do you translate the bustle and frenzy of the real world into line and form? Since you can't do it directly, you've got to imply it – and there are plenty of ways to do that. Which one you choose will depend on the effect you want to achieve. Are you going for tension? Chaos? Humour?

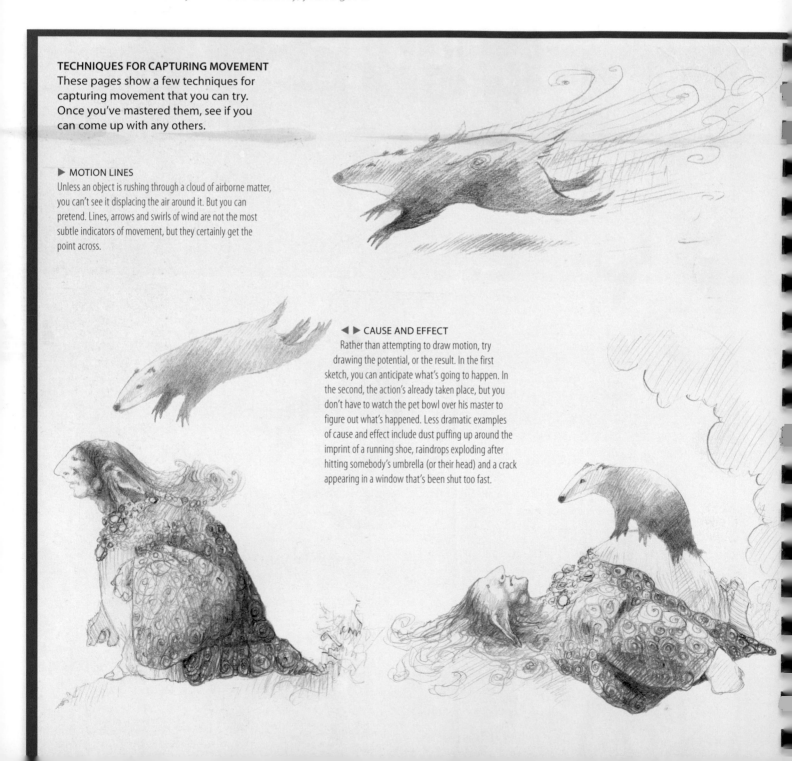

TECHNIQUES FOR CAPTURING MOVEMENT
These pages show a few techniques for capturing movement that you can try. Once you've mastered them, see if you can come up with any others.

▶ **MOTION LINES**
Unless an object is rushing through a cloud of airborne matter, you can't see it displacing the air around it. But you can pretend. Lines, arrows and swirls of wind are not the most subtle indicators of movement, but they certainly get the point across.

◀ ▶ **CAUSE AND EFFECT**
Rather than attempting to draw motion, try drawing the potential, or the result. In the first sketch, you can anticipate what's going to happen. In the second, the action's already taken place, but you don't have to watch the pet bowl over his master to figure out what's happened. Less dramatic examples of cause and effect include dust puffing up around the imprint of a running shoe, raindrops exploding after hitting somebody's umbrella (or their head) and a crack appearing in a window that's been shut too fast.

BE A BETTER ARTIST! *Study how people and animals move and then practise ways of depicting that movement.*

- It's not enough to know that things move. Make a study of how they move. Watch video clips of people walking and running; birds flying, taking off and landing; animals going about their lives. Which techniques work best for representing each type of movement?

- Illustrate a big battle scene, with plenty of people and monsters bashing and whacking and diving at one another. Don't worry about realism; just try to get as much movement as you can in there.

- Try using two or more methods of illustrating movement in the same picture.

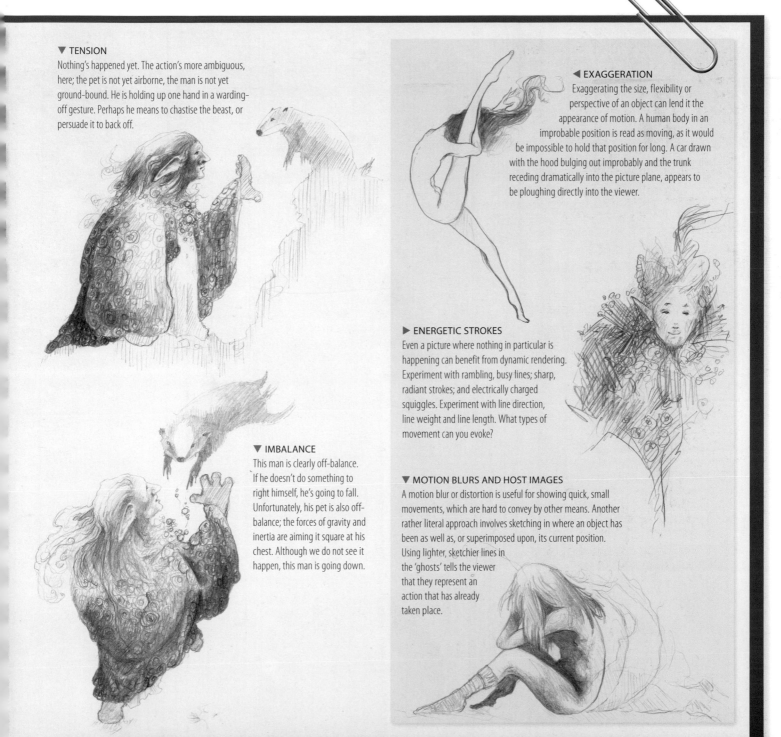

▼ TENSION
Nothing's happened yet. The action's more ambiguous, here; the pet is not yet airborne, the man is not yet ground-bound. He is holding up one hand in a warding-off gesture. Perhaps he means to chastise the beast, or persuade it to back off.

◀ EXAGGERATION
Exaggerating the size, flexibility or perspective of an object can lend it the appearance of motion. A human body in an improbable position is read as moving, as it would be impossible to hold that position for long. A car drawn with the hood bulging out improbably and the trunk receding dramatically into the picture plane, appears to be ploughing directly into the viewer.

▶ ENERGETIC STROKES
Even a picture where nothing in particular is happening can benefit from dynamic rendering. Experiment with rambling, busy lines; sharp, radiant strokes; and electrically charged squiggles. Experiment with line direction, line weight and line length. What types of movement can you evoke?

▼ IMBALANCE
This man is clearly off-balance. If he doesn't do something to right himself, he's going to fall. Unfortunately, his pet is also off-balance; the forces of gravity and inertia are aiming it square at his chest. Although we do not see it happen, this man is going down.

▼ MOTION BLURS AND HOST IMAGES
A motion blur or distortion is useful for showing quick, small movements, which are hard to convey by other means. Another rather literal approach involves sketching in where an object has been as well as, or superimposed upon, its current position. Using lighter, sketchier lines in the 'ghosts' tells the viewer that they represent an action that has already taken place.

MANIPULATING THE VIEWER – *Learn to give the right visual cues in order to convey a particular mood or atmosphere.*

Mood and atmosphere

The images we remember best tend to be the ones that move us most. It's not difficult to pick subject matter that carries an emotional charge; the challenge lies in conveying that charge to the viewer.

Consider the people, places and events entrenched most firmly in your memory. What do you recall best about them? The smells? The sounds? Something you ate? Odds are, it's not the sights. Long after visual details have faded to ghosts, a whiff of cooking, a clip of music or a burst of flavour can plop us right back into the moment. Writers deliberately make reference to all five senses in order to create vivid settings – but these are difficult to convey through marks on paper. For most people, a drawing of bacon sizzling in a pan does not reverberate as strongly as a verbal reminder of the hissing of the fat, the toothsome maple-smoke scent, the anticipation of hot, crispy rashers crunching between your teeth. A drawing that people deem 'almost real enough to touch' does not necessarily carry

any more emotional impact than an entirely abstract one. Visual art has its own library of atmospheric tools.

General to specific

When we view a picture, we work from general to specific. Our first impression, before we begin to examine the details, is immediate and instinctive. How do you achieve that swift impact? That instant understanding when the viewer cannot help but see something familiar in your world? At its most basic level, the trick is to ask yourself two questions: 'What do I want people to feel?' and 'What makes me feel that way?' Discard the answers that are too specific and what remains is likely to be right on the money.

▶ CREATING MOOD
Let's say you want your audience happy and the things that make you happy are warmth, good company and grandma's goulash. Grandma's goulash is specific to you, but food, in general, is a popular source of comfort. Almost everybody likes warmth and good company – but how can you bring the warmth of a bowl of soup or the laughter of a merry gathering to an illustration that has nothing to do with either?

The figure is at eye level with the viewer, not above or below. A figure looking down from above is likely to look contemptuous or menacing. A figure looking up from below may seem confused, or in need of help. A straightforward angle suggests honesty and lack of guile; you can take this character at face value.

The first thing you'll notice is the fairy's open body language; she is looking straight out of the picture, palms open in an inviting gesture.

Delicate, slightly loose rendering creates a light, carefree feeling.

Pairs of flowers lean in towards one another; roots and vines tangle together – more subtle indications of a welcoming atmosphere.

Flowers, insects and healthy foliage suggest a season of warmth and growth – spring or summer.

ATMOSPHERIC TECHNIQUES
Consider your subject matter from two points of view: what are you looking at and how are you looking at it?

▼ **DISTANCE**
The object's position in the picture influences the viewer's perception.

A nearby object draws attention to itself. It reads as important, interesting and possible to interact with.

An object at a moderate distance is something to investigate; close enough to make out a few details, but not so close as to give everything away at once.

A distant object seems lonely and unreachable. Even major details are lost; the object reads as an idea or suggestion of itself.

▼ **VISIBILITY**
Obscuring your subject can have a variety of effects, depending on how you go about it, as the example illustrates. In addition, weather effects, such as mist, fog, snow, rain and lightning storms, affect visibility and have their own symbolic connotations.

A figure shrouded in shadow tends to inspire caution. We interpret the need to hide in darkness as an indication of nefariousness and ill intent.

A figure dissolving into light is more likely to inspire awe, admiration and curiosity. Angels, paladins, gods and other icons of power and righteousness are often depicted as emitting or attracting light.

▼ **SCALE**
Changing the size of an object affects the way the viewer sees it.

An object that takes up most of the picture plane demands attention. A character that's much larger than the others in the scene, either by virtue of actual size or proximity, commands attention and appears strong, imposing and possibly frightening.

An object that takes up so much of the picture plane that it slops over the edges and cannot be seen in its entirety can be absolutely terrifying – especially when the viewer does not know how large it really is.

An object that takes up very little of the picture plane tends to look lost, overwhelmed and powerless. Contrasting a tiny human figure with a massive natural formation, for example, can call attention to the majesty of that formation.

▼ **ANGLE**
The rules on angles apply in most cases, but there are exceptions. A king on his elevated throne does indeed carry an air of majesty, but a tightrope walker seen from the street below looks fragile – the angle only draws attention to how far he has to fall.

 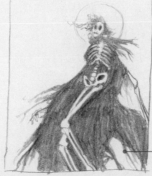

An object seen from a low angle tends to look powerful, daunting and possibly threatening.

◄ **SUBTLE SIGNALS**
Something unexpected – a tree with limbs that resemble arms; a horse fully saddled and riderless; a human body with a shark's head – alerts the viewer to something extraordinary afoot. Depending on exactly what is amiss, the effect can range from interest and anticipation to outright dread. Even small deviations from the norm, where the human body is concerned, tend to cause unease. This is because we tend to react quite viscerally to 'body horror' – any representation of our bodies deformed, diseased, mutilated, degenerating or grotesquely harmed or altered. The less human your character appears to have been to begin with, the less powerful this effect becomes.

A high angle puts the viewer in the position of power – looking down upon the scene, like a scientist admiring a specimen under a lens, or a general surveying his troops from atop a tank.

ADDING CONTEXT – *How to choose an appropriate setting for your characters.*

Backgrounds

When you talk about a person's background, you are generally referring to upbringing, education and experience. You are filling in the details behind that person's current role and position, or demonstrating the person's relevance to the conversation at hand. A well-drawn background or environment can serve the same purpose. For example, a man with a pack slung over his shoulder can be presumed to be a traveller. However, a burning city in the background will provide a very different context for his journey than a green and sheep-scattered valley. Not all backgrounds are environments; superimposing the same figure upon a map might suggest the places he has been.

Background and meaning

Avoid choosing backgrounds at random, or simply for the purpose of filling up the page. Even backgrounds that seem purely decorative at first glance – wreaths of flowers, textile-style patterns of waves and clouds – are often rich with symbolism. Roses, for instance, are a sign of love, whereas calla lilies are associated with purity. Daisies are for spring, poinsettias for winter, sunflowers for summer and Chinese lanterns for autumn. Forest environments suggest fantasy, mystery and a connection with nature. Urban environments are a good way of setting a time period; the architecture of a Dark Ages society will look nothing like that of a futuristic utopia.

WHO'S THIS THEN?

You've imagined a character; now you need to provide a background that will suggest its story.

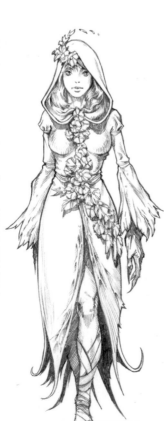

Step one: Here, we have a character whose appearance and costume are not specific to any particular setting or time period. Let's put her in her place.

Step two: Gather reference material for inspiration. This can come from your sketchbook or from photographs, films and the real world. Remember, you don't have to copy from reality: Impress the stamp of your own imagination upon it.

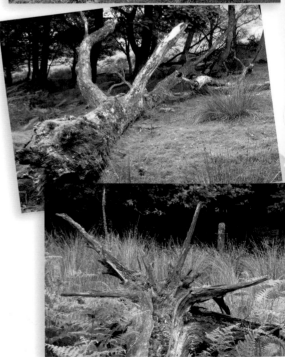

Step three: Sketch a series of thumbnails. Now is the time to try out all those ideas flitting about in your head. Which ones are most and least effective when it comes to creating context? The thumbnail stage is also a good time to work out what falls in the foreground, the middle ground and the background. At this stage, group foreground, middle ground and background objects together according to value. This allows you to see what goes where at a glance.

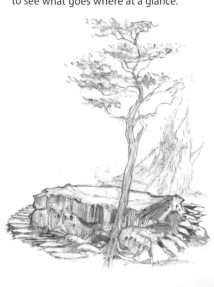

TIPS

- Consistent lighting means that light sources should affect everything in that environment, including characters and other focal elements.
- Overlap and lost edges – blurring the line between foreground and background elements – avoids a pasted-on look.
- Textures, colours or symbolic elements should carry over from background to foreground.

In this finished picture, the pencil sketches were digitally scanned in, then colour was added to different layers to add atmosphere and enhance the feeling of distance (see pages 26–27).

Step four: The environment you've added gives a much clearer picture of who this character is and what she is doing. Elements of symbolism and fantasy in the details give the viewer something to think about – and a reason to take a longer and closer look!

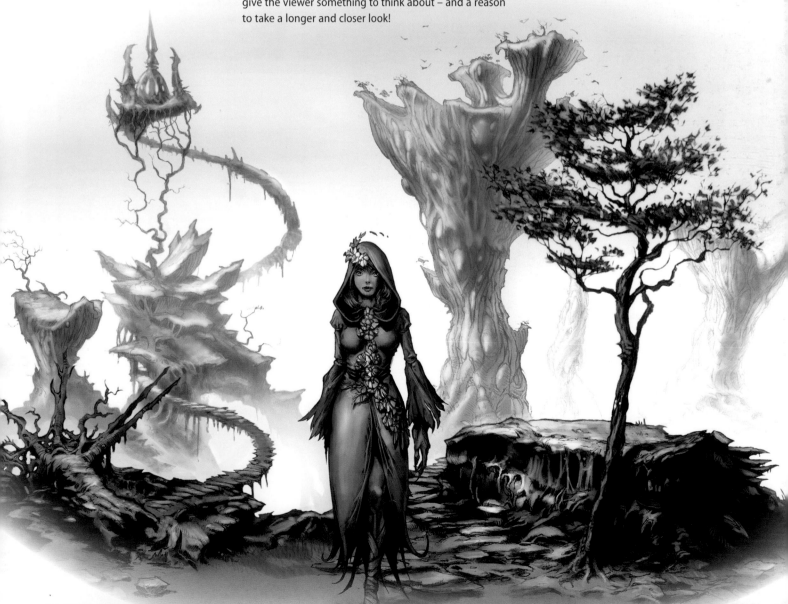

ARRANGING COMPONENTS – How to put together engaging and harmonious pictures.

Basics of composition

Composition is a complex subject that can be boiled down to a simple question: What goes where? What is your focal point, and where will it be? How can you use light, shadow, pattern, detail and scale to draw attention to areas of interest? What elements can be used to create leading lines (lines that draw the viewer's eye into the picture plane)?

THE RULE OF THIRDS

The 'rule of thirds' is a helpful tool for deciding where to place focal points. If you divide your page into thirds, horizontally and vertically, there will be four spots where the lines intersect. Compositions with points of interest that fall on these spots tend to be pleasing to the eye. Compositions based around the rule of thirds leave some space around the subject, without placing it dead centre. Objects placed smack in the middle tend to overpower the rest of the composition, while objects too close to the edge can read as unimportant.

Balance

An ideal composition appears balanced. Lines and shapes guide the eye to the focal point, then to secondary points of interest and then back to the focal point for another look. When the gaze meanders, following lesser details, it should always be corralled before it can wander off the page, and redirected to the important bits.

▼ PUTTING IT ALL TOGETHER
This drawing exemplifies a number of compositional elements: the rule of thirds, leading lines, points of interest, gaze lines and negative space. Can you see where and how they have been used and why they work?

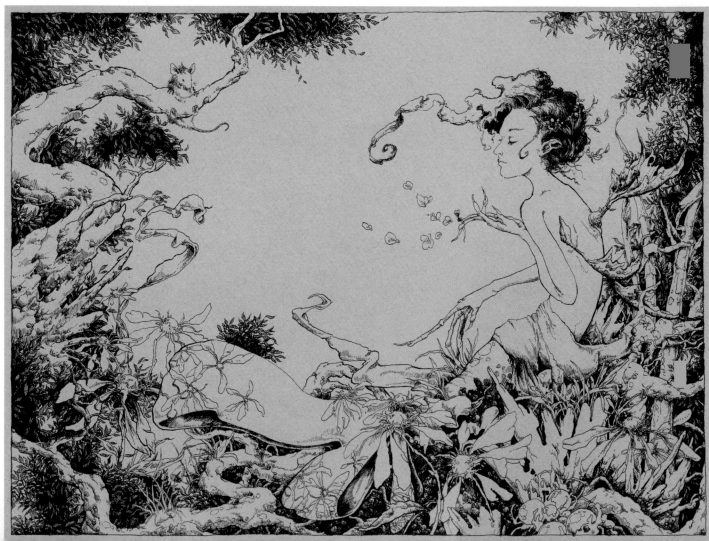

COMPOSITIONAL ELEMENTS

Think of the viewer's eye as a bird, and composition as the cage you build to keep it from escaping your picture. Keep the following points in mind as you place the bars of your cage.

LEADING LINES

The gaze tends to enter the image from the lower left. Grab it immediately with a strong directional line that leads into the picture plane. Placing objects of interest on the right causes viewers to survey the scene naturally as they follow your leading lines.

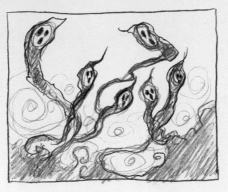

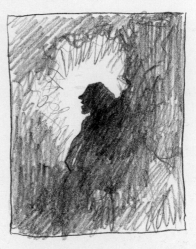

DIAGONAL LINES

Strong diagonal lines heading off the corners of your page, like the mouse's tail here, create 'arrows' that the viewer's gaze will follow right out of the picture; what you want is to keep their attention within it.

POINTS OF INTEREST

Too many points of interest, as here, create confusion if you don't find a way to tie them together. Secondary points of interest should always lead the eye back to the main focal point.

CONTRAST

Contrast draws the eye. Don't put an area of dense shadow in a sea of highlights, or an area of ornate detail amid a network of simpler lines, unless you want people to look at it.

GAZE LINES

'Gaze lines' are still lines. Be aware of where the figures in your composition are looking; the viewer will look there, too. As the figures here are all looking out of the composition, so will the viewer. We are naturally inclined to look where other people are looking because we expect to find something interesting there.

PARALLEL LINES

Parallel lines reinforce one another. When multiple lines sweep in the same direction, the eye follows them. This can be a powerful tool for creating dynamism — but make sure your lines don't go careening straight off the picture plane. Arranging parallel lines around a central circle helps prevent this, as here.

NEGATIVE SPACE

Negative space isn't just a resting place for the gaze. Just as objects and design elements create shapes, so do the spaces around them. Here, the gaps between the trees form the shape of a skull. Place your negative spaces wisely; an empty area encircling an object will draw attention to it. A negative space above an important leading line will keep the viewer's eye from wandering off before it reaches the focal point.

COMPOSITIONAL STRUCTURES

When you're designing a new composition, start with a basic shape that you can hang everything else on.

▶ CIRCULAR
This simple circular composition invites the gaze in via a projection on the lower left, loops the loop, and finishes up at the focal point: a dog having a sniff around. The focal point is usually the most detailed part of the picture; here, it's the one area with no detail at all. This works because the rest of the picture is busy, offering little respite for the eyes, which means that, in contrast, a basic outline stands out.

◀ C-SHAPED
The 'C' has been inverted here to keep the focal point on the right-hand side. A large negative space on the left implies a vast, open area and emphasises the comparative insignificance of the creatures and their conversation. Perhaps Mr. Badger is telling Ratty a tale of the Wide World.

▶ MULTI-CIRCULAR
For a more complex effect, try a composition involving multiple overlapping and intersecting circles. The points where the circles join will be where you stick the good parts. Here, the tree in the background forms one circle, the roots in the foreground form another and the figure forms a third. All three intersect at the curve of the figure's back, which is also the main point of tension.

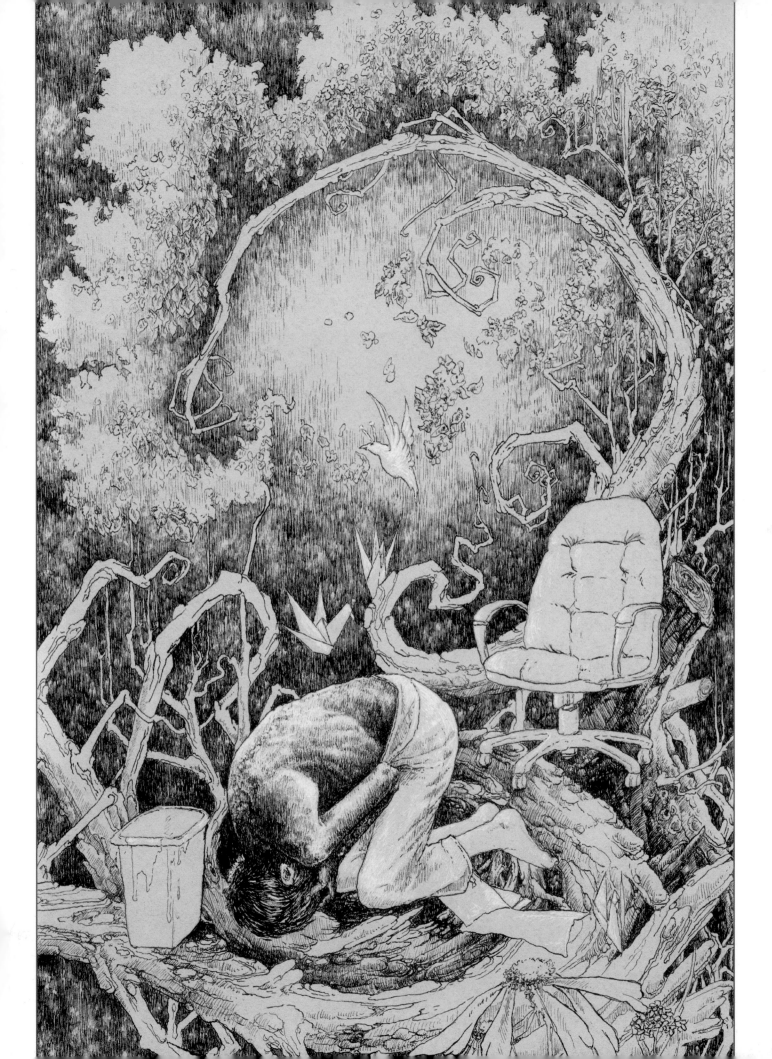

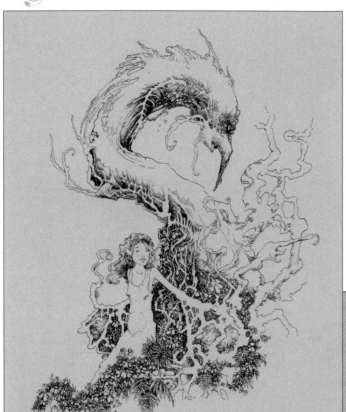

◀ S-SHAPED

The bottom of the 'S' is the start of a leading line that draws the gaze first to the figure amid the leaves, and then to the beaked dragon rising from the roots. Note that the dragon's beak points back in the direction of the main figure.

▶ T-SHAPED

This composition places the focal point dead centre, and it is useful for illustrations focused on a single subject — in this case, a character. For a more subtle effect, try moving the stalk of the 'T' to the left or to the right. Note that although the composition hangs on simple straight lines, secondary details, like the leaves and roots of the tree and the bushes in the background, curve slightly inwards, leading the viewer's eye back to the focal point rather than allowing it to scuttle off the sides.

▶ U-SHAPED

Points of interest can be placed along the bottom of the 'U', or up either of the sides. Here, one focal point has been placed at each intersection: the dryad's head on the left, and her hips on the right. Lines curving inwards from the top of the right-hand side draw the eye back down the left-hand stalk of the 'U', so it doesn't get lost at the top.

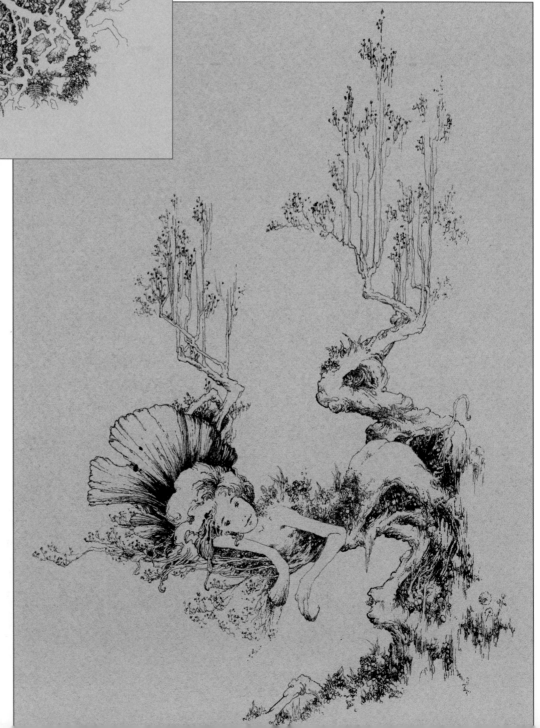

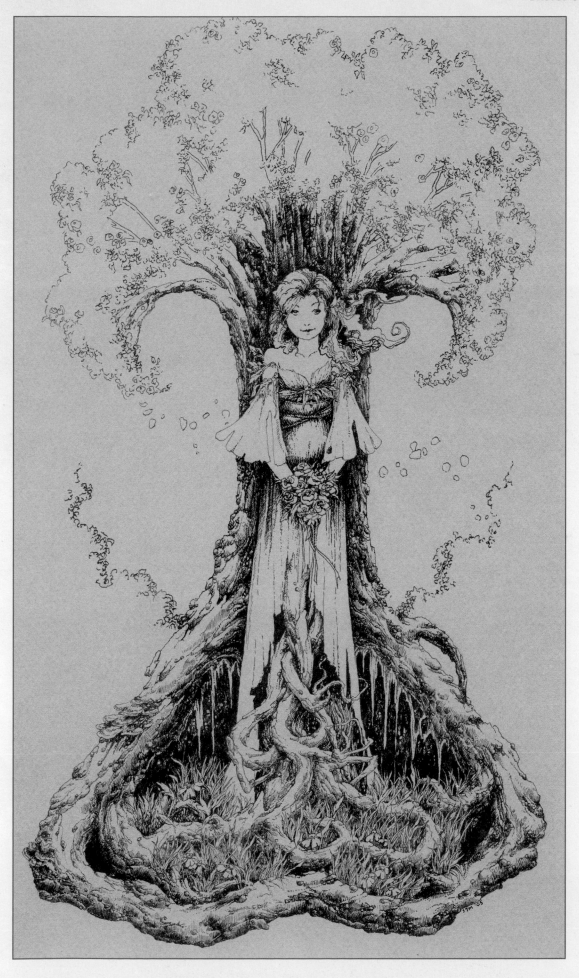

WEIGHTS AND BALANCES – *How to make your composition seem harmonious to the viewer.*

Balance

Consider a pose that's not entirely balanced: a runner caught mid-stride; a football player poking out a leg for a kick; a dancer about to alight from a flying leap. Such a pose creates the illusion of movement and makes for an interesting, dynamic picture. But take it a step too far – the runner jackknifed into a position he can't get out of without tripping; the football player's body twisted at an angle that spoils the force of his kick; the dancer landing at an angle that can only end in

a crash – and your picture goes from dynamic to awkward. Compositional balance works in a similar manner, only instead of keeping the body's centre of gravity from passing the point of no return, you're keeping the elements of your image functioning together in harmony.

Compositional balance

There are three basic types of compositional balance: one, radial balance (compositional elements are arranged around a central point, like petals on a daisy); two, symmetrical balance (both sides are identical, or nearly identical); and three, asymmetrical balance (the image cannot be mirrored down a central axis, but each side carries equal visual weight).

Checking balance

To check your balance, split your composition in two, down the middle. Does each side carry equal weight? And how can weight be determined when the image is not symmetrical?

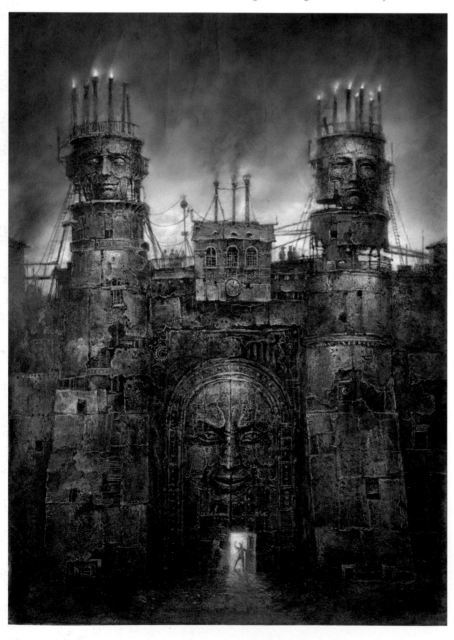

◀ SYMMETRICAL BALANCE
Mirrored shapes and forms assure a harmonious composition.

BE A BETTER ARTIST! *Experiment with balance in composition and when drawing a fantasy creature.*

- Create your own zodiac of fantasy creatures using a radially balanced composition.

- How many ways can you balance out an asymmetrical composition? Try using shape, movement, pattern and even perspective to create innovative balances.

- Try to draw a completely symmetrical creature entirely freehand – no tracing paper, carbon paper or photocopy machines allowed. A fairy with butterfly wings, a tiger demon with dramatic stripes or a dragon with a variety of scale sizes and textures would make challenging subjects for this exercise.

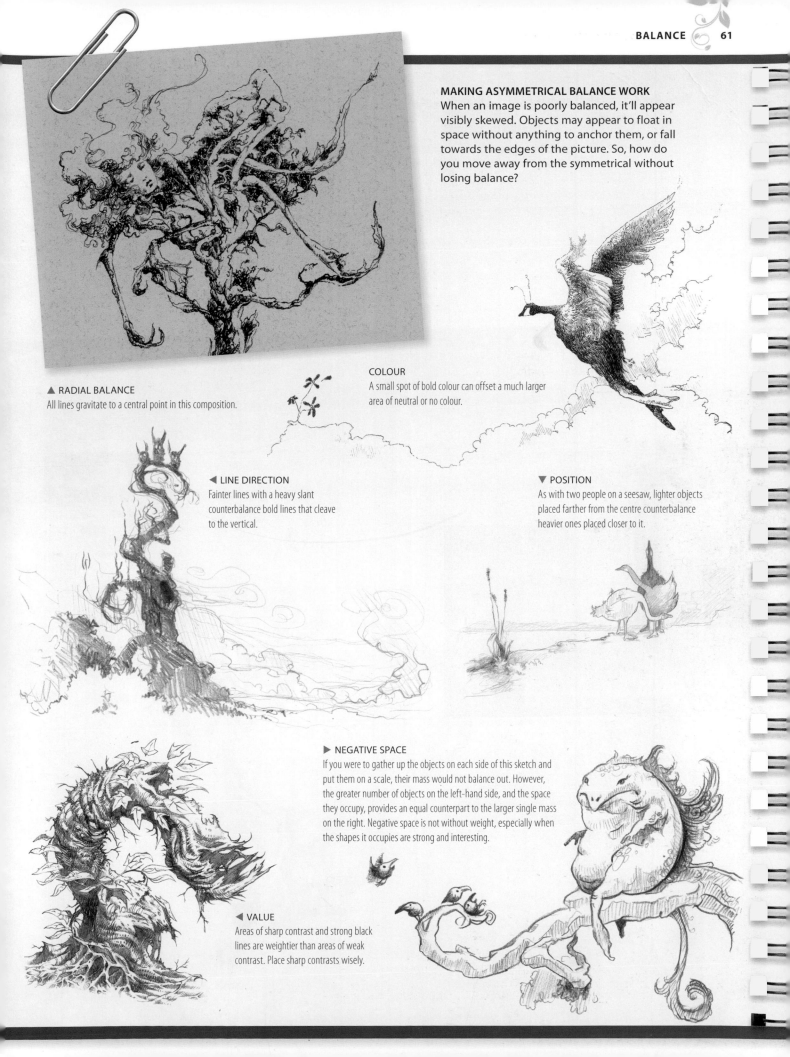

MAKING ASYMMETRICAL BALANCE WORK
When an image is poorly balanced, it'll appear visibly skewed. Objects may appear to float in space without anything to anchor them, or fall towards the edges of the picture. So, how do you move away from the symmetrical without losing balance?

▲ **RADIAL BALANCE**
All lines gravitate to a central point in this composition.

COLOUR
A small spot of bold colour can offset a much larger area of neutral or no colour.

◄ **LINE DIRECTION**
Fainter lines with a heavy slant counterbalance bold lines that cleave to the vertical.

▼ **POSITION**
As with two people on a seesaw, lighter objects placed farther from the centre counterbalance heavier ones placed closer to it.

▶ **NEGATIVE SPACE**
If you were to gather up the objects on each side of this sketch and put them on a scale, their mass would not balance out. However, the greater number of objects on the left-hand side, and the space they occupy, provides an equal counterpart to the larger single mass on the right. Negative space is not without weight, especially when the shapes it occupies are strong and interesting.

◄ **VALUE**
Areas of sharp contrast and strong black lines are weightier than areas of weak contrast. Place sharp contrasts wisely.

MAKING IT FIT – You can distort a figure to fit a composition that doesn't quite accommodate it.

Subverting reality

It's easier to fit picture elements into an underlying composition than it is to build your composition around a collection of disparate elements. Arrange the smaller shapes of figures, buildings and scenery into the overarching lines and shapes that hold everything together.

Adapting reference

The human body is full of awkward parts: pokey joints, spines that are only flexible to a point, parts that jut out where they aren't wanted. Buildings are full of hard verticals. Trees sometimes contain birds' nests, which put tangles of darkness and detail where only the delicate lace of twigs and skeleton leaves is required. Fortunately, a pen is not a camera. If something doesn't fit, change it. Soften the angle of a knee into a curve. Hide an unwelcome elbow behind a piece of cloth. Break up the stiff verticals of a skyscraper with the organic forms of reflected clouds, or perhaps a blinding sunburst. Leave the birds' nests out; in your fantasy world, let birds be vagrants.

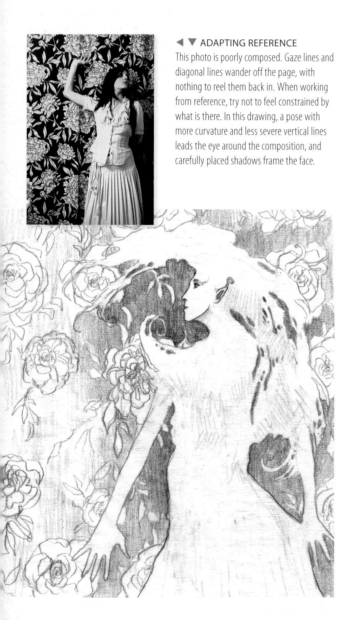

◄ ▼ ADAPTING REFERENCE
This photo is poorly composed. Gaze lines and diagonal lines wander off the page, with nothing to reel them back in. When working from reference, try not to feel constrained by what is there. In this drawing, a pose with more curvature and less severe vertical lines leads the eye around the composition, and carefully placed shadows frame the face.

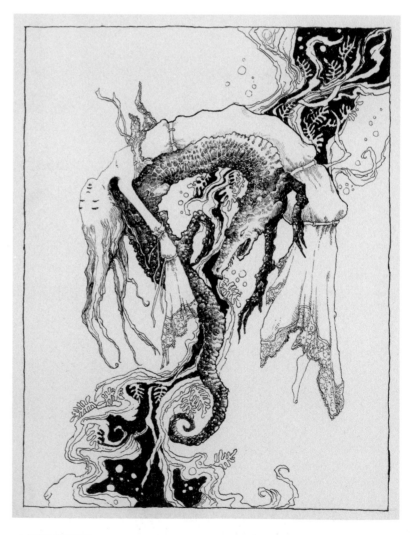

▲ PROPORTIONS
This body would be about twelve heads tall and likely unable to support its own weight if it were real. But here it forms the top of an umbrella-shaped composition perfectly.

◀ DISTORTION

This figure is not anatomically accurate. The spine and legs have been lengthened, and angles have been softened, to better fit within a circular composition. Try to keep objects recognisable for what they are, without sacrificing the flow of line and shape.

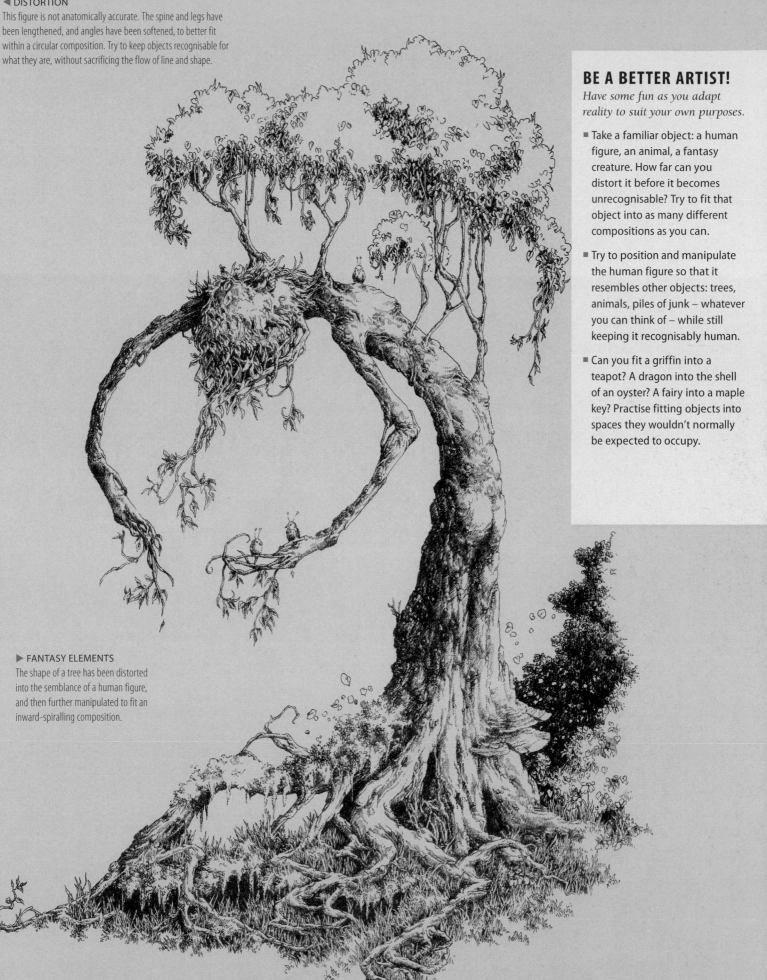

BE A BETTER ARTIST!

Have some fun as you adapt reality to suit your own purposes.

- Take a familiar object: a human figure, an animal, a fantasy creature. How far can you distort it before it becomes unrecognisable? Try to fit that object into as many different compositions as you can.

- Try to position and manipulate the human figure so that it resembles other objects: trees, animals, piles of junk – whatever you can think of – while still keeping it recognisably human.

- Can you fit a griffin into a teapot? A dragon into the shell of an oyster? A fairy into a maple key? Practise fitting objects into spaces they wouldn't normally be expected to occupy.

▶ FANTASY ELEMENTS

The shape of a tree has been distorted into the semblance of a human figure, and then further manipulated to fit an inward-spiralling composition.

CREATING DEPTH – How to use lines and vanishing points to give a flat surface the illusion of depth.

Linear perspective

Imagine the paper in front of you as a window through which you can see another world, the world you're going to draw. In order to put that imaginary world into perspective, you'll need three things: a horizon line (actual or implied), at least one vanishing point and a set of straight diagonal lines that radiate from the vanishing point towards the edges of the picture plane. These lines are used to determine how tall and how wide an object will appear as it recedes into space.

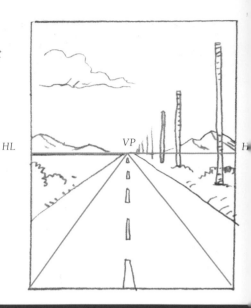

ONE-POINT PERSPECTIVE

When both the viewer and the object viewed are on parallel planes, you can only see one side of the object and there will only be one vanishing point, so this type of perspective drawing is called one-point perspective.

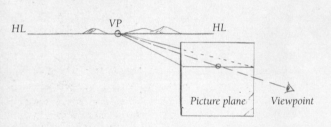

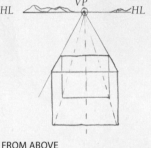

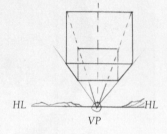

▲ TO BEGIN
Draw a horizon line (HL), then add a single vanishing point (VP) on the horizon line. Now draw a square at any point on the picture plane and project lines from the edges of the square to the vanishing point where the receding lines will converge.

▲ CUBE FROM ABOVE
To construct a cube in perspective, draw a square on the picture plane parallel to the horizon line, and project lines from each corner to a vanishing point. Choose a point along one projected line and draw another square, bounded by the projected lines. This forms the back surface of your cube. Here, the lines have been drawn downwards from the vanishing point so that we appear to be looking down on the cube from a bird's-eye view.

▲ CUBE FROM BELOW
If we do the same exercise, but draw above the horizon line, the cube appears to be above us. We have the impression that we are looking up at anything drawn above the horizon line from a worm's-eye view.

TWO-POINT PERSPECTIVE

When an object is viewed from an angle, there will be one edge or corner that is closer to the viewer; this is called the leading edge. Both sides of the object that recede from this leading edge will have their own vanishing points. This type of perspective drawing is called two-point perspective.

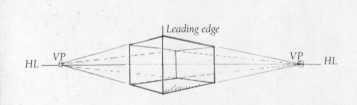

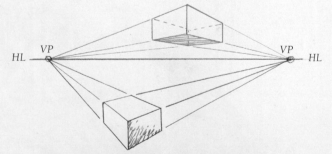

▲ LEVEL WITH THE HORIZON
To construct a box in two-point perspective, draw the horizon line and add two vanishing points anywhere along it. Project lines outwards from the vanishing points, and where they meet on the picture plane will be the leading edge. Add vertical parallel lines to construct a box. In this example, the viewpoint is at the same level as the horizon line, so the box appears to be at the same eye level as the viewer.

▲ CHANGING THE VIEWPOINT
As with one-point perspective, drawing above or below the horizon line changes the apparent viewpoint. Using two viewpoints together gives the impression that one object is flying over the other.

▶ INORGANIC FORMS
Perspective is most clearly seen and easily used when depicting scenes that include at least one set of parallel lines receding towards a vanishing point, such as those composed of rigid, inorganic forms.

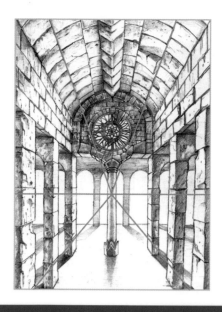

◀ VANISHING POINT
The visual lines of this scene all meet at the vanishing point, including those of the central highway and the top and bottom of the poles on the right.

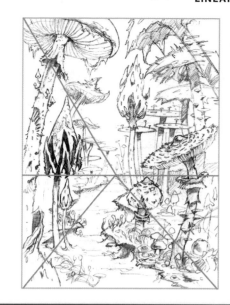

◀ ORGANIC FORMS
Perspective can also be applied to the drawing of scenes that are composed of organic forms. It can add a realistic touch to an unrealistic fantasy scene.

INTERIORS
To construct an interior, use two-point perspective – this may be a room, cavern or any similar space.

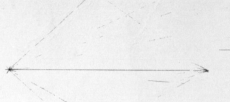
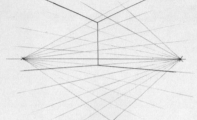
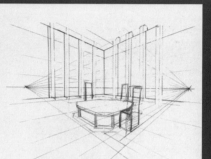

▲ DRAWING THE PERSPECTIVE FRAMEWORK
Draw the horizon line and two vanishing points. Then draw a series of lines projecting from these points, above and below the horizon line. To draw these lines, put your pencil on the vanishing point and slide the ruler up to it. Draw the line, then put your pencil back on to the vanishing point before moving your ruler up or down to the position for the next line.

▲ CONSTRUCTING THE ROOM
Draw in one vertical line to form the far corner of the room or space. Next, take your ruler and line up the top point of the vertical line with each of the vanishing points. By drawing outwards from the top of the vertical line, you can create the top horizontal lines of the walls. Do the same at the bottom of the vertical line for the edges of the floor.

▲ ADDING PILLARS AND FURNITURE
Use the same basic process to add pillars and furniture. The chairs are based on the basic cube shape, and their lines match up with either of the vanishing points. For variation, you can cut into the basic cube shape to make the table a hexagon. This can be quite difficult to begin with, so you will need to practise.

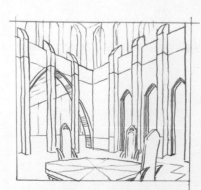

▲ ADDING DETAIL
Add arches and a gallery at the top of the wall using the same method. Make sure your vertical lines are all parallel, otherwise the drawing will start to look askew. Be warned. This can be incredibly frustrating, but it is essential to learn this skill. No artist can get by without it.

▼ ▶ FIGURES
The artist may use perspective lines to draw figures.

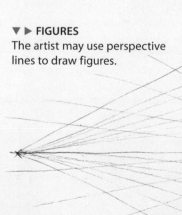

▲ USE A GRID
A basic grid can be used as a rough guide for drawing a figure. The lines of the figure do not have to match up perfectly with the vanishing points, but following the grid fairly closely will help to give the figure a more dynamic pose.

▶ BUILD UP DETAIL
Once you have the basic structure of your figure nailed, you can build up detail. This method is particularly useful when the drawing creates an illusion of looking up or down at a figure.

THREE-POINT PERSPECTIVE
As the name implies, three-point perspective adds a third vanishing point. This enhances the impression that we are looking up or down at an object. The third point is not placed on the horizon line like the other two, but above or below it instead.

▲ TO BEGIN
Three-point perspective often requires that the first two points be widely spaced. You might find that, in order to get the angle you are looking for, your perspective points are off the page. This may be hard to deal with at first, requiring you to draw the points on your drawing board and use a very long ruler, but eventually you will be able to judge perspective without using a ruler at all. In fact, once you have mastered the rules of perspective, you will be able to break them by twisting perspective and changing it to create different visual impressions, as some of the examples here demonstrate.

◄ LOOKING DOWN
Position the horizon line above the objects so that we seem to be looking down on them. Chip away at the basic blocks to create more natural forms, such as the decaying temple perched on a batholith shown here.

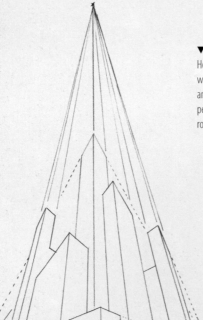

▼ LOOKING UP
Here, the horizon line is drawn at the bottom of the page, so we are now looking up. As before, cut into the basic blocks and reshape them with the confidence that you have strong perspective lines to work to. In this case, the blocks have been rounded into circular towers.

BE A BETTER ARTIST! *Experiment with perspective and point of view.*

■ How does the emotional impact of an object viewed from above differ from that of the same object viewed from below? Now that you have the tools to position objects convincingly in space, try drawing them from as many angles as possible.

■ Go for walks in the city and in the country. Wherever you can identify receding sets of parallel lines – whether on buildings, riverbanks, roads, cliffs, beaches or anywhere else – take photos of them. Which type of linear perspective suits each one best? As a fantasy artist, it's important to see the world from an interesting angle. Unexpected viewpoints are your friends!

◄ USING PERSEPCTIVE
Perspective is used to great effect in this drawing; the vanishing point leads the eye into the heart of the composition and creates a dramatic sense of scale that makes the dragon seem enormous and very dangerous.

▼ BREAKING THE RULES
As your confidence with perspective builds, you will find that you can draw perspective without using guidelines. This example was drawn freehand. The perspective is not entirely accurate; this was partly deliberate, in an attempt to create a wide-angle or fish-eye lens feeling to the drawing.

NO RULER? – How to convey the illusion of space without lines and vanishing points.

Non-linear perspective

▼ **POSITION IN PRACTICE**
Although there is no horizon line here, and no visual information about the area between mountain and branches, the mountain is still read as being in the background because of its position, the viewer's knowledge of the relative sizes of trees and mountains and the overlap of the clouds and branches.

Perspective is often seen as a technical, intimidating topic, full of lines and measurements and frameworks that have to be erased once the drawing's done – and, indeed, perspective can involve all these things. However, not all scenes lend themselves to the use of linear perspective. Natural vistas, close-up renderings of organically shaped objects and scenes with a lot of curves still benefit from the illusion of space – but how do you convey that without a convenient set of lines and vanishing points?

Other methods

Artists discovered ways to convey depth, distance and relative size long before modern linear perspective came into being. For example, in Ancient Egyptian art, gods were drawn higher, larger and brighter than human beings. Although in modern representational art these techniques are not often used on their own, they're handy to use in conjunction with linear perspective, and in situations where linear perspective doesn't apply.

Fantasy art

Although fantasy art may draw upon elements of architectural design, technical drawing and medical illustration, it's none of these things. No buildings will fall down, no machines will malfunction, and no surgeries will be botched because a fantasy artist's work was not a faithful representation of reality. Formal linear perspective does not fit every drawing, even when it's theoretically possible. Figures drawn in traditional Egyptian style, for example, are liable to look foolish in an apparently three-dimensional space. Let your spatial cues fit your style and subject matter, rather than the other way around.

BE A BETTER ARTIST! *Now try all these techniques in your fantasy art.*

- Draw a massive creature, such as a dragon or sea serpent. Use value and saturation to underscore its size; the colours of its head should be significantly brighter and more saturated than those of its tail (or vice versa, if it's walking away).

- Draw several fantasy creatures occupying the same landscape. Assume the viewer doesn't know what size these would normally be, and use non-linear perspective techniques to imply their relative statures.

- Objects that appear closer to the viewer are often read as more important. Can you think of any situations where the opposite would be true? How might you draw something that appears to be at a distance, but still have it dominate the composition?

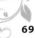

▲ VALUE AND SATURATION

Saturated colours and values towards the black end of the scale will appear closer than greyed-out hues and values towards the white end. Note that although cool colours have traditionally been thought to recede, whereas warm ones come forth, this isn't a good rule of thumb. Blue, for example, is no more inherently sky-coloured than brown is the sole province of the earth. Two hues of equal value and saturation will occupy roughly the same perceived depth. A royal blue sky will appear close and oppressive, whereas a foreground full of faded browns and olives seems out of reach — possibly in time, as well as space, as sepia tones carry connotations of old photographs, dirty paintings and distant memories.

► SIZE

When no other clues concerning placement are present, larger objects appear closer than smaller ones. This doesn't mean that a lion will read as closer than a mouse when both are drawn to scale — but a large mouse will seem closer than a little one.

▲ OVERLAP

One of the simplest ways to illustrate that one object is closer than another is to let them overlap. The object that's partially obscured will be read as farther away. This effect can be used to create some interesting cognitive dissonances. Try drawing several human figures overlapping each other, with the smallest ones in front. The brain will want to read the smaller ones as farther away, but the overlap contradicts that signal.

▲ POSITIONING

Just as the earth tends to be closer to the viewer than the sky, objects near the bottom of the page appear closer than objects near the top.

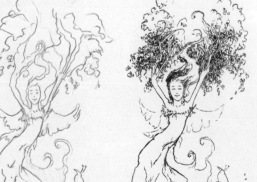

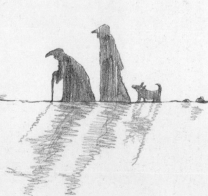

▲ LINE WEIGHT

In the sketches above, the thin, broken lines of the cloud bank (above) and the fairy wings (below) cause them to recede into the background, while objects described with heavier lines push forwards.

▲ ► OTHER VISUAL CLUES

Cast shadows stretching towards or away from the viewer, objects seen from angles other than head-on and gaze lines leading into or out of the picture plane can all be used to suggest depth.

PUTTING PEOPLE IN PERSPECTIVE – *How to ensure that your figures don't have squashed heads and one arm longer than the other.*

Foreshortening and the figure

Your very familiarity with the human figure can become a stumbling block to drawing it in perspective. Foreshortening, the apparent compression of an object when seen from an unusual viewpoint, distorts these familiar proportions. When a body is viewed at an angle from above, the pubic bone might appear to fall as low as mid-thigh or knee level, with tiny legs receding into the space below. Viewed at an angle from underneath, on the other hand, the feet might seem two or three times as large as the head.

Foreshortening

Many beginning artists get an overwhelming sense of 'doing it wrong' the first time they try to foreshorten the figure. When you look down at someone from a balcony in real life, or see a fist flying towards your face, your brain filters and interprets that visual information so that you don't see a big bubble head or a massive fist, but a normally proportioned human being looking up at or punching you. But when you look at a drawing of a figure under a balcony, or of a fist punching towards the picture plane, you're looking at an image on a two-dimensional surface, rather than a person occupying a three-dimensional space, so that extra layer of interpretation doesn't take place. As a result, if no artificial foreshortening has been applied, you see a confusing drawing, where the figure appears misplaced, flat or out of proportion.

GETTING SPECIFIC
Of course, the body won't always be neatly arranged in a rectangle, with limbs extended and torso pointed forwards. A lot of the time you'll be foreshortening body parts individually, as each has its own orientation in space, resulting in its own set of parallels and its own relationship to a vanishing point. In this case, it helps to break down the body into basic shapes: cylinders for the limbs, a sphere attached to a triangular prism for the head, geometric solids for the torso and so on. Then, use one-point perspective to orient each within the picture plane. This breakdown into component parts also helps you figure out which forms are going to overlap, and where.

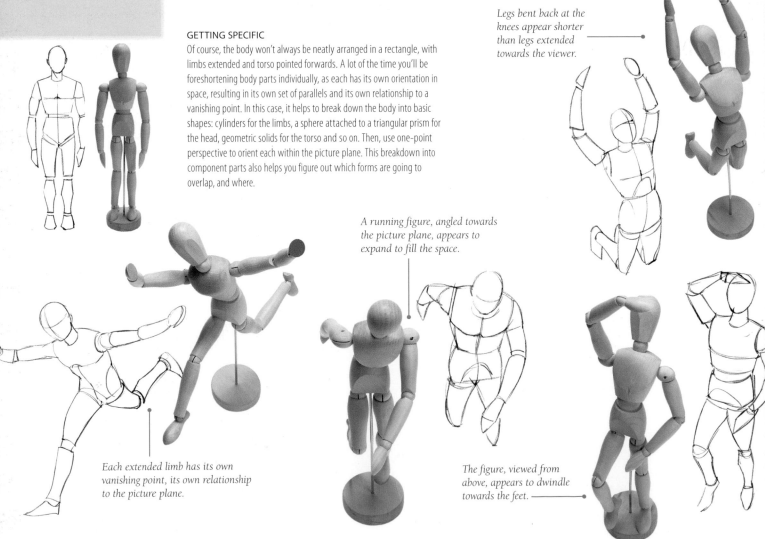

Legs bent back at the knees appear shorter than legs extended towards the viewer.

A running figure, angled towards the picture plane, appears to expand to fill the space.

Each extended limb has its own vanishing point, its own relationship to the picture plane.

The figure, viewed from above, appears to dwindle towards the feet.

USING PROPORTION MARKERS

The easiest way to position the body in space, correctly foreshortened, is to use the rules of one-point perspective to place key points, and then build shapes and forms around those.

▶ **DRAW A RECTANGLE**
Draw a rectangle, receding towards a vanishing point. The sides of the rectangle will serve as the boundaries of your figure, so decide now how tall and wide you want that figure to be.

FIND THE MIDPOINT ▲
Draw an 'X' in your rectangle to find the mid-point; that's where the pubic bone falls, approximately halfway down the body. Then use the same technique to find the mid-points of the top and bottom halves of the body; that's roughly where the nipples and knees will fall. You can split the body up further, into eight segments, if you want to use the chin, navel, mid-thigh and mid-calf as reference points as well.

◀ **ANGLE OF OBSERVATION**
Looking up from below, we see the figure receding into space. Bear in mind the angle of observation, as well as the foreshortening of the figure: from this angle, we can see the underside of the chin and nose, and the seat of the trousers beneath a raised thigh.

PRACTISE, PRACTISE, PRACTISE

The best way to get to grips with foreshortening is to practise. Sketch other people and yourself from as many different angles as possible – the more extreme, the better!

If you don't have a willing model, practise by drawing your own arm and hand.

The unusual angle of this face challenges what the brain knows about the relative sizes of features and forces the eyes to look.

Pay attention to the contours of the body and how they overlap. Make sure that forms in the foreground overlap forms in the background.

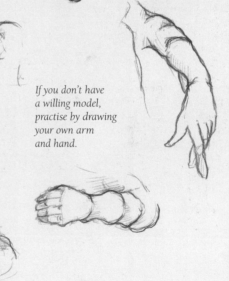

▶ **NON-HUMAN BODIES**
Obviously, non-human bodies are subject to foreshortening too! Treat them as you would the human figure: break them down into basic shapes, use one-point perspective to place key points, then build the details from there.

*ADDING COLOUR – How to use a colour wheel
to choose your palette.*

Colour basics

The human eye is sensitive to a narrow band of
wavelengths along the electromagnetic spectrum,
between 400 and 750 nanometers. This narrow band
translates to millions of colours – an overwhelming
range. Fortunately, this pandemonium of shades can
be organised into smaller, broader categories, which
have been conveniently arranged on the colour
wheel, for purposes of reference.

Colour wheel

The colour wheel consists of three primary colours
– red (1), blue (2) and yellow (3) – and three
secondary colours – orange (4), purple (5) and
green (6). Although the orange-red of a poppy and
the purple-red of a bruised lip are both red, they're
about $\frac{1}{12}$ of the colour wheel apart and have
different aesthetic and emotional connotations
for the viewer.

THE COLOUR WHEEL
You can use the colour wheel to quickly identify
primary and secondary, contrasting and
complementary and warm and cool colours.

Using the colour wheel

The visible spectrum, arranged around a wheel, is
pleasant enough to look at, but what's the point?
Simply put, organisation. The wheel serves as a
quick visual reference for several rules of thumb.

The rule of thirds

Split the colour wheel into thirds, along any lines,
and the range of colours falling within each third
will appear harmonious when used together in a
picture. For example, if red is your starting point,
you could use the entire range of colours between
red and orange-yellow, or between red and
purplish blue, and they wouldn't clash.

One useful application of this rule is for drawing
something that's ostensibly all one colour; adding
subtle hints of adjacent hues from the colour wheel
brings richness to what would otherwise be a fairly
featureless expanse of picture. Using the same
technique of subtle colour addition, you can also
liven up blacks, greys and whites, which have a
tendency to look like holes in the picture when
applied solidly.

The other rule of thirds

When a dramatic image with plenty of contrast
is the order of the day, try picking three colours
spaced at thirds around the wheel, and building
your composition around them. For example, you
could have angry purple clouds roiling across a
flaming orange sky and a polluted green lake
contaminating the foreground. Or, for a
more cheerful feel, try a flock of bright red
birds chasing each other through a field
of sunflowers under a cerulean sky.

When you're using the second rule of
thirds, choose just one colour as your
dominant hue, and introduce the other
two more subtly to offset it. Using all
three in equal measure can result in a
cluttered, oppressive image, which
offers no rest for the eye – an effect to
employ only when warranted by the
subject matter.

Complementary colours

When you draw any straight line passing through
the centre of the colour wheel, the two colours it
hits on its way through are called complementaries.

*Any colours in the same
third of the colour wheel
will not clash.*

*Colours spaced at thirds
around the colour wheel will
contrast with one another.*

*Colours opposite each other on
the colour wheel will complement
one another.*

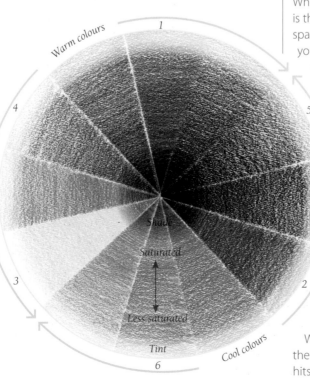

Warm colours

1

4

5

3

2

Shade

Saturated

Less saturated

Tint

6

Cool colours

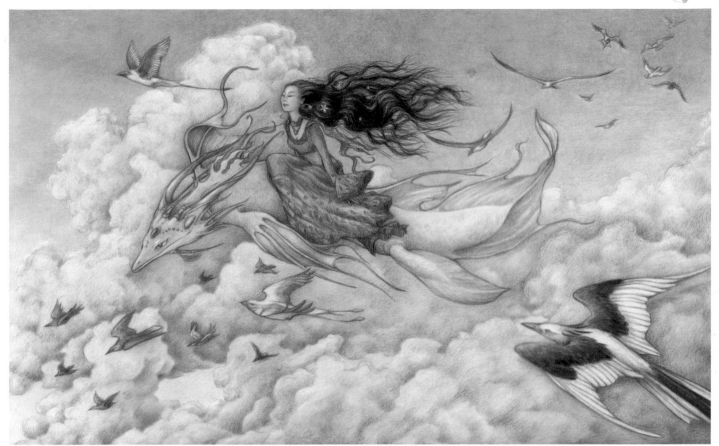

In other words, any two colours directly opposite each other are complementary colours: red is the complement of green; purple is the complement of yellow and so on.

When you're creating colour layouts, remember that complementary colours contrast sharply with one another, and can therefore be a powerful way of drawing the eye to areas of interest.

When you're adding shadows, remember that the colours found in shadows will be complementary to the colour of the light that's casting them. Shadows cast by yellow light will contain purples, those cast by green light will contain reds and so on.

Saturation, tints and shades

Saturation refers to the intensity of a colour. A soft rose and a radiant magenta may have similar hues, but the magenta has a much higher saturation. When you're planning a composition, bear in mind that the more saturated a colour is, the closer it appears to the foreground. Paint a featureless band of moss green below an equally bland streak of pearl grey, and the green will read as closer at hand. The decrease in saturation towards the horizon line is called atmospheric perspective – but avoid using saturation levels as a substitute for the more formal rules of perspective! Tints and shades are hues with the addition of a neutral – a tint is a hue plus white and a shade is a hue plus black.

Warm and cool colours

Colours don't literally have temperatures, but those that fall between red and yellow-green are often referred to as 'warm', whereas those between green and reddish purple are 'cool'. Warm yellow light with cool purple shadows is an effective way of suggesting a hot summer's day, whereas a chilly blue light with orange-brown tones in the shadows is more suggestive of winter.

USING COLOUR

The orange tones of the cloud gently complement the blue of the sky, and the red of the fairy's dress contrasts with the green of the dragon's skin. However, the soft blending of the coloured pencils and the addition of reflected colours in highlights and shadows makes this a gentle, harmonious composition.

COMMON PITFALLS

- **Localised colour schemes:** Avoid having several different, self-contained colour schemes within the same picture. Unify areas of contrasting colour by making use of reflected colour and similarly hued highlights and shadows, and by placing elements of one colour region within another. (For example, to unify a blue sky with a green field beneath, try placing a few bright blue bachelor's buttons in the foreground of the field, where the green is at its most saturated.)
- **Monochromatic shading:** Avoid shading each object in your picture with the same hue in different values. For example, a brown earthenware mug will look more interesting and realistic with yellow highlights and purplish-blue shadows than with beige highlights and burnt umber shadows.
- **Holes in the picture:** When you're going for naturalistic colour and lighting, avoid pure whites and blacks, as these lack richness and flatten out your image.
- **Presumed colour:** Is the sea really blue? Is the grass really green? Not always. Check out some reference before you get started. Observe your intended subject in various states and lighting conditions: What colour is it really?

CHAPTER 3
Anatomy

We live in a world of reflective surfaces; windows, mirrors and puddles greet us at every turn. And when we're not seeing ourselves, we're looking at each other. Thus, anatomy is an important thing to get right. Even the most casual of viewers will notice when something doesn't look quite as expected.

STRUCTURE AND PROPORTION – *How to get started on drawing the proportions of the human figure with its range of shapes and sizes.*

The human figure

Human anatomy can be a daunting subject; getting started is tough, even without the added challenge of throwing in imaginary elements. Proportions vary wildly between individuals, especially once you start to improvise. A crude troll or goblin may be all nose, while a cannibal ogre may have a huge mouth, extending almost as far back as the jaw itself, and filled with teeth! When experimenting with proportion, try to keep two things in mind: functionality and personality.

Functionality

Imagine your fantasy creation living its life. Would it be able to walk? Eat? Talk? Hear? And what sort of life does it lead? A troll that spends most of its time in the dark, under a damp, mouldy bridge, will probably have thick skin, big ears and not much in the way of eyes – these traits fall under functionality. There isn't much to see in the troll's environment, but being able to hear the quiet sounds of people shuffling overhead allows him to hunt more effectively. A heavy, coarse hide protects him from the damp, and maybe from nibbling fish. Long, ape-like arms help him reach atop the bridge to seize his dinner. A solid, muscular physique makes him a force to be reckoned with.

HEIGHT AND PROPORTION

To start with, consider eight human heads stacked up, one on top of the other. Sounds like something you might find adorning the stronghold of a scalp-stealing ogre, doesn't it? It's also a convenient way to measure height and proportion because it breaks the figure into manageable segments and allows you to arrange features predictably within a framework.

▶ HUMAN HEIGHT
The average human being stands between seven and eight heads tall, and has a shoulder span of roughly three heads' width. These proportions describe an idealised figure and are not absolute, especially when depicting fantasy creatures. A humanoid with an elongated, willowy body – think of an elf or fairy – might have proportions closer to nine, ten or even eleven heads tall. A dwarf or a gnome may be five heads tall, with a shoulder span of five or six heads (see pages 88–89).

Personality

A pair of large, beetling eyebrows, on the other hand, reveals the troll's personality: dour, churlish and in a perpetual state of pique over anyone and everyone using his roof as a means to cross the river. A heavy brow and heavily recessed eyes suggest that he's not too bright. Bad teeth and bitten fingernails indicate a hand-to-mouth lifestyle, with little time or care for personal grooming.

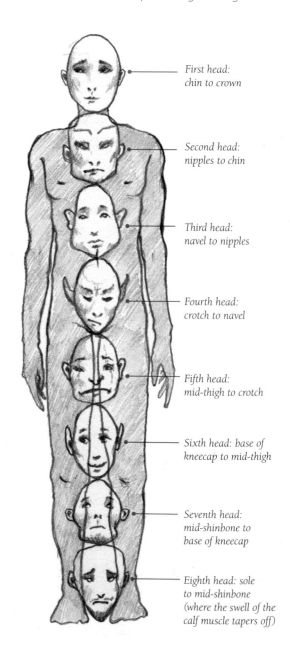

First head: chin to crown

Second head: nipples to chin

Third head: navel to nipples

Fourth head: crotch to navel

Fifth head: mid-thigh to crotch

Sixth head: base of kneecap to mid-thigh

Seventh head: mid-shinbone to base of kneecap

Eighth head: sole to mid-shinbone (where the swell of the calf muscle tapers off)

▶ DIFFERENCES BETWEEN MEN AND WOMEN

Contrary to popular belief, women don't have an extra layer of fat under their skin – but a woman's subcutaneous fat layer is slightly thicker than a man's. As a result, you see softer angles and more rounded forms on the female body. Fatty tissue is also distributed differently. However, the guidelines illustrated by the images won't hold true for every individual, especially in the realm of fantasy. A female warrior will have a more massive build, and more defined muscles, than a male accountant – unless that accountant is a superhero by night. A female troll will have coarser facial features than a male elf or fairy.

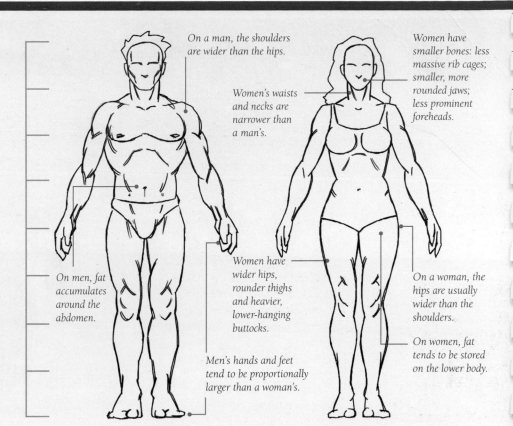

On a man, the shoulders are wider than the hips.

Women's waists and necks are narrower than a man's.

On men, fat accumulates around the abdomen.

Women have wider hips, rounder thighs and heavier, lower-hanging buttocks.

Men's hands and feet tend to be proportionally larger than a woman's.

Women have smaller bones: less massive rib cages; smaller, more rounded jaws; less prominent foreheads.

On a woman, the hips are usually wider than the shoulders.

On women, fat tends to be stored on the lower body.

BUILD A BETTER BODY

Once you have worked out your height and you are happy with the outline proportions of the body, you can move on to the arms, legs, feet, hands and face.

When the arms hang loosely at the sides, the fingertips should hang to approximately mid-thigh.

The distance between the tips of the fingers, when arms are fully outstretched, should be slightly greater than the height of the figure.

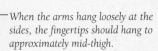

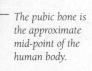

The distance from kneecap to sole should roughly equal the distance from elbow to fingertips.

The length of the foot should roughly equal the length of the forearm, from elbow to wrist.

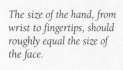

The size of the hand, from wrist to fingertips, should roughly equal the size of the face.

The pubic bone is the approximate mid-point of the human body.

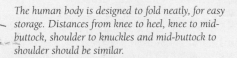

The human body is designed to fold neatly, for easy storage. Distances from knee to heel, knee to mid-buttock, shoulder to knuckles and mid-buttock to shoulder should be similar.

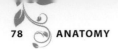

BENEATH THE SURFACE – *Use your knowledge of what lies beneath the human skin to inform your drawings of fantasy creatures.*

Underlying structures

Peeling back the skin reveals a variety of structures beneath. Knowing how these work in human beings is helpful, even if you want to delve right into inventing fantasy creatures. Every living organism has its underpinnings, and having a familiar framework to work from will help you extrapolate from mundane to monstrous. A towering ogre might need extra muscles to swing his mammoth limbs – but where would those muscles connect? How would they work? Adding random bulges is liable to yield something resembling a sack of turnips. Working in secondary musculature around existing structures, on the other hand, creates a more realistic effect.

1. Trapezius
2. Biceps
3. Triceps
4. External obliques
5. Adductors
6. Gluteus maximus
7. Vastus muscle group
8. Biceps formis
9. Triceps surae
10. Peroneus longus

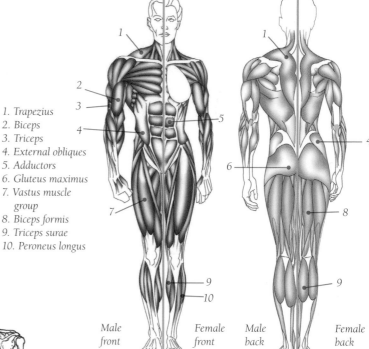

Male front *Female front* *Male back* *Female back*

▲ MUSCLE STRUCTURE
Muscles cover and support the skeleton and give the body its substance. In general, male musculature is much larger than that of the female.

Observation

The human body may seem overwhelmingly complex, but just as we can break down the shape of the head into geometric forms to make it easier to draw, we can also simplify the intricacies of human biology by placing the emphasis on how underlying elements affect surface appearance. Before you read on, take a look at your hand – the one that's not holding the book. What can you see? The palm, the fingers, the tendons that move the fingers, the bones that support those tendons, the blood vessels that feed the whole system – and, there, you're already peeking inside. You may not be able to identify every bone that thrusts its knobbly end against the skin, but you can certainly observe its presence.

▶ SKELETON
The skeleton is the frame that everying else hangs off, so getting it right is important.

1. Skull
2. Vertebrae or spinal column
3. Ribs
4. Sternum or breast bone
5. Radius
6. Ulna
7. Carpus or wrist
8. Femur or thigh bone
9. Fibula
10. Tibia
11. Tarsus or ankle bone

BE A BETTER ARTIST! *Start by drawing different types of people and then try some fantasy creatures.*

- Try drawing people with different body types. Consider how varying distributions of fat and muscle might affect balance and centre of mass. Bear in mind that muscle tissue is dense and very heavy!

- Draw the skeletons of humanoid fantasy creatures. How would a goblin's skull differ from that of an ogre? Or a mermaid? What sorts of bone structures would support the mermaid's fins?

- Take various physical characteristics to their extremes – and try to make them plausible. How would a goblin with a portly body and little skinny bird legs support his weight? How would a three-headed troll keep from falling over or knocking his heads together?

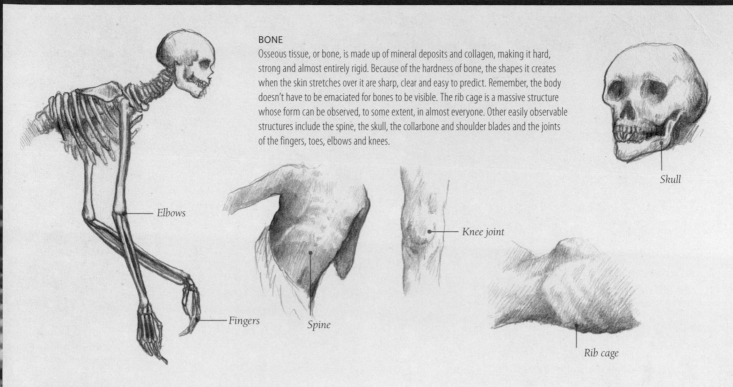

BONE

Osseous tissue, or bone, is made up of mineral deposits and collagen, making it hard, strong and almost entirely rigid. Because of the hardness of bone, the shapes it creates when the skin stretches over it are sharp, clear and easy to predict. Remember, the body doesn't have to be emaciated for bones to be visible. The rib cage is a massive structure whose form can be observed, to some extent, in almost everyone. Other easily observable structures include the spine, the skull, the collarbone and shoulder blades and the joints of the fingers, toes, elbows and knees.

Skull

Elbows

Fingers

Spine

Knee joint

Rib cage

▼ CONNECTIVE TISSUE

Cartilage, tendons and ligaments are tough, flexible connective tissues, which perform such important functions as connecting bone to muscle (tendons), bone to bone (ligaments), padding the spaces between bones and preventing our skeletons from wobbling to pieces. You can see tendons quite clearly on both surfaces of the hand, on the upper surface of the foot, at the wrists and ankles, at the backs of the knees and in the neck. Cartilage forms the shapes of the nose and the ears.

Ear

Hand tendons

Foot tendons

▶ VITAL ORGANS

Unless you are planning on drawing the undead, you can get away with little more than a passing acquaintance with your viscera. Just keep in mind that even a slender person needs to keep their vitals somewhere. You've got around 7.6 m (25 ft) of intestine to pack into the abdominal cavity, as well as urinary and reproductive systems, all of which account for a certain volume.

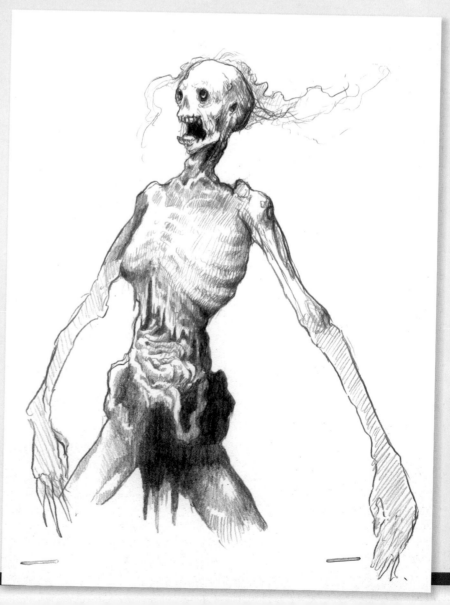

START WITH STICKS – Begin with simple line drawings, then add flesh, clothing and accessories.

Building the figure

When drawing the human figure, particularly if it's going to be in motion, avoid the temptation to start with the most interesting part – most commonly the face – and work your way down. This is a recipe for poor proportions and static poses. Instead, ask yourself: Where's the tension? Where's the movement or potential for movement? Will this character be at rest or in motion? In perfect equilibrium or off-balance? Try to picture the figure as a whole, rather than the interesting details you're going to add later.

Lines

At the most basic level, there are two types of lines upon which forms can be built. The first type is purely descriptive; think of a basic stick figure, with lines for arms and legs, and maybe a couple of flat polygons for the torso. The second type is an energetic, gestural line, not necessarily straight, which shows areas of tension, imbalance or movement. A descriptive line might show the position of a limb; a gestural line shows its kinetic potential, or its importance to the composition.

These descriptive and gestural lines form a framework upon which three-dimensional shapes can be plotted: the cylindrical forms of the limbs; the spade-like forms of the hands; the spheres and angular solids of the torso. Details – facial features, clothing, the fine structures of the hands and feet – come last.

Step one: **Even at the stick figure stage, gestural lines reveal areas of tension, movement and imbalance, whereas descriptive lines plot out the position of the body in space and its proportions.**

BE A BETTER ARTIST! *Try combining different body types with a variety of poses.*

- Experiment with outrageous poses. How wild can you go – and still allow your figure to keep its balance?

- How do you think body type affects centre of mass? Try to draw a huge creature, like an ogre or an orc, in an unbalanced, dynamic pose, without having him look like he's about to keel over.

- Practise gestural drawing. How many lines does it take you to imply a pose? Try to express an action taken by a figure in only one line.

CLOTHING A FIGURE

Once you're happy with the underlying figure, you can add clothes. One of the hardest things about drawing clothing effectively is getting it to drape and fold convincingly over the figure. By learning to recognise and draw the different types of fold, you will be able to draw all sorts of clothing on all sorts of figures.

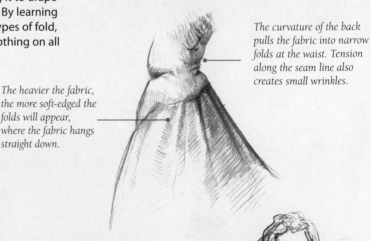

The heavier the fabric, the more soft-edged the folds will appear, where the fabric hangs straight down.

ZIGZAG AND HALF-LOCK FOLDS

Here, a series of zigzag folds follows the seam of a pair of trousers down the side of someone's leg. The fabric is pulled constantly in opposing directions by the motion of walking and the contours of the body and results in this ladder of wrinkles. A deeper half-lock fold occurs at the bend of the knee.

ROLLING OR PIPE FOLDS

Here, a heavy skirt falls in a series of rolling or pipe folds, so named for their rounded, cylindrical shape.

The curvature of the back pulls the fabric into narrow folds at the waist. Tension along the seam line also creates small wrinkles.

SCOOP OR NAPPY FOLDS

Where fabric hangs loosely between two points of tension, you get 'scoop' or 'nappy' folds. These folds congregate at the points of tension and billow out more loosely, in between.

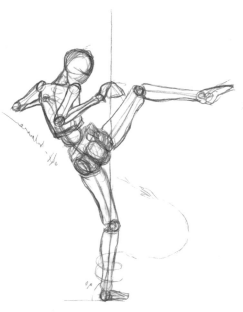

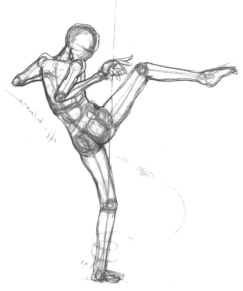

Step two: This figure is off-balance; the mass of the body is not equally distributed on either side of the line of balance. Drawing the body in an unbalanced state can indicate movement – the transition between one position and the next. Rough geometric forms have been used to describe where the mass of the body lies.

Step three: Draw realistic contour lines on top of your geometric constructions. You may wish to use tracing paper for this stage, so you won't have to erase the underlying framework.

Step four: Finally, add clothes, hair and accessories to your figure. Remember, just as gravity and balance apply to your figure, they also apply equally to everything on your figure.

TIP An easy way to determine whether a body is in a state of equilibrium is to extend a line – the line of balance – upwards from the point supporting the majority of its mass. If the body's mass is more or less equally distributed on either side of that line, then the body is in a state of balance.

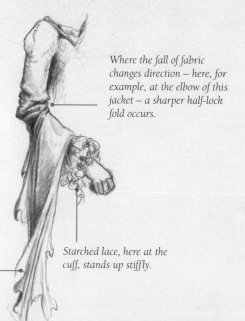

SPIRAL FOLDS
Fabric bunched up around a cylinder, like the sleeve of a coat, gathers in soft, spiralling folds. The heavier the fabric, the more it resists such gathering: a heavy woollen coat will have almost no folds in a straight section of sleeve, while a linen shirt will have many.

Where the fall of fabric changes direction – here, for example, at the elbow of this jacket – a sharper half-lock fold occurs.

A light scarf hung over the forearm, here, billows out in soft, looping folds, following the direction of the wind.

Starched lace, here at the cuff, stands up stiffly.

▶ FOLDS IN PRACTICE
The thin cotton dress folds into numerous pipe folds, whereas those of the thick, heavy cape are larger and less defined. Spiral folds around the wrist and waist describe the gathered fabric there.

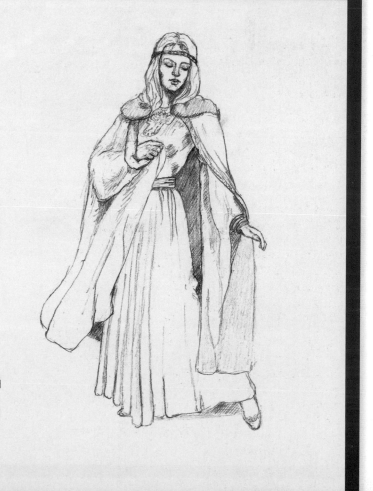

FLESHING OUT THE FACE – Where to place
and how to shape human features.

Face and features

Fantasy art, by virtue of its source material, deals in the exaggerated and improbable: ghouls with eyes like saucers, ogresses with toothy grins and fairies with pointed ears. A faithful representation of reality is neither expected nor ideal. However, it's a good idea for the artist to study the features of a normal face and try to retain as many of them as possible. Grounding your characters in reality creates the illusion that the character is not a cartoon but that it exists somewhere in reality. A convincing monster is more terrifying than one that only manages to look silly.

Lengthening or shortening features
By lengthening or stretching the features, the subject can be turned into an elf, wizard, witch, zombie or any character that has longer features than those considered as normal. In contrast, by shortening facial features, the character takes on the appearance of an imp, troll and a multitude of animal–human combinations. The addition of scars, warts, wrinkles and facial hair can greatly enhance the look of a fantasy character. Don't be afraid of exaggerating the features to what you might initially regard as too extreme – use your sketchbook to gradually transform your character from normal to fantastical.

TIP When drawing in colour, note where the blood flows close to the surface of the skin. Capillary-rich skin will be a bit pinkish; where arteries flow close beneath the surface, there will be a bluish hue.

PROPORTIONS OF THE HEAD AND FACE
The human head has an egg-like shape, which can be broken down further into the sphere of the skull and the blunted triangular prism of the jaw. Start by drawing the face head-on and then try a side view.

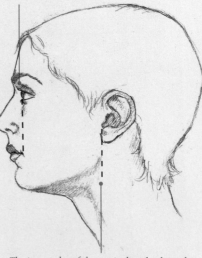

The hairline occurs about halfway down the top half of the face. Some people have much higher or lower hairlines.

The eyes are located halfway between crown and chin and are one eye's width apart.

If you look at a nose from the front, note that the skin of the nostril rim flaps comes all the way around under the nostrils and does not come to an abrupt end at the alar-facial groove.

The width of the head is about two-thirds of its height.

The distances between crown and brow bone, brow bone and nose tip and nose tip and chin should be approximately equal.

The distance between the bottom of the nose and the corner of the eye is equal to the height of the ear.

When you divide the lower half of the face into fifths, the bottom of the nose can be found two-fifths below the eye line, and the slit of the mouth one-fifth below that.

The width of the mouth is roughly equal to the distance between the pupils of the eyes.

The inner edge of the eye roughly lines up with the corner of the mouth, and also with the alar-facial groove (where the nose meets the face).

The width of the head is about seven-eighths of its height.

The inner edge of the ear is directly above the angle of the jaw bone. The angle of the jaw bone is just to the rear of the mid-point of the head.

▼ ROTATING THE HEAD

What happens when you want to rotate the head up or down, or to the side? Lightly sketch some basic heads (the sphere of the skull, the wedge shapes of the jaw and nose, the flaps of the ears). If you're not sure how a human head would look in the position you've got in mind, get somebody to pose for you or look at a photograph. Remember the basic rules of proportion. No matter what angle you regard the head from, the features remain in the same positions.

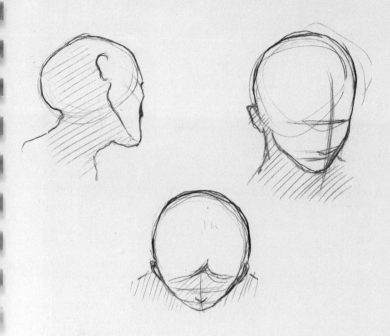

▼ NOSES

It's tempting to simplify the nose to a pair of scores, to signify nostrils, or a shadowed patch, to indicate the tip of the nose. But the nose is actually quite an interesting structure that comes in many shapes and forms.

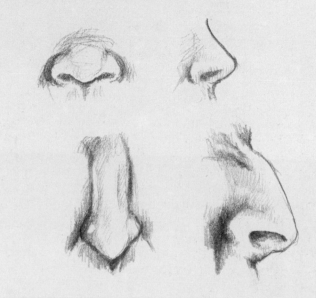

▼ EYES

The surface of the eye is convex, and slightly wet. Remember this when placing and rendering highlights.

Eyelashes radiate upwards and outwards on the upper lid and downwards and outwards on the lower lid.

Unless the eye is open very wide, as in fear or rage, you won't be able to see the whole iris; the top will be partially hidden under the top eyelid. Even when the eye is not open wide, some of the white may be visible above or below the iris.

Seen from the front, the eye's shape is more like a leaf than an almond. The inner corner of the eye protrudes slightly, forming the 'stalk'; the eye is wider and more steeply angled at the inner corner, tapering off at the outer corner.

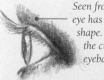

Seen from the side, the eye has an arrowhead shape. Don't forget the curve of the eyeball.

The eyelids have some thickness to them. They aren't just membranes that cover the eyes.

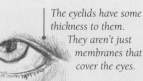

TIP When drawing characters with exaggerated features, such as very long ears or noses, remember what direction those features point in. A long nose won't dip down to cover the mouth, when seen from the front, unless it already did so from the side. If you're having trouble visualising those sail-like ears from an angle other than head-on, break them down to basic shapes, and start sketching from there. Or try finding an object that roughly approximates their shape and use that as reference.

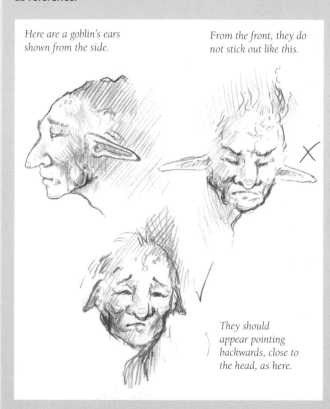

Here are a goblin's ears shown from the side.

From the front, they do not stick out like this.

They should appear pointing backwards, close to the head, as here.

MOUTHS

We all think we know what a mouth looks like – our gaze goes straight to it when we look somebody in the face – but the tendency is still to draw it like a pair of plastic 'hot lips'. Remember that when the lips move, so does the skin around them. Smiling causes dimpling at the corners of the mouth, whereas frowning draws down the skin of the cheeks, creating 'marionette lines'.

Teeth sit on a curved plane, not a flat one. They are not all the same shape; know your incisors from your canines and your premolars from your molars. Human beings usually have 32 teeth.

Lips are not flat; muscles under the skin give them form. Imagine two peas under the skin on the lower lip and three on the upper lip when rendering the contours of the lips.

Smiling causes the lips to stretch and thin. Frowning causes them to draw down and press together. Pouting makes them bunch up and push out.

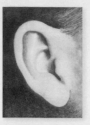

EARS

Although we see them every day, most people aren't too sure where all those curves and curlicues lead. Don't fake it! No two ears are the same, but the basic structures are similar.

The outer ear doesn't have any bones but features a confusing double-curl design.

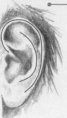

It's possible to teach yourself to wiggle your ears by identifying the muscles that are attached to them and training those muscles to flex on command.

▶ OWLMEN

When drawing fantasy creatures with gross, mis-shapen, or non-human features, use realistic anatomy as a framework, which you can then bend and distort. These men have been given subtle similarities to owls: hair peaked up into horns; large-lensed spectacles that resemble owl's eyes; long noses, like beaks; gnarly, claw-like hands.

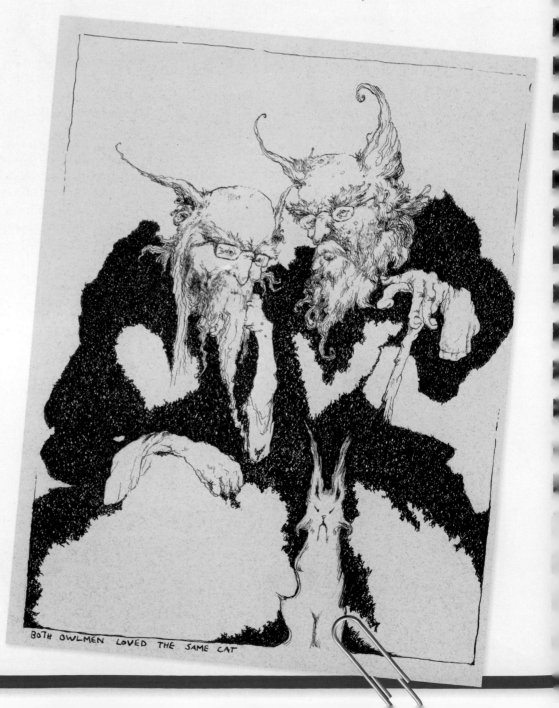

BOTH OWLMEN LOVED THE SAME CAT

FACIAL EXPRESSIONS

The face is the most expressive part of the body. Make sure your expressions are clear and comprehensible. Don't be afraid to exaggerate. Fantasy art is all about drama, adventure and intrigue, so think in terms of extremes. Try making faces at yourself in the mirror. What happens to your features when you scowl in anger? How about when you break out in a genuine grin? Sketch each expression – and hope the wind doesn't change.

▶ **HAPPY**
Crinkled crow's feet, eyebrows raised, smiling, chin slightly raised.

◀ **SHOCKED**
Wide eyes, raised brows, flared nostrils and lips parted in a gasp indicate shock.

▶ **SAD**
Eyebrows furrowed, lowered gaze, corners of mouth turned down.

◀ **WORRIED**
Eyebrows raised in the middle, slightly narrowed eyes, biting the lip.

▼ **ANGRY**
Eyebrows beetled, eyes narrowed, teeth pressed tightly together and mouth drawn downwards at the corners.

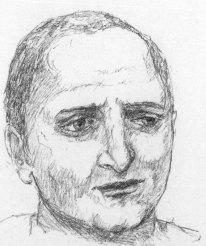

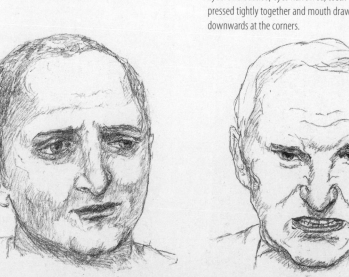

▶ **THOUGHTFUL**
Wrinkled brow, gnawed-upon lip, eyes set in a thousand-yard stare: this person's mind is a million miles away.

ANATOMY AND EXPRESSION – *Getting*
fingers and toes in the right places and using
them to add to the story.

Hands and feet

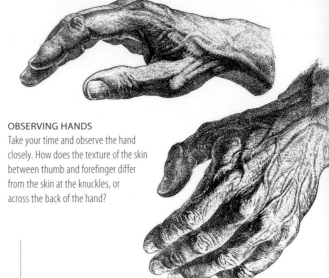

Hands

After the face, hands are the most expressive
parts of the body, so they often require as much
attention as the whole figure. At first glance, these
structures appear impossibly complex. Fortunately,
just as the larger structures of the human figure can
be reduced to basic shapes and forms, in order to
understand them better, these more delicate and
intricate structures can also be broken down to
component parts. When drawing hands with the
intention of exaggerating or distorting them,
remember that they must always be capable
of performing their functions.

OBSERVING HANDS

Take your time and observe the hand
closely. How does the texture of the skin
between thumb and forefinger differ
from the skin at the knuckles, or
across the back of the hand?

Feet

Exaggerating feet can be an effective way of
turning a normal-looking character into one from
the world of fantasy. The desired effect can be
achieved by using an anatomically correct version,
then lengthening parts and making the joints more
obvious. Use your own feet as models, and then
exaggerate the basic drawings.

BE A BETTER
ARTIST! *Look at hands*
and feet and think about
how you can use them to
convey character and
narrative in your drawing.

- Draw your own hands
 and feet. Try tensing and
 relaxing them, holding
 them at different angles
 and holding various
 objects in your hand. How
 does your grip differ?

- Draw the hands and feet
 of five human/creature
 hybrids. How do a
 werewolf's appendages
 differ from a tengu's?
 How can you use your
 knowledge of human
 anatomy to make your own
 creations more convincing?

- Learn some sign language,
 and try to explain how it
 works to somebody else,
 using only your sketches
 of human hands. This will
 improve your precision.

HANDS

Study the bones of the hand. Unless you understand the
underlying form, you will have difficulty making your
drawing look realistic.

It's a common mistake to draw
the body of the hand as a
rectangle, flat across the
knuckles. In fact, the knuckles
and finger joints form a series of
gentle curves, with the joints of
the middle finger at the apexes
and those of the other fingers
falling away to the sides.

The hand consists of three basic
shapes: a pentagon, to represent
the main body of the hand; a
triangle, for the thumb; and
a series of cylinders, to
represent the fingers.

The bones of the fingers extend
beyond the division of skin,
between the fingers. When
drawing fingers, remember that
they will bend at the knuckle,
not at the webs of skin in
between them.

Fingers taper towards
the tips and bulge
outwards slightly at
the joints.

The length of the phalanges
of the middle finger is
approximately equal to the
distance between middle
knuckle and wrist.

A straight line extended
from the wrist positions
the divide between thumb
and fingers.

Fingers don't tend to press together in
a mass, like a bunch of bananas. They
do bend in, slightly, towards the space
between the second and third knuckle, but when
the hand is at rest, there tends to be some space
between them.

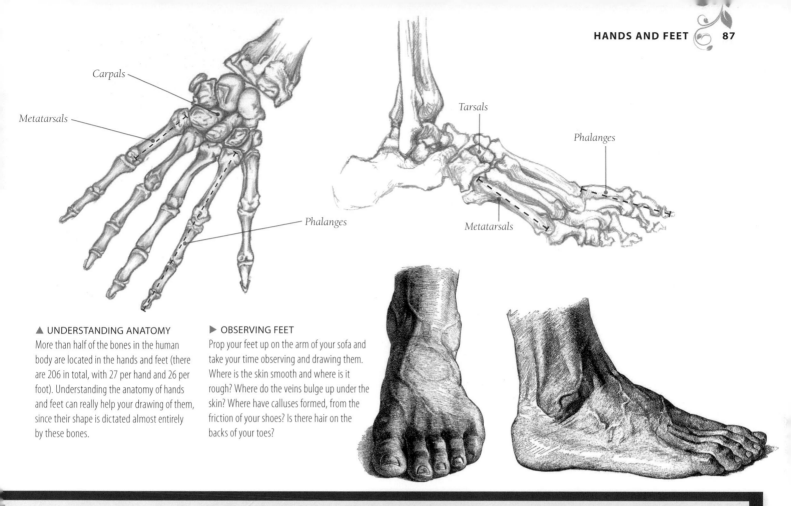

Carpals

Metatarsals

Phalanges

Tarsals

Phalanges

Metatarsals

▲ UNDERSTANDING ANATOMY

More than half of the bones in the human body are located in the hands and feet (there are 206 in total, with 27 per hand and 26 per foot). Understanding the anatomy of hands and feet can really help your drawing of them, since their shape is dictated almost entirely by these bones.

▶ OBSERVING FEET

Prop your feet up on the arm of your sofa and take your time observing and drawing them. Where is the skin smooth and where is it rough? Where do the veins bulge up under the skin? Where have calluses formed, from the friction of your shoes? Is there hair on the backs of your toes?

FEET

Feet are another area of the body that deserves detailed anatomical study. It's easy to draw feet like blobs if you don't understand their structure.

As with the fingers, you'll notice that the toe bones extend farther into the foot, beyond the skin line. The first joints of the toes do not have a large range of motion. Most people cannot move one of the four minor toes without also moving the other three.

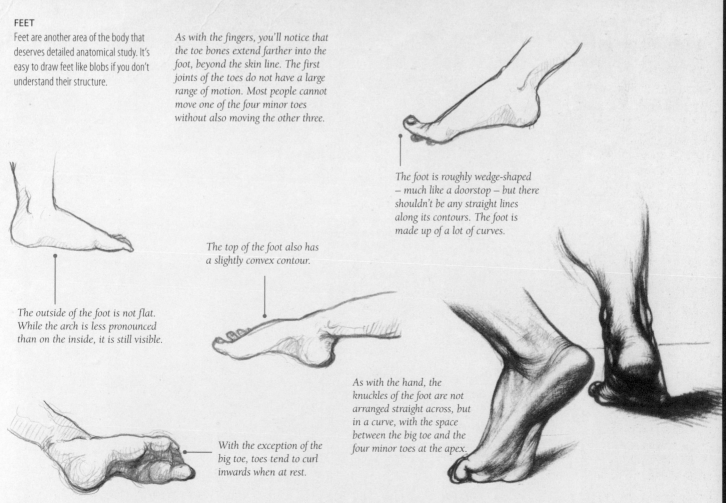

The foot is roughly wedge-shaped – much like a doorstop – but there shouldn't be any straight lines along its contours. The foot is made up of a lot of curves.

The outside of the foot is not flat. While the arch is less pronounced than on the inside, it is still visible.

The top of the foot also has a slightly convex contour.

As with the hand, the knuckles of the foot are not arranged straight across, but in a curve, with the space between the big toe and the four minor toes at the apex.

With the exception of the big toe, toes tend to curl inwards when at rest.

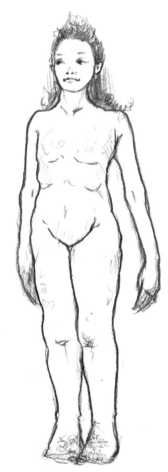

◀ ▶ PLAYING WITH ANATOMY
Once you understand what you're looking at, it gets a lot easier to play with anatomy, while preserving an underlying structure that makes sense. A winged figure will have a totally different physique from that of a creeping zombie.

TURNING ANATOMY ON ITS HEAD – Using what you know to create believeable fantasy creatures.

Fantasy anatomy

Once you are completely familiar with how normal human bodies work, you can start to experiment with abnormal ones. Fundamental elements – skin, bone, muscle, joints and so on – are tweaked to fit your fantasy creations, rather than scrapped entirely. Attached to different beasts though they are, a bird's wing and a bat's wing have structural similarities. Similarly, while a ghoul's fingertips might brush his knees and a mouseman might have four fingers and no thumbs, both can be rendered believably, using the underpinnings of human (and non-human) anatomy.

▼ RELATIVE PROPORTIONS
Even if it's roughly humanoid, it needn't be proportioned exactly like a human being. Stretch, compress, distort and exaggerate to create the dimensions of fantastic creatures. In order to make the proportions look plausible, use the head as a unit of measure. As discussed on page 76, the body of a normal human is eight heads in height, and you can increase or decrease this ratio to create particular impressions about the type of creature you are drawing.

The mouseman is small and slight, slender of limb. He has a mouse's heavy haunches, good for jumping and springing, and a man's long forelimbs, useful for balance and everyday tasks.

The fairy is proportioned like a short, solid human being, trim and athletic from an outdoor existence.

The dwarf is heavy, compact and muscle-bound. He is a formidable warrior and a hard worker, and his physique reflects his lifestyle.

The hobbit is proportioned much like a regular human being. His large, flat feet reflect his disdain for shoes. His stocky build is appropriate for a farmer's life.

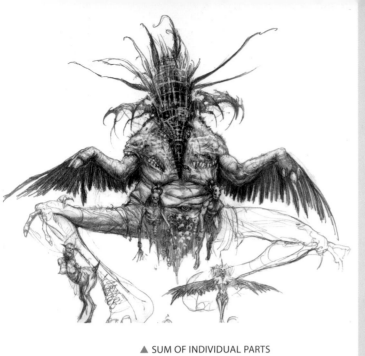

▲ SUM OF INDIVIDUAL PARTS
This demon, with bird wings, cloven hooves, human legs and amphibian body, shouldn't make sense, yet because the artist has based his creation on realistic proportions and details, the eye accepts it as a fantastic whole.

THINGS TO BEAR IN MIND

- Where is your creature's centre of mass?
- Is your creature a biped, or does he move on all fours?
- How does your creature's body shape help or hinder him in his environment? Is he well or badly adapted to his lifestyle?
- If you made an action figure based on this design, would it have a full range of motion? If you can't imagine how a three-dimensional version of your creature would work, you probably have problems in the joint areas. Beware of structures and embellishments that would inhibit motor function.
- Would the anatomy you've designed fulfill its intended purpose? Delicate dragonfly wings might allow a garden fairy to flit from flower to flower, or float safely to the ground – more of an assisted leap than outright flight – but she wouldn't be able to take off like an eagle. If your heart is set on drawing her in the clouds, give her larger wings or a bird to sit on.

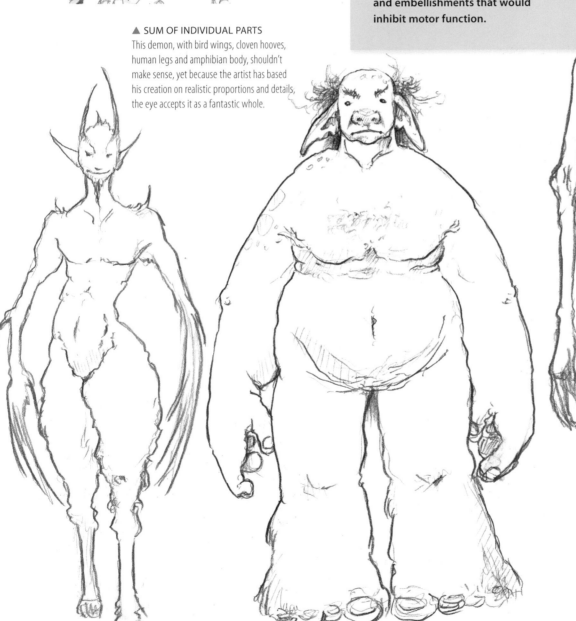

The devil's anatomy draws on human and caprine sources, as well as a hint of the wolverine. His hands fall at mid-thigh, but his claws sweep nearly to his knees. He is tall and slender, and attractive in a bad-news sort of way.

The troll seems heavy, flabby and out of shape at first glance. But beneath all that rude mass lies astonishing strength. Don't annoy (or feed) the troll.

The ghoul is tall and gangly, bone and sinew from head to toe. His arms are long and grabby – the better to ensnare you with, and perhaps tear you to pieces, as well. He has a wide mouth to match his massive appetite for dead human flesh.

FANTASY CREATURES – How to imagine and create original creatures that work as a harmonious whole.

Non-human references

No need to feel cast adrift when faced with the challenge of drawing something that doesn't exist. Odds are, the component parts of it exist somewhere, on something – your mission is to find them, figure out how they work and adapt them to your purposes.

Brainstorming

Imagine you're planning a game of Dungeons and Dragons with your friends. You've decided to indulge in a spot of world-building, and to that end you've asked your friends for some suggestions on the local wildlife. After some hemming and hawing, and a digression into the patently absurd, they've come up with the following ideas:

'It's a cross between a cat, a bird and a dragon, with ears like sails, a long moustache and giant glow-in-the-dark eyes. It tries to be stealthy, but the jingling of its metallic claws tends to give it away. It can't fly, outright, but its wings generate enough lift to allow gentle landings from great heights.'

'It's humanoid, but it can jump like a rabbit. No, wait – a kangaroo. No – definitely a rabbit.'

'It's a raven on stilts. With massive antlers, like a moose. And capable of flight.'

From ideas to creatures

The temptation is to dive in piecemeal, cobbling together scraps of different creatures in any way they'll fit – but try to think of your creations as entirely new animals. While your friends' first suggestion may look like a funny cat-bird-dragon composite, it's not really any of these things. Think of it, instead, as a sinuous nocturnal mammal, with excellent vision and semi-vestigial wings. It favours craggy, mountainous terrain and uses its powerful claws to grab lambs for dinner.

The second one's a bit tougher. Because it's basically humanoid, the obvious solution is to append a pair of rabbit legs

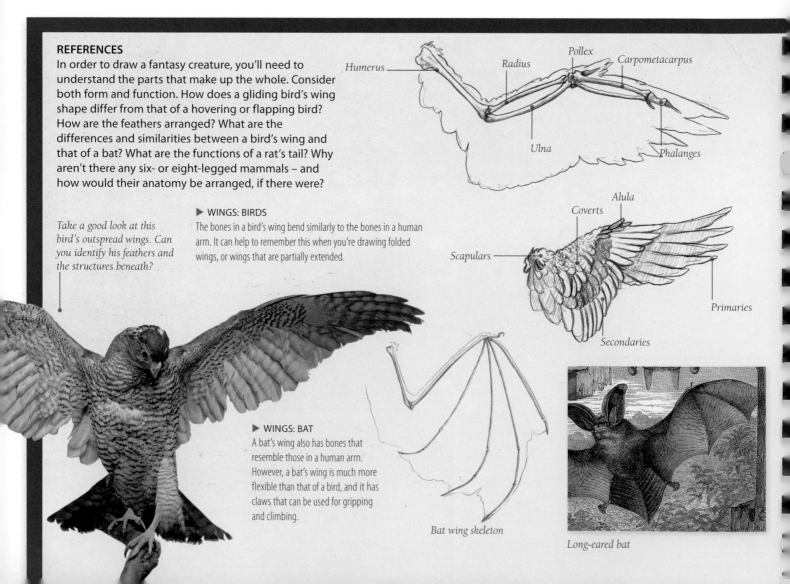

REFERENCES
In order to draw a fantasy creature, you'll need to understand the parts that make up the whole. Consider both form and function. How does a gliding bird's wing shape differ from that of a hovering or flapping bird? How are the feathers arranged? What are the differences and similarities between a bird's wing and that of a bat? What are the functions of a rat's tail? Why aren't there any six- or eight-legged mammals – and how would their anatomy be arranged, if there were?

Take a good look at this bird's outspread wings. Can you identify his feathers and the structures beneath?

▶ WINGS: BIRDS
The bones in a bird's wing bend similarly to the bones in a human arm. It can help to remember this when you're drawing folded wings, or wings that are partially extended.

Humerus
Radius
Pollex
Carpometacarpus
Ulna
Phalanges

Coverts
Alula
Scapulars
Primaries
Secondaries

▶ WINGS: BAT
A bat's wing also has bones that resemble those in a human arm. However, a bat's wing is much more flexible than that of a bird, and it has claws that can be used for gripping and climbing.

Bat wing skeleton

Long-eared bat

to a human torso and be done with it. In fact, the kangaroo idea is probably better; a human torso is quite massive, and a thick, kangaroo-like tail would provide a counterbalance, so the creature wouldn't fall on its face after a forwards leap. A humanoid creature that jumped like a rabbit would need to be quadrupedal (at least during locomotion), or have heavy hindquarters and a light torso.

The raven on stilts, although outlandish at first glance, is the easiest to render plausibly. Birds have very light skeletons. Even long-legged breeds are perfectly capable of flight, with a little added wingspan. And as long as the antlers are kept in proportion to the body, and are not actually the size of a moose's, they won't create a significant encumbrance. Just keep them pointed forwards, so they won't interfere with the flapping of the wings.

BE A BETTER ARTIST! *Observe, photograph and sketch, and then have fun creating new creatures.*

- Find your own references! Take your camera along during a nature walk or trip to the park and see what interesting specimens you can capture. Note how animals and birds move, as well as how they look in a state of rest. A small sketchbook can be useful for jotting down observations, either in words or in sketch format.

- Take a field trip to a natural history museum. You probably won't be allowed to use a camera inside, but take your sketchbook along to record interesting specimens.

- Try drawing animal heads and the heads of imaginary creatures from different angles. Having trouble? Try sculpting that troublesome dragon or basilisk head out of modelling clay, and viewing it from every angle, to help you understand the forms you are drawing.

- Get your friends to suggest their favourite animals, real or legendary. Try to combine elements from these creatures with human beings and with other animals. Study the anatomy of the animals you're using in your creations to help you fit it all together.

- Try a more subtle approach: can you give an average human being a slightly feline or canine appearance by making slight alterations to the physique?

- Look at other artists' fantasy creations. Try and figure out how the skeleton and muscle structure would work. Can you improve on what's there?

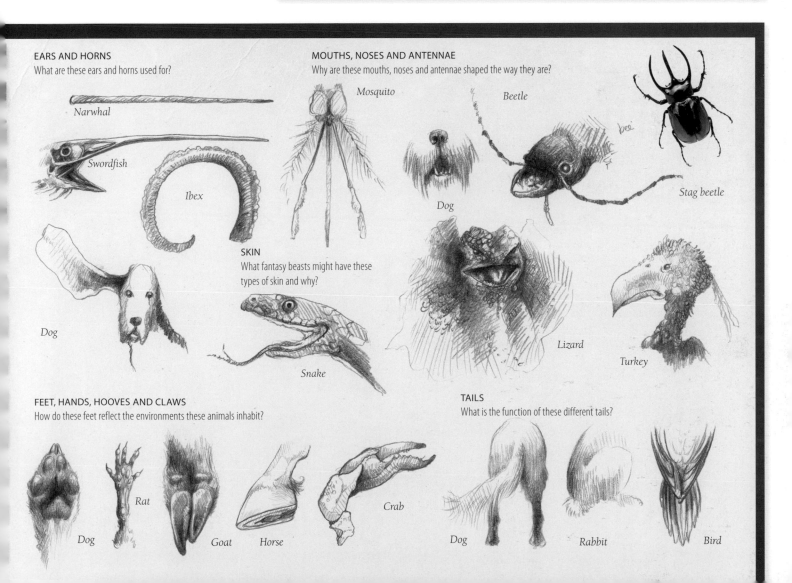

EARS AND HORNS
What are these ears and horns used for?

Narwhal

Swordfish

Ibex

Dog

MOUTHS, NOSES AND ANTENNAE
Why are these mouths, noses and antennae shaped the way they are?

Mosquito

Beetle

Dog

Stag beetle

SKIN
What fantasy beasts might have these types of skin and why?

Snake

Lizard

Turkey

FEET, HANDS, HOOVES AND CLAWS
How do these feet reflect the environments these animals inhabit?

Dog

Rat

Goat

Horse

Crab

TAILS
What is the function of these different tails?

Dog

Rabbit

Bird

RAT-NOSE MAN

The defining feature of this character is his nose. But before you begin drawing it, start with his general shape and size, move on to positioning and shaping his features, then sketch him from all sides so that you can see what his nose will look like in different positions.

Dark shadows under and around the eyes draw attention to them.

▶ *Step one:* When you're starting out, try not to get carried away with small details. Decide on one primary feature that'll set your character apart from the pack, and two or three secondary characteristics, and put the emphasis on those. You can emphasise features by making them larger than normal, giving them interesting shapes, or simply drawing attention to them with your rendering.

Wild hair and an unkempt beard suggest madness, or perhaps genius.

Protuberant teeth and mismatched eyes give this face a dazed and oafish appearance.

Drooping ears and upslanted eyebrows make this version of the Rat-nose Man appear sad.

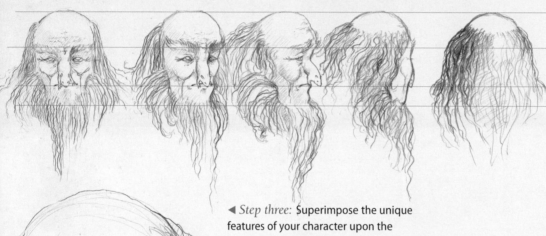

◀ *Step two:* Since we tend to recognise one another primarily by facial features, start with the face. Draw a series of horizontal lines across your chosen face and extend them out to the right, marking off the measurements of the features. Working from left to right, rotate the head 45 degrees at a time, until you've drawn it from behind. The facial features should line up from every angle.

◀ *Step three:* Superimpose the unique features of your character upon the loose head you've constructed, altering the structure where necessary. It'll probably take a few tries to become proficient at this.

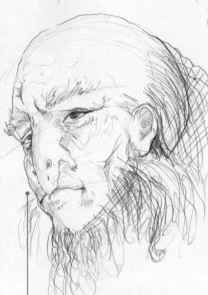

Deep wrinkles create an impression of age. But remember, the map of one's wrinkles, unlike the map of a disputed territory, is not subject to constant revision. Wrinkles should be in more or less the same places every time you draw them.

▶ *Step four:* Draw the full body from different angles, as you did for the head in step two. Pay attention to the build and the volume the body occupies in space. A body that is broad in the front view is likely to have a fair heft from the side. A more fragile body will be similarly slight in every view.

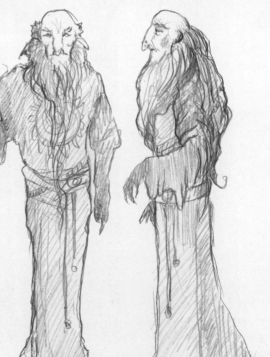

FLOCK OF FLYING PUFFER RATS

Rats, parrots and puffer fish – a bizarre combination, right? Let's see what happens when you borrow anatomy from all three.

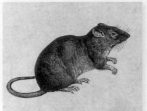

Rat

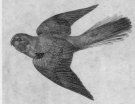

Parrot

Puffer fish

Tiny wings provide no lift but serve as oars, allowing the puffer rat to drift wherever it chooses. Vestigial feet serve no purpose.

▲ *Step one:* Gather together as many references as you can.

▶ *Step two:* Start doodling and sketching. Allow your imagination to run wild. Then make a more detailed drawing of the underlying structures that you've imagined.

A long tail can serve as a rudder, a mooring or, in case of curious birds of prey, a weapon. A long nose and sensitive antennae allow the puffer rat to sniff out food and predict wind and weather.

Small, plum-shaped organs convert inhaled gases to helium, which passes into the flight bladder, allowing the puffer rat to rise into the sky.

▲ *Step three:* Don't forget your textures! Thick, warm fur provides insulation at high altitudes. The skin of a rat's tail has a scaly texture. The skin of its feet is slightly rough. Although these wings are not used for flight, their structure is much the same as that of any other wing. If you're not sure how to draw fur, feathers or any other texture, look at some examples. A little extra realism in the details can make even the most bizarre of concepts come to life.

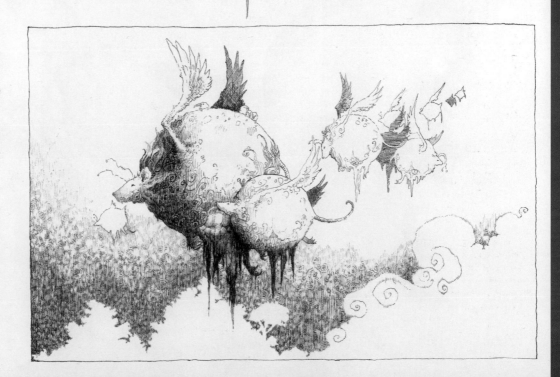

▶ *Step four:* And here he is, the puffer rat, often found floating majestically over the rooftops, providing conveyance for roosts of lazy birds.

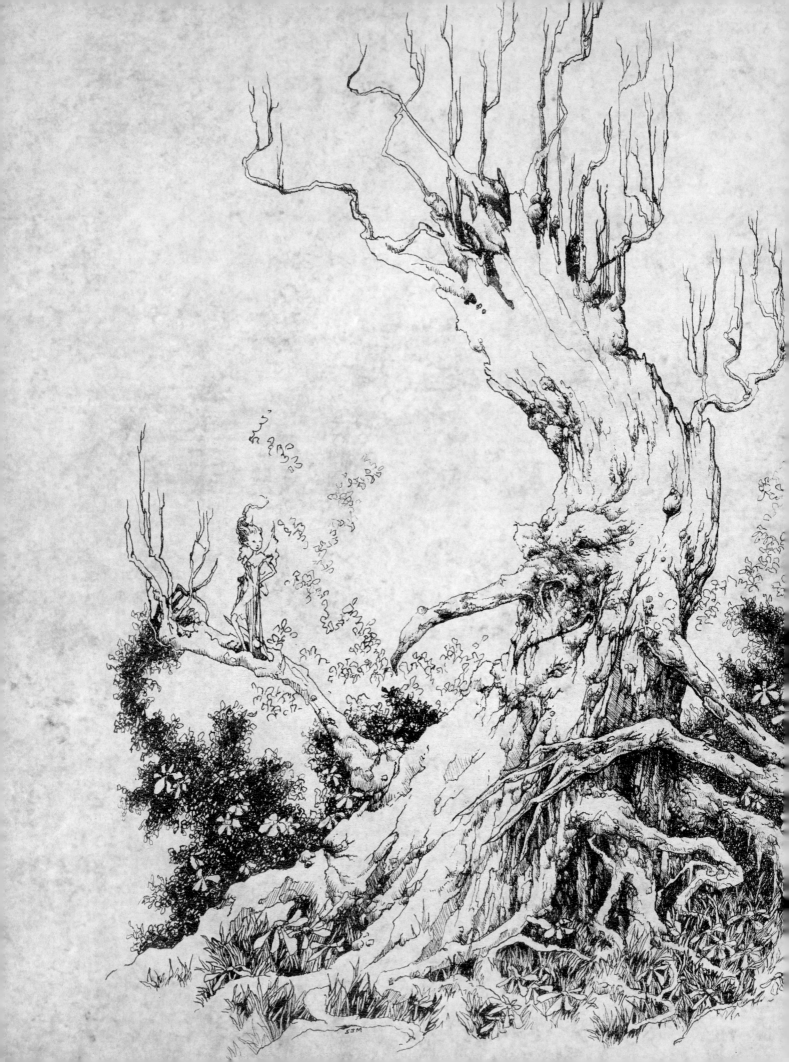

CHAPTER 4
Concepts and characters

Now, it's time to pull together everything we've learned, and create some memorable characters of our own. An artist's greatest challenge is translating the private vision of the mind's eye to something all might see and enjoy. Don't be disappointed if it doesn't go quite as planned. Often, the happy accidents of creation work in one's favour, and if not, there's always next time.

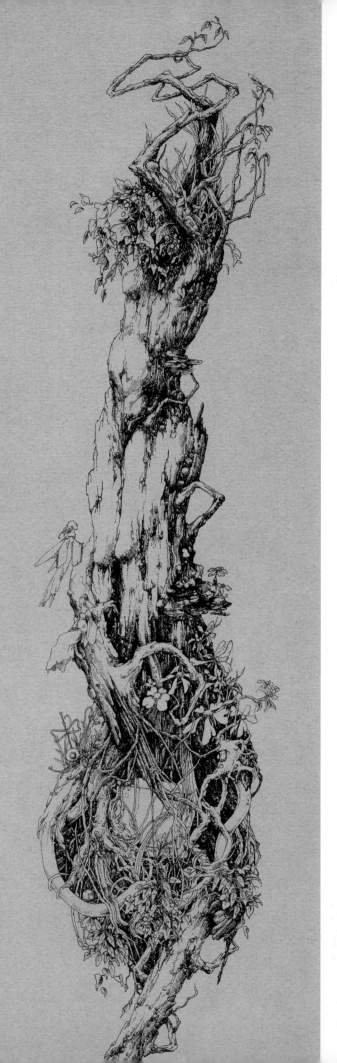

Storytelling and planning

Every great work of imagination begins with a simple question: 'Wouldn't it be brilliant if …' And after the 'if' comes anything you want. The fantasy genre has a lot of familiar tropes: noble knights, ferocious dragons, mischievous fairies – but you don't have to stick with what you know. Odds are, if you're drawn to fantasy, you're a creative person who already has at least a few 'Wouldn't it be brilliant ifs' floating around in your head. Of course, they're not doing you much good locked up in there. Ideas, much like children, only grow strong when they're let out to play.

Purpose

In the best of illustrations, nothing is without purpose. Every element, whether descriptive or symbolic, makes sense; everything contributes. Get used to questioning your choices. Why should a dragon have a long nose? (So the smoke from his furnace breath won't vent too close to his sensitive eyes? In that case, you might also want to give him heavy eyelids and

◄ **THE TREE OF KNOWLEDGE**
This tree is filled with the products of human thought, innovation and knowledge, from the practical to the fanciful. However, it is an unlovely creature, old and corrupted, nearing the end of its life cycle, although still reaching optimistically for the skies.

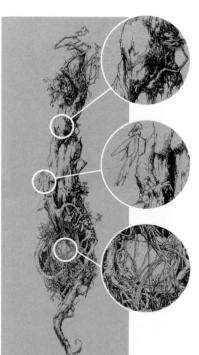

The tree is roughly human in form, with a shock of leaves in place of hair and gnarled knots and bulges of bark forming the curves and bumps of the body.

A pair of little fairies (one shown here, one below), frolicking around a twisting root, show that whimsy remains, even in an age of industry and science.

Webcams, satellite receivers and a large television screen contaminate the roots of this plant. Some of the roots are sprouting wires and light bulbs instead of their natural tendrils, suggesting that an unquenchable thirst for information and knowledge has begun to supersede the thirst of the plant itself.

nictitating membranes.) Why would a barbarian warrior carve and stain devil heads into her teeth? (To intimidate her enemies? So her body can be identified after being mutilated beyond recognition in battle?) What would a mermaid's clothes be made of? (Probably not fish skin, as the scales rub off easily. Try kelp, or eel skin, or a thick layer of subcutaneous fat – immersion in salt water would not be good for clothing.) Where would a wicked witch live? (In a shack in the woods with seven black cats and an arsenal of weird powders? But then people might notice her witchy habits. So maybe she's a famous courtier, who lives in a palace and has ghouls for servants. Maybe she's your neighbour's wife, with a lovely house but a terrifying cellar. Maybe she's a man.) Try to see your characters as individuals, rather than as archetypes.

A story in a scene

Every picture should communicate a complete idea – no verbal explanation required. A still illustration can't usually tell an entire story, from beginning to end, so focus on a single, vivid scene.

The witch's husband has his nose in a book. He is surrounded by burned-out candles, which suggests that he spends most of his time thus occupied.

BE A BETTER ARTIST!

Try creating fantasy characters by depicting their surroundings.

■ Look at the illustrations in some of your favourite fantasy books. How well do they relate to the text? If you hadn't read the books, would you be able to figure out what's going on? Does the imagery stand on its own? Can you identify symbolism related to the story?

■ Look around your home and the homes of friends. What do the objects and furnishings say about the occupants? Try to create 'portraits' of people you know by drawing only their surroundings. The decisions you make about what to put in and what to omit can help you emphasise or downplay particular facets of their personalities.

■ Try this exercise again, but using fantasy characters and creatures. How would a dragon's den differ from a troll's cave? How would one troll's cave differ from another's? Try to give your characters distinct personalities.

▲ SUBURBAN WITCH
Let's say you're tackling the suburban witch with the basement of horrors. A simple solution would be a portrait of a pleasant, middle-aged lady, with round cheeks, smiling lips and a black cat peeking around her skirt...

▶ ... On the other hand, you could draw her in her environment. Consider a cross-section of her home. From this image, the viewer can surmise that the lady is leading a double life; that she is dabbling in the dark arts. Whose skeleton is in the basement? Who's coming to dinner? We don't know the answers, but we do know that the witch has a life beyond that single image.

Strings of garlic and onions hang from the ceiling; a spice rack adorns the wall. A slobby old cat dozes by the fire. A rickety ladder ascends to the attic.

In the cellar, a cauldron bubbles; a skeleton is stretched on a rack; cobwebs festoon bottles of weird ingredients.

Coming up with concepts

Just as it's a good idea to sketch in the whole body first, rather than start with a detailed head and work your way down, you'll want to have a good idea of where you're headed, concept-wise, before you get into specifics. If you're overwhelmed with ideas, don't try to use them all. Start out with loose sketches. What's working? What's not? Once you've come up with a concept that looks good and makes sense, you can start to embellish it. It's fine to add small, enriching details at the end, but if you start adding or altering major elements on a whim, you risk a result that appears more decorated than integrated. All those modifications you thought would be so brilliant will end up looking like ornaments tacked on to the original idea, rather than natural parts of it.

▼ INITIAL IDEAS
Start coming up with concepts by sketching out different characters from mythology, from fantasy or even from reality. Having trouble getting started? Try these: devil, unicorn, fairy, griffin, troll, zombie, elf, banshee, giant rat, hellhound, dragon.

BE A BETTER ARTIST! *Let your imagination run wild as you sketch and jot down notes.*

■ Ask a friend for a random adjective and a favourite animal. Draw your most creative interpretation of what you're given.

■ Pick a theme – anything from creatures to buildings to costumes – and come up with as many related concepts as you can in under 10 minutes. It doesn't matter if you jot your concepts down or sketch them out quickly – use whichever method you're more comfortable with.

■ Take a few of your favourite concepts and build a world around them. What sort of environments would this world have? What sorts of creatures, people and societies would live there? What types of languages would there be? Be as general or as detailed as you like. If a particular idea jumps out at you, stop and flesh it out further.

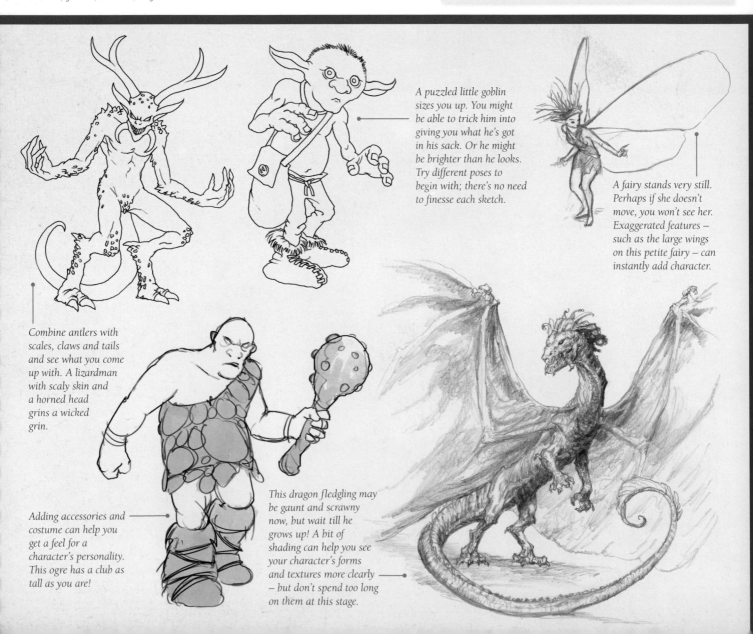

Combine antlers with scales, claws and tails and see what you come up with. A lizardman with scaly skin and a horned head grins a wicked grin.

A puzzled little goblin sizes you up. You might be able to trick him into giving you what he's got in his sack. Or he might be brighter than he looks. Try different poses to begin with; there's no need to finesse each sketch.

A fairy stands very still. Perhaps if she doesn't move, you won't see her. Exaggerated features – such as the large wings on this petite fairy – can instantly add character.

Adding accessories and costume can help you get a feel for a character's personality. This ogre has a club as tall as you are!

This dragon fledgling may be gaunt and scrawny now, but wait till he grows up! A bit of shading can help you see your character's forms and textures more clearly – but don't spend too long on them at this stage.

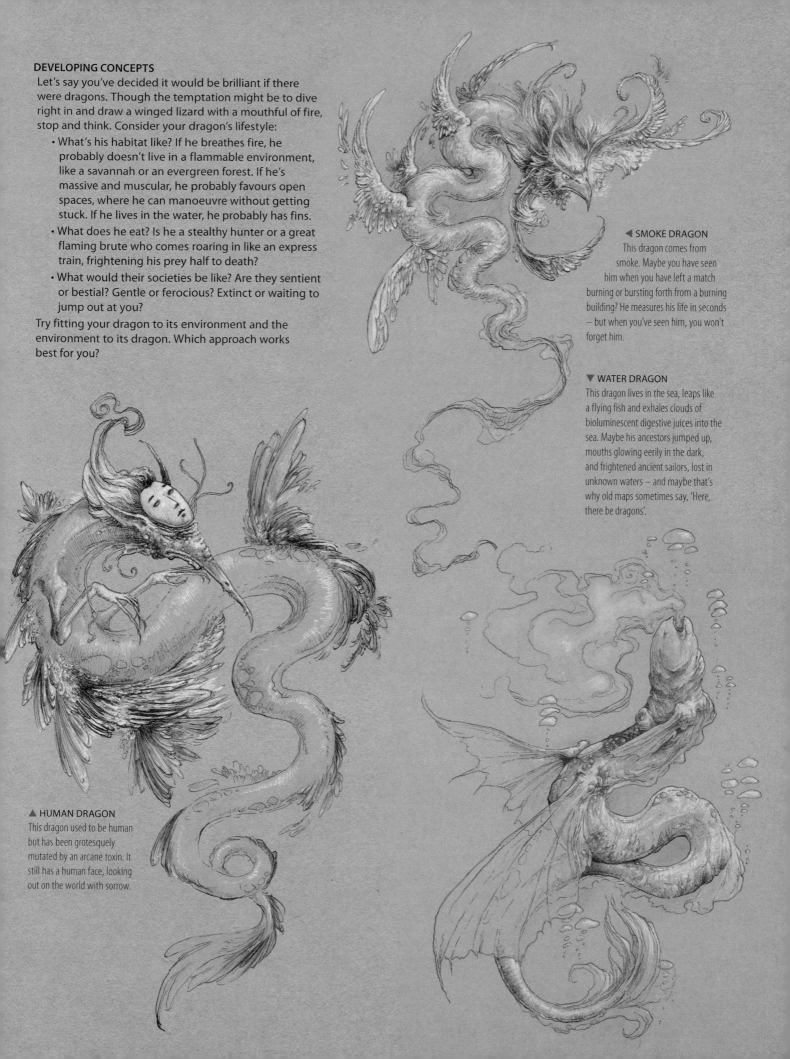

DEVELOPING CONCEPTS

Let's say you've decided it would be brilliant if there were dragons. Though the temptation might be to dive right in and draw a winged lizard with a mouthful of fire, stop and think. Consider your dragon's lifestyle:

- What's his habitat like? If he breathes fire, he probably doesn't live in a flammable environment, like a savannah or an evergreen forest. If he's massive and muscular, he probably favours open spaces, where he can manoeuvre without getting stuck. If he lives in the water, he probably has fins.
- What does he eat? Is he a stealthy hunter or a great flaming brute who comes roaring in like an express train, frightening his prey half to death?
- What would their societies be like? Are they sentient or bestial? Gentle or ferocious? Extinct or waiting to jump out at you?

Try fitting your dragon to its environment and the environment to its dragon. Which approach works best for you?

◀ SMOKE DRAGON

This dragon comes from smoke. Maybe you have seen him when you have left a match burning or bursting forth from a burning building? He measures his life in seconds – but when you've seen him, you won't forget him.

▼ WATER DRAGON

This dragon lives in the sea, leaps like a flying fish and exhales clouds of bioluminescent digestive juices into the sea. Maybe his ancestors jumped up, mouths glowing eerily in the dark, and frightened ancient sailors, lost in unknown waters – and maybe that's why old maps sometimes say, 'Here, there be dragons'.

▲ HUMAN DRAGON

This dragon used to be human but has been grotesquely mutated by an arcane toxin. It still has a human face, looking out on the world with sorrow.

MAKING FANTASY RING TRUE – Learn how to depict lives you have never experienced.

Depth and context

We're naturally drawn to things we recognise. The eye, for example, is so attuned to the sight of the human face that it'll pick out familiar features in piles of dirt, in drifts of clouds and in the seas of the moon. Give viewers something that feels familiar and they'll look longer.

Drawing attention

Anthropomorphic characteristics aren't the only way to attract attention. The eye is also drawn to bright spots, things that appear to be moving and anything that provokes a fearful reaction. Spider-shaped shadows, for example, tend to draw repeated

nervous glances, even if no spider is directly represented. Once you've caught the eye, recognition works on two levels. First, the general (shapes, forms, archetypes, cultural constants – things we're constantly exposed to and understand immediately, without conscious thought); second, the specific (details that either support, contradict or manipulate our initial impressions).

Level one

When you create a character or setting, start with that initial impression. What, in your drawing, will be instantly identifiable? What's the viewer's first-gasp reaction? This could be anything

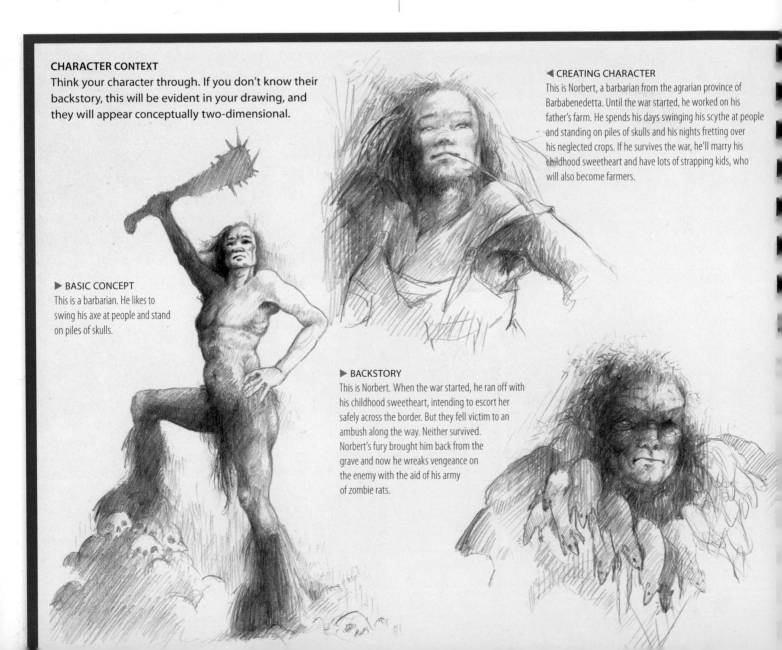

CHARACTER CONTEXT
Think your character through. If you don't know their backstory, this will be evident in your drawing, and they will appear conceptually two-dimensional.

◀ **CREATING CHARACTER**
This is Norbert, a barbarian from the agrarian province of Barbabenedetta. Until the war started, he worked on his father's farm. He spends his days swinging his scythe at people and standing on piles of skulls and his nights fretting over his neglected crops. If he survives the war, he'll marry his childhood sweetheart and have lots of strapping kids, who will also become farmers.

▶ **BASIC CONCEPT**
This is a barbarian. He likes to swing his axe at people and stand on piles of skulls.

▶ **BACKSTORY**
This is Norbert. When the war started, he ran off with his childhood sweetheart, intending to escort her safely across the border. But they fell victim to an ambush along the way. Neither survived. Norbert's fury brought him back from the grave and now he wreaks vengeance on the enemy with the aid of his army of zombie rats.

from 'My, what a lovely forest glade' to 'Ugh! What a horrid multi-eyed roach!' Or even 'What's that horrid multi-eyed roach doing in that lovely forest glade?'

Level two

Next you'll move on to supporting details. Why is there a horrible insect in an otherwise beautiful forest? Perhaps it's lost? Try drawing its eyes all looking in different directions; its tiny little roach head pointed in one direction, its antennae in another; a leg or two raised, as though it's ready to scuttle off at the first whiff of home. Perhaps it's hunting? Draw some holes in the ground, with rabbits looking nervously out of them, and your roach's foreleg buried carapace-deep in the nearest burrow. Perhaps it's the prey? Put the roach under a massive leaf, antennae poking out nervously, as camouflaged warriors lurk in the shadows, spears at the ready. Differentiate this multi-eyed horror roach from all other horror roaches. Give it a personality, a history, a reason for being where it is, however rudimentary. Manipulate as many details as you can to support that idea.

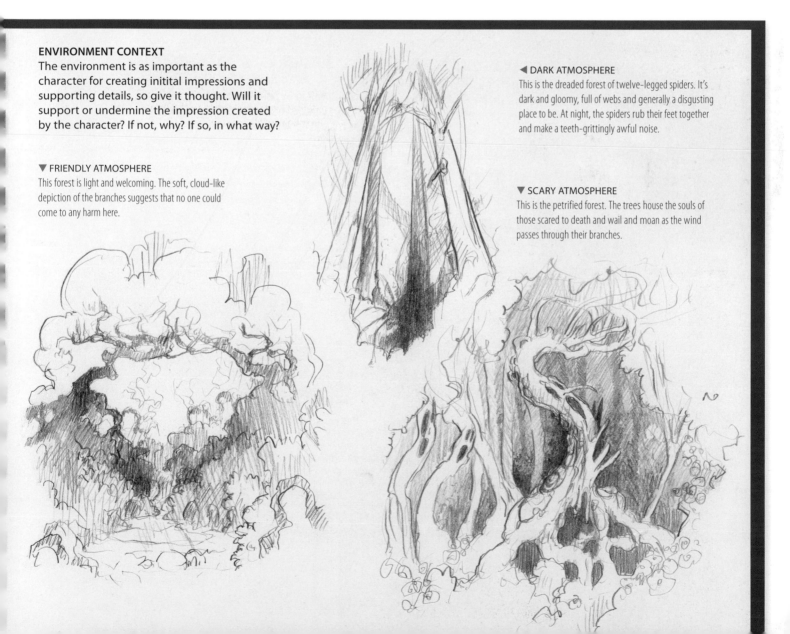

ENVIRONMENT CONTEXT
The environment is as important as the character for creating initial impressions and supporting details, so give it thought. Will it support or undermine the impression created by the character? If not, why? If so, in what way?

◀ **DARK ATMOSPHERE**
This is the dreaded forest of twelve-legged spiders. It's dark and gloomy, full of webs and generally a disgusting place to be. At night, the spiders rub their feet together and make a teeth-grittingly awful noise.

▼ **FRIENDLY ATMOSPHERE**
This forest is light and welcoming. The soft, cloud-like depiction of the branches suggests that no one could come to any harm here.

▼ **SCARY ATMOSPHERE**
This is the petrified forest. The trees house the souls of those scared to death and wail and moan as the wind passes through their branches.

DEATH AND DECAY – *How to create images of horror and dread.*

Zombie dog

Zombies are hungry, single-minded revenants, whose fixation with eating brains inspires visceral dread. What's worse than a human zombie? Why, a canine zombie, of course. A dog bite is about five times as powerful as a human one, and would you bet your life on your ability to out-run that thing?

The horror of betrayal by man's best friend, who now yearns for human flesh, is compounded by the horror of Bartlett's physical decay. Flesh loses a lot of moisture during the decomposition process. A zombie will look leaner, meaner and quite possibly greener than a living creature. Where the organs

Bartlett, the Zombie Dog, was once a roly-poly puppy, all huge paws and voracious appetite. He ate everything in sight, including the carpet, the leather furniture coverings and his master's favourite shoes. Bartlett was out on his cute, floppy ear. He snuffled sadly around the streets, begging, snarling and whining at the gates of markets and restaurants. Everybody ignored him. Bartlett faded away to a shadow, died and rotted, but he couldn't sleep on an empty stomach …

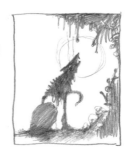

◄ *Step one: Behavior* A zombie dog is still a dog. It likes to jump on people, bark at the moon and roll in carrion. Thumbnails allow you to play with different stories. But a zombie dog is first and foremost a zombie, so its favourite behaviour might involve sitting on piles of dead creatures while thinking about eating their brains.

SOURCES OF INSPIRATION
This snarling Alsatian, wild-eyed and sharp-toothed, is terrifying even in life! This artist has emphasised the curl of the dog's lip, the flare of his nostril and the wickedness of his teeth. Small exaggerations add up to an image that's realistic and frightening at the same time.

▶ *Step two: The pile* Planning a big pile of anything is a challenge. First decide on the general shape and then begin sketching in the details from front to back. It's easier to draw an object behind something that's already there, rather than in front of it. If your pile of junk is particularly large or detailed, try sketching it out in several pieces and experimenting with different configurations. You can trace over them later, either digitally or with a piece of tracing paper. Draw the skulls and rib cages at the bottom first, then experiment with various configurations of twisted bodies and dangling limbs.

▲ *Step three: Decay* Decay goes fastest in the softest tissues and in and around any orifices. Eyes take on a hollow look. Nostrils become cavernous. Hair and fur fall off, leaving bare skin exposed. Buzzing insects and flying gobbets of organic matter emphasise the general nastiness of undeath.

▶ The key feature of the animal is emaciation. His stomach can never be filled because he no longer has one.

and connective tissue have begun to break down, the skin goes unsupported. The skin itself shrinks and dries, stretching more tightly over the remaining framework beneath – that is to say, the skeleton. Bones become visible through the skin. Mildews, molds, lichens and discolourations appear.

 The choice of background will add to the viewer's feelings of fear and horror. How about a big pile of dead things – skulls, rib cages, clawed hands?

CONSIDER ALL ANGLES

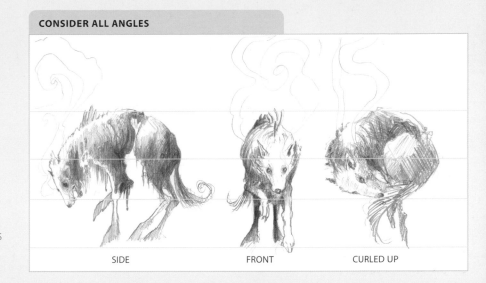

SIDE FRONT CURLED UP

▶*Step four: Composition* The skulls are deliberately arranged so they're not all pointing in the same direction. When many pairs of eyes (or eye sockets) are focused on the same thing – even if that thing isn't on the picture plane – the viewer's eye will follow. With the skulls arranged at random angles, they read more as a collection of objects and less as an audience inspecting a centre of interest. The dog's line of sight leads straight down his nose to a gnarled hand sticking out of the pile. The viewer's eye will follow the arm back down to the corpses. Objects are arranged in circles and sweeps, as much as possible, to keep the eye moving.

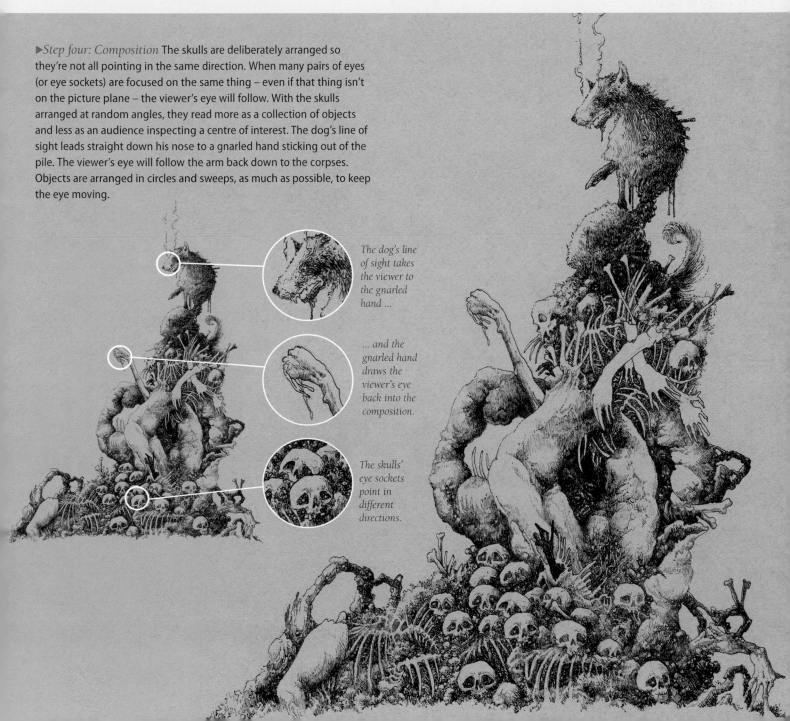

The dog's line of sight takes the viewer to the gnarled hand ...

... and the gnarled hand draws the viewer's eye back into the composition.

The skulls' eye sockets point in different directions.

We humans harbour an instinctive distrust of other forms of intelligence, especially artificial ones. We fear that an advanced android might be able to override its programming and rise up against us. But Rickety Rick, the robot ranger, doesn't have world domination on his mind. All he wants to do is his job – picking up rubbish, keeping kids out of the lily pond and stopping old-timers from feeding bread to the birds who torment him.

CREATE A STORY – *Condensing your character's attitude and history into a single image.*

Robot

You've made a good start by turning the concept of artificial intelligence on its head, but you need to work some more on the character and then create a story for him.

Rickety Rick is not happy in his work because he is unappreciated. Humans keep dropping rubbish; kids paddle in the pond; birds not only foul park benches but try to roost in his gears at night. When the park closes, Rick is supposed to go back to his shed, plug himself in and engage sleep mode. And

most nights, he does. But once in a while, when the stars are out and the air's sweet, he rebels. He borrows a boat and sculls to the middle of the pond. He listens to the calls of the night birds, watches the ripples on the water and wonders what it would be like to sink beneath the surface to rust quietly in the reeds, as decades of bird lime and humiliation float from his shoulders.

Is that the scene you are after? Or would a snapshot of Rick in his boat be more effective?

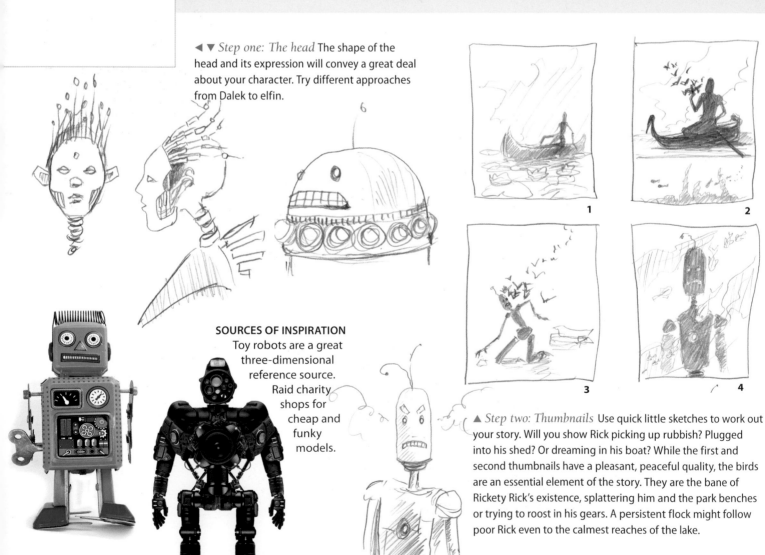

◀▼ *Step one: The head* The shape of the head and its expression will convey a great deal about your character. Try different approaches from Dalek to elfin.

SOURCES OF INSPIRATION
Toy robots are a great three-dimensional reference source. Raid charity shops for cheap and funky models.

▲ *Step two: Thumbnails* Use quick little sketches to work out your story. Will you show Rick picking up rubbish? Plugged into his shed? Or dreaming in his boat? While the first and second thumbnails have a pleasant, peaceful quality, the birds are an essential element of the story. They are the bane of Rickety Rick's existence, splattering him and the park benches or trying to roost in his gears. A persistent flock might follow poor Rick even to the calmest reaches of the lake.

CONSIDER ALL ANGLES

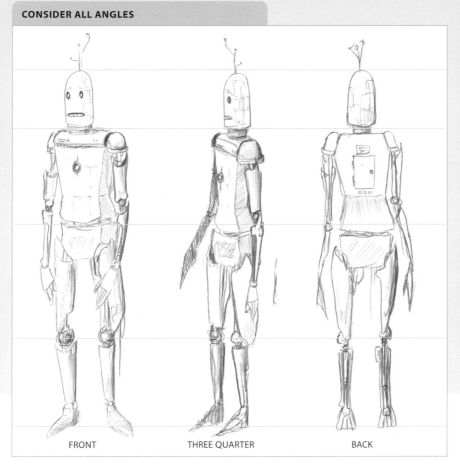

FRONT THREE QUARTER BACK

◄ Sketch your robot from all angles, focusing on his joints and body shape.

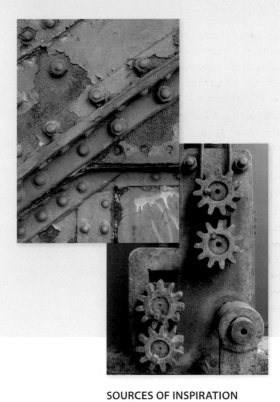

SOURCES OF INSPIRATION
Take pictures of gears, rust, rivets and interesting metal textures; these come in handy when you get down to details.

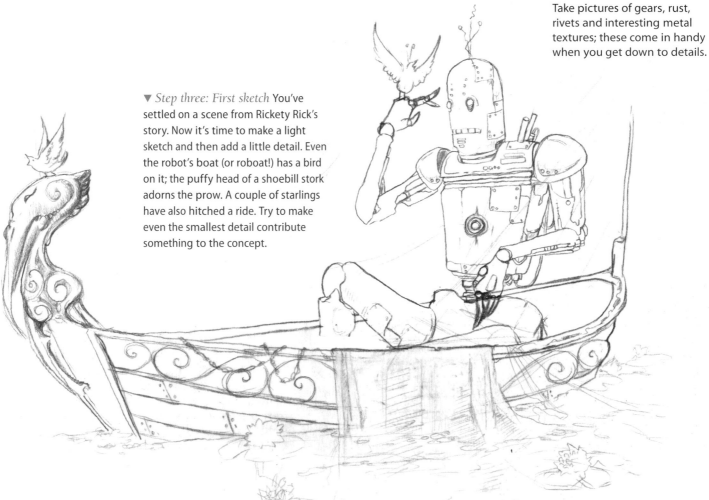

▼ *Step three: First sketch* You've settled on a scene from Rickety Rick's story. Now it's time to make a light sketch and then add a little detail. Even the robot's boat (or roboat!) has a bird on it; the puffy head of a shoebill stork adorns the prow. A couple of starlings have also hitched a ride. Try to make even the smallest detail contribute something to the concept.

▼ *Step four: Stars* A star-studded night sky creates a fairy-tale atmosphere. There are almost as many ways to draw stars as there are, well, stars. Here are a few of them.

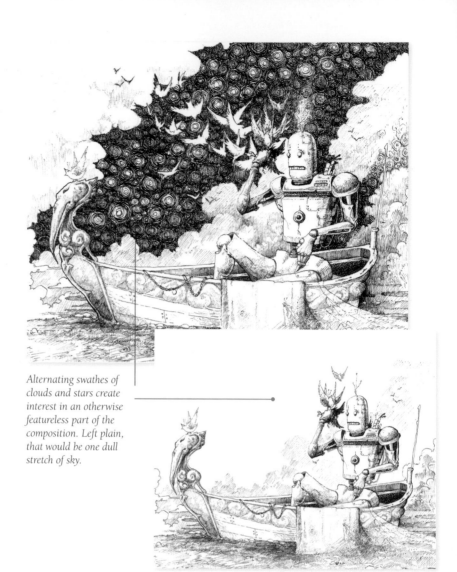

Swirly, playful stars are not particularly realistic but create a pleasing sense of movement in an area that would normally be quite static (the sky).

Vertical hatching over some of the stars makes them 'shine' less brightly. Stars left unhatched become points of interest.

Alternating swathes of clouds and stars create interest in an otherwise featureless part of the composition. Left plain, that would be one dull stretch of sky.

Spatters of white ink or paint across a black background are certainly dramatic! This method sacrifices some degree of control, however.

▲ *Step five: Adding background and story*
Adding the starry background adds texture and visual richness to the piece. A flock of birds converges on the boat, much to Rick's dismay.

▶ *Step six: Picking out detail* It's important to know when to enhance detail and when to leave out features. Here, a few small details, picked out in red, draw attention to points of interest: the bird-shaped prow, the robot's body and a dead bird sinking into the lake. The swooping birds, however, haven't been given much in the way of detail. It's hard to pick out small features on moving objects, so leaving out such features helps imply motion.

The bird-shaped prow suggests that Rick cannot escape the birds that torment him.

The colour on Rick's body ensures that focus is not taken away from the main subject of this detailed composition.

A dead bird sinks into the lake. The idea of joining it at the silty bottom is not entirely unappealing to Rick.

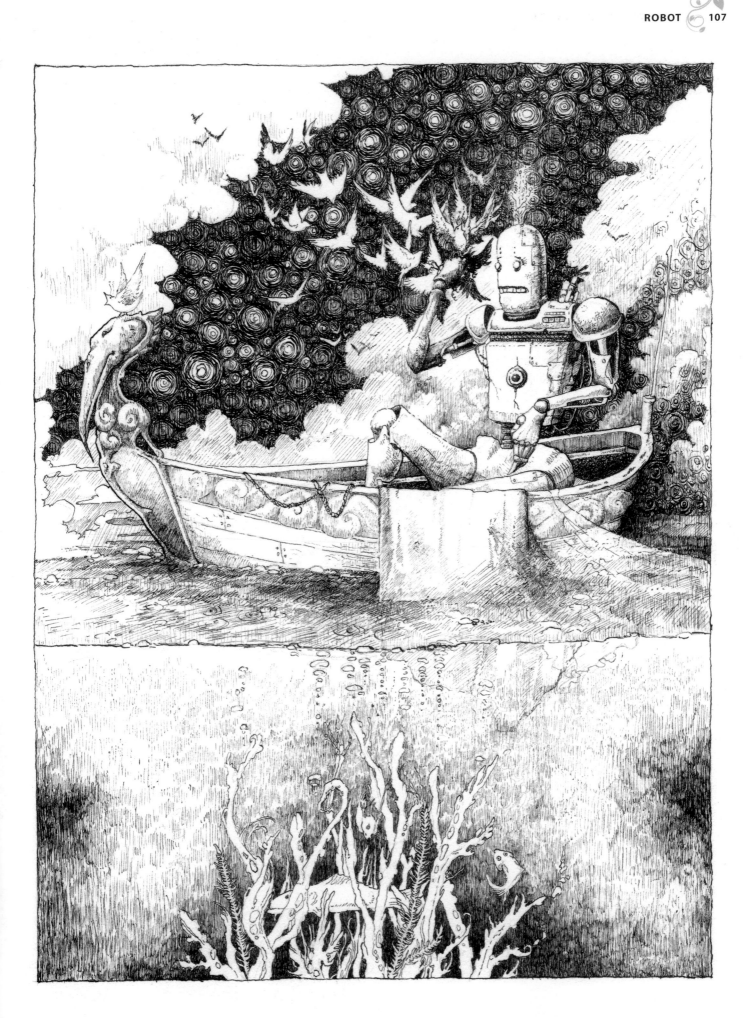

Wouldn't it be brilliant to have avian armies at your beck and call? To blacken the skies with starlings on a whim? Or bring a hundred hungry eagles down on the bald head of the pickpocket making off with your camera? But what might the birds expect in return? Sparrow Sun, the Bird Queen, has spent 80-odd years picking mites, filing beaks, preening feathers, trimming toenails and scattering millet. But she curses her dying day, sure that her birds will peck over her remains – stealing all her shiny buttons, and possibly her eyes – before they carry her to the sky.

MATCHING CONCEPT TO DRAWING – Imagine, sketch and modify until your original concept comes to life.

Bird queen

When you have a vivid idea for a character but are not sure how best to convey it, try sketching on tracing paper. Not only is it much cheaper than regular paper, but it also allows you to draw different elements on different scraps of paper. You can then move them around till you come up with a composition that you like. Here, tracing paper was invaluable for trying out several arrangements of wings before settling on one that worked. Once you have a sketch that you like, you can transfer it to a fresh piece of paper with a sheet of carbon or graphite paper. Carbon lines can be difficult to erase, however, so don't press too hard.

When you're transferring your sketch to your final piece of paper, don't worry about small details and shading. Concentrate on outlines and major forms. You can use your sketch as reference to copy everything else over afterwards.

▶ *Step one: Visualising character*
It's said that people who spend a lot of time with their pets eventually begin to resemble them. Sparrow Sun has a bird-like shape; the hunched shoulders of a vulture and a hooked, beakish nose. Her gnarled hands mimic bird claws. Feathers festoon her costume. A dour expression completes the look. She perches on a high branch, unafraid of falling; she knows her minions will always hold her up.

▶ *Step two: Refining the concept* The bird-like shape from the first sketch was effective, but a vulture might not have been the best choice. Sparrow Sun is meant to be grouchy and bitter, but not evil. She's a person who does good with bad grace; hence, the shape of a grackle. A grackle is a pompous, greedy and ill-humored bird, which can puff itself up to nearly twice its normal size. The background is a collage of ostrich, vulture and budgie wings – all birds known for their poor dispositions.

SOURCES OF INSPIRATION
Scour the bottom of your birdcage or the ground under your local rook tree for feathers. Understanding their structure on an individual level helps you draw them convincingly on the bird.

CONSIDER ALL ANGLES

FRONT SIDE BACK

▲ Imagine the 'rotten old biddy' from different angles. Here, she crouches like a roosting bird, draped in a feathered cloak.

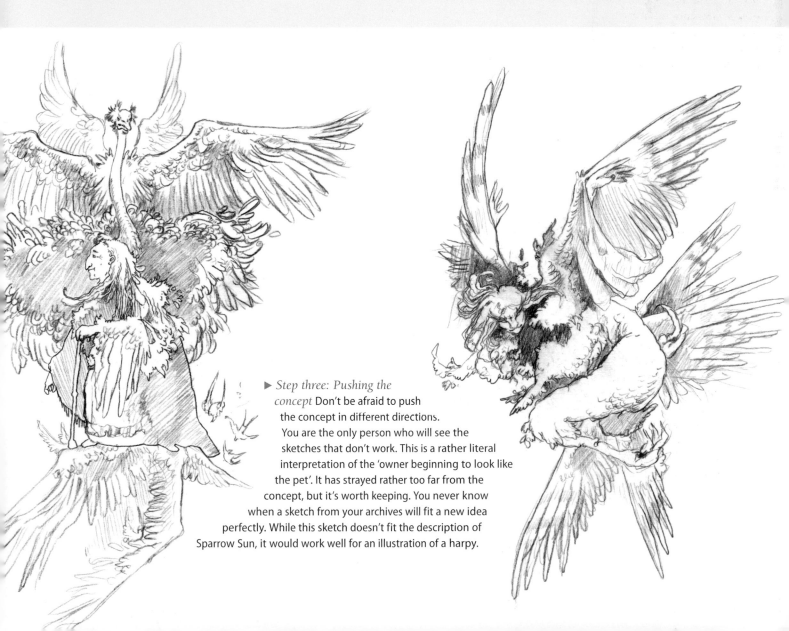

▶ *Step three: Pushing the concept* Don't be afraid to push the concept in different directions. You are the only person who will see the sketches that don't work. This is a rather literal interpretation of the 'owner beginning to look like the pet'. It has strayed rather too far from the concept, but it's worth keeping. You never know when a sketch from your archives will fit a new idea perfectly. While this sketch doesn't fit the description of Sparrow Sun, it would work well for an illustration of a harpy.

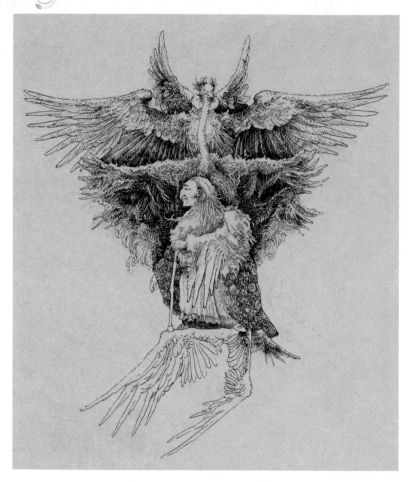

◄ *Step four: Rendering detail* It's not a good idea to outline absolutely everything before you start rendering. Note that the interior area of the ostrich's wings doesn't have many c-ur lines and has simply been filled with feathery textures. However, the stiffer feathers have been given definite outlines, to indicate that they are not so soft or fluffy. The less stiff the feather is, the less rigidly it's been defined.

TIPS

■ Plan areas of light, shadow and detail in advance. Sparrow Sun's face stands out as a focal point because it's simple and well lit against a background of complex, dark detail. Remember, you can always add MORE detail or MORE shadow, but you can't easily take it away again.

■ Where your image is asymmetrical, balance it carefully. The ostrich's gaze, angling to the right, is offset by the left-trailing feathers on the wing Sparrow Sun is standing on.

Study the types and layering of feathers on a bird's wing; different feathers perform different functions in flight. They also provide a nice variety of textures and shapes.

Sparrow Sun has a nose like a beak. Her small, beady eyes are a lot like the ostrich's.

An ornery ostrich glowers. Bother Sparrow Sun and he'll bother you.

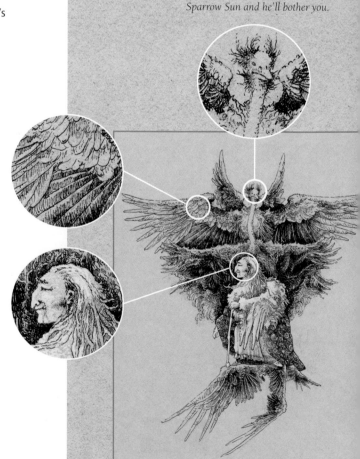

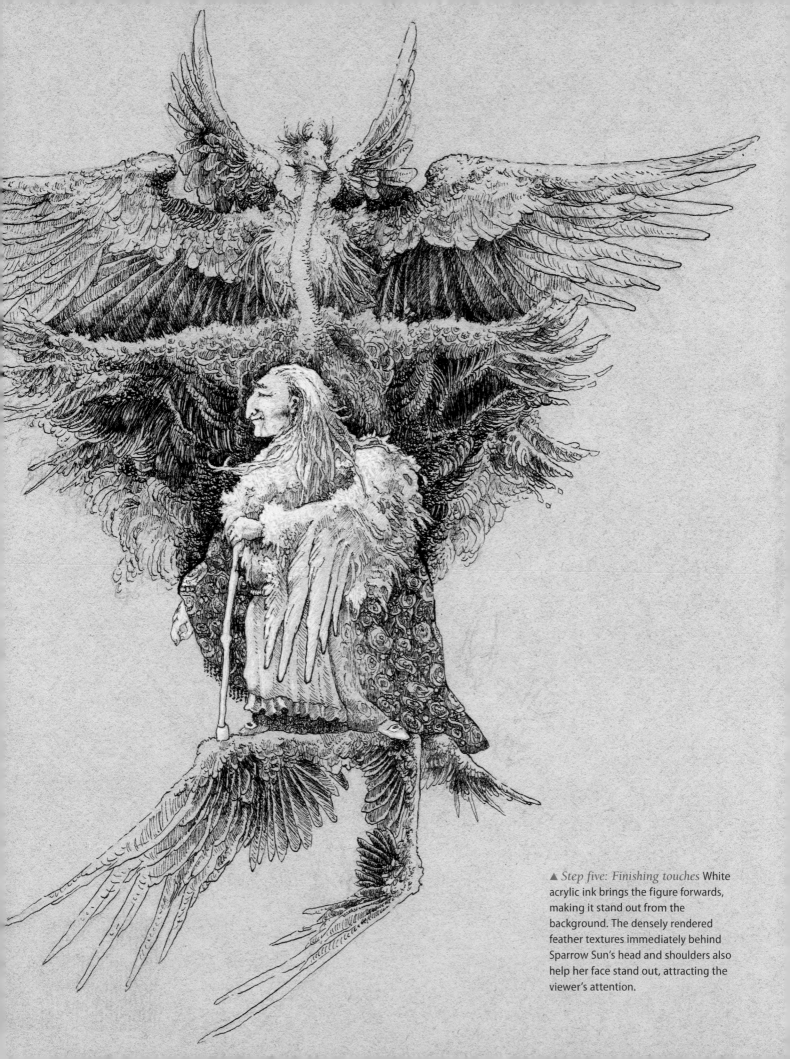

▲ *Step five: Finishing touches* White acrylic ink brings the figure forwards, making it stand out from the background. The densely rendered feather textures immediately behind Sparrow Sun's head and shoulders also help her face stand out, attracting the viewer's attention.

Trolls used to spend most of their time under bridges, demanding tolls from people wanting to cross. But in an age of automatic tollbooths and automatic weapons, the position of bridge troll has become less desirable and, indeed, rather dangerous. Trolls in the know have taken their business online. It's not entirely clear how they make a living, but prosper they must, for they thrive and multiply. Grogglemeier Sneezleboot, however, is a traditional sort of troll. The recession has forced him to venture online, but he has no aptitude for it. As a result, he has no proper job, no girlfriend, no car and no nice apartment. In other words, Grog is a real loser.

LINE, INK AND SHADING – How to use shading rather than line to create realistic detail.

Troll

When you give a traditional fairy tale creature a whimsical update, it's important to retain much of the original imagery, so that viewers will instantly recognise what it is. A traditional troll is a big, smelly, moon-eyed monster, fond of raw meat and shiny objects. Even a successful troll is a miserable creature: bulgy of eye, wobbly of belly, foul of temper. Your online troll may well be holding a computer mouse or looking at screens, but he is still tough-skinned, massive and just about impossible to ignore.

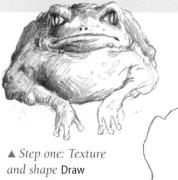

▲ *Step one: Texture and shape* Draw inspiration from everywhere! A wrinkly toad becomes the perfect model for a wrinkly troll. Whereas a successful troll is like a rhino, Grog is more like a toad: small, squat, warty and frequently trodden upon. A toad-like silhouette brings out these qualities.

▲ *Step two: Head* If Grog walked into a bar, the bartender would ask him, 'Why the long face?' A long, droopy face, framed by long, droopy hair and ears and topped off by an exaggerated frown fits Grog just right. Deep lines and downward-tending features etch misery into this face.

◄ *Step three: Thumbnails* Test several troll shapes at the thumbnail stage.

► *Step four: Conveying the concept* The squat, toad-like troll is the most successful image because his face is showing, and because he's clearly a disgruntled troll. The large creature embracing a deck of monitors, with his face turned away, could be a man – the concept isn't as clear.

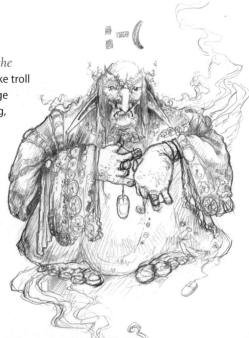

SOURCES OF INSPIRATION

This leathery skin is the perfect model for our tetchy troll, emphasising both the rugged and the melancholy nature of Grog.

CONSIDER ALL ANGLES

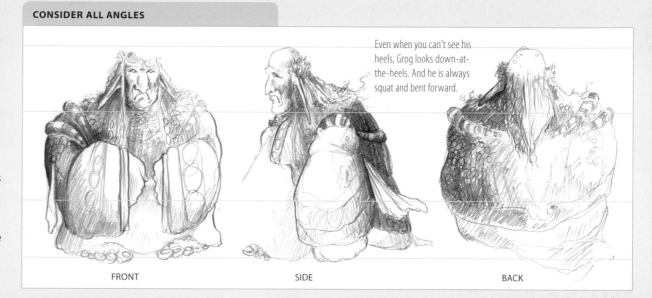

Even when you can't see his heels, Grog looks down-at-the-heels. And he is always squat and bent forward.

FRONT SIDE BACK

▶ *Step five: Inking the sketches* To achieve very light, fine shading, as on Grog's hands, sleeves and gown, be sure to wipe excess ink off your nib (see Tips box).

To achieve a realistic effect, use solid lines sparingly, especially on soft-edged objects. Here, solid lines have been used to call attention to Grog's clumsy hands, but most of his costume is described only by shading.

TIPS

- To make sure you've succeeded in wiping off excess ink after dipping it in the inkwell, try a few test strokes on a spare piece of paper after every dip.
- To avoid ink blobs, check your nib frequently for paper fibres, clotted ink and other debris. Most nibs are split at the end, and small fibres and blobs of ink tend to get stuck in the crack.

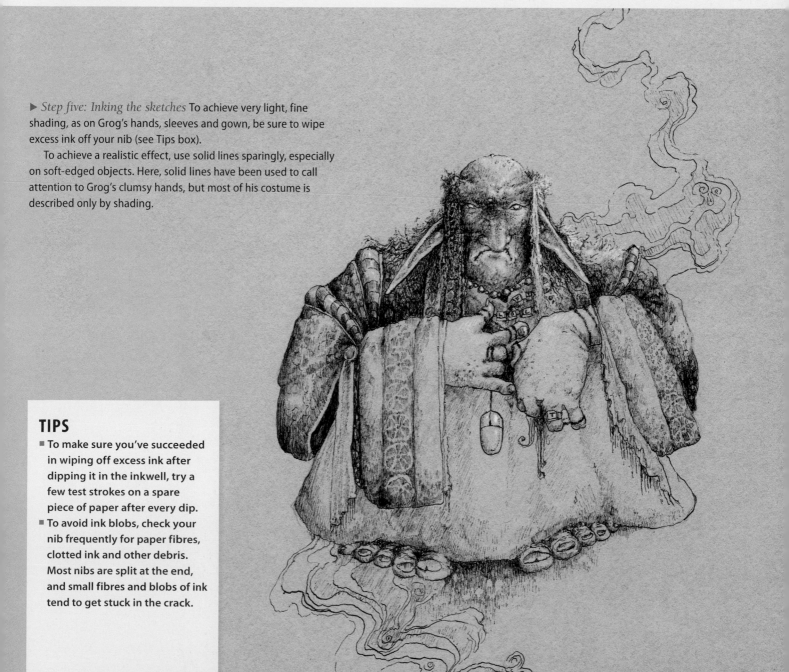

CHARACTER CONCEPT

A toad is a small amphibian, known for its unpleasant appearance and poisonous, warty skin. But remember Mr. Toad in *The Wind in the Willows*. Could you create a similar character? King Toad of Snaily Bump is a man of the world! King Toad has vast wealth, verdant lands and a thousand-stringed harp. King Toad is brilliant, powerful and magnanimous. He's also a snappy dresser and loves to ornament himself with diamonds and ermine and silk from the East.

OBSERVATION OF NATURE – How to transform an animal into a fantasy creature with a distinctive character.

Toad

You've started creating a character by choosing an animal and then imagining some of his characteristics. Now how are you going to bring out the contradictions between your character's appearance and his self-image? He fancies himself as a talented entertainer, but think how those fine ballads sound: 'Grubbit. Grubbit.' He decks himself in finery, but what if you transform it into snail shells and spider-silks and pieces of cheesecloth held together with string? Your King Toad obviously lacks self-awareness, social awareness and awareness of the sound of his own voice, but in spite of his shortcomings, he is an affable fellow. And so your depiction of him will poke gentle but affectionate fun rather than cruel mockery.

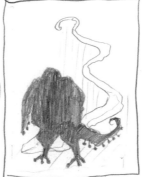

▲ *Step one: Thumbnails* Have fun with these quick little sketches. King Toad thinks of himself as quite the Renaissance creature. He dances, sings and lounges around like a Romantic poet. But, although he believes himself graceful, he's really quite clunky, so unbalanced poses and compositions will call attention to his unfortunate shape.

▼ ► *Step two: Costumes* King Toad has a vaguely humanoid shape, but he's awkward, with spindly little limbs and a great bloated body. His costume has to be designed to conform to his unusual body type, as well as his personality; standard human clothes won't work.

Start with a sketch of King Toad with no clothes to focus your mind on his shape. Now make as many sketches of outfits as possible. Some won't work, but you may take elements from one sketch and combine them with elements from another sketch.

CONSIDER ALL ANGLES

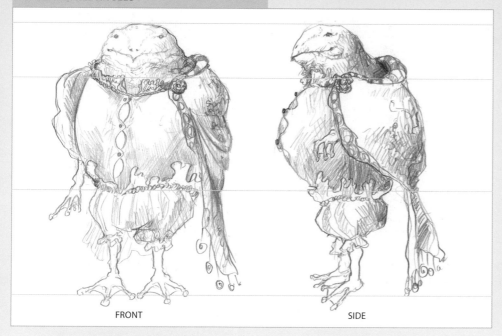

FRONT

SIDE

SOURCES OF INSPIRATION

Observing the appearance, texture and proportions of a real toad will enable you to realistically copy, exaggerate or distort the features you want for your character.

◄ Start by sketching different poses. Try adding some clothing. King Toad is bursting out of his dubious finery.

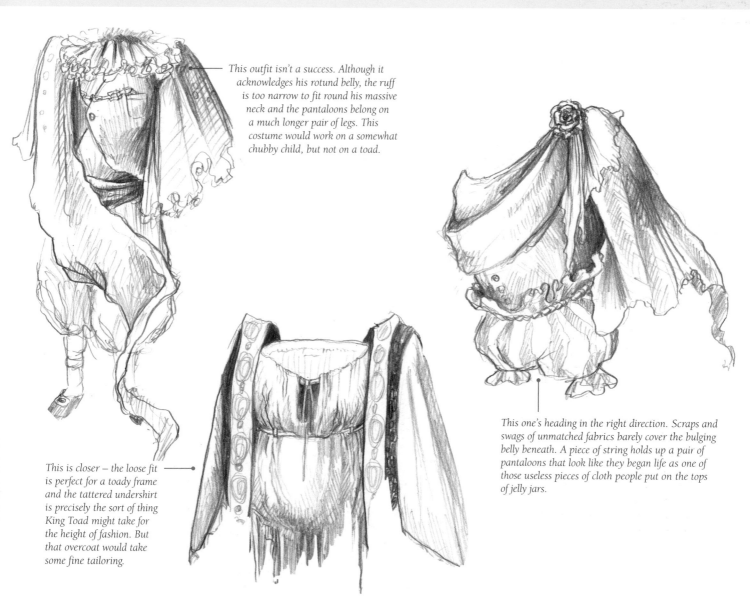

This outfit isn't a success. Although it acknowledges his rotund belly, the ruff is too narrow to fit round his massive neck and the pantaloons belong on a much longer pair of legs. This costume would work on a somewhat chubby child, but not on a toad.

This is closer – the loose fit is perfect for a toady frame and the tattered undershirt is precisely the sort of thing King Toad might take for the height of fashion. But that overcoat would take some fine tailoring.

This one's heading in the right direction. Scraps and swags of unmatched fabrics barely cover the bulging belly beneath. A piece of string holds up a pair of pantaloons that look like they began life as one of those useless pieces of cloth people put on the tops of jelly jars.

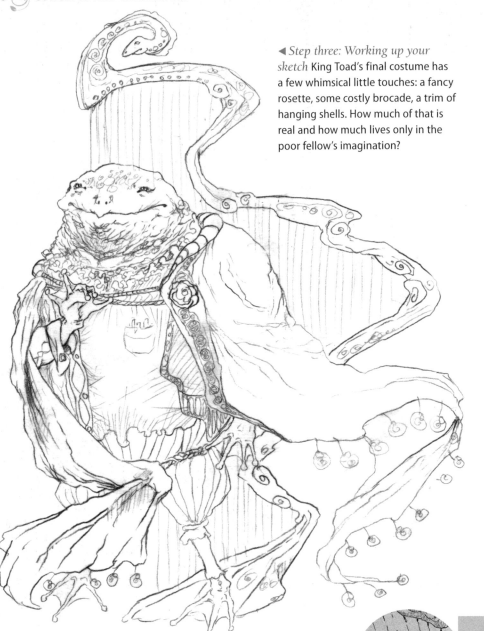

◄ *Step three: Working up your sketch* King Toad's final costume has a few whimsical little touches: a fancy rosette, some costly brocade, a trim of hanging shells. How much of that is real and how much lives only in the poor fellow's imagination?

SOURCES OF INSPIRATION
A king's outfits are designed for form first and function second. Swags of drapery and heavy furs that would impede movement are no barrier to style if one has no need to move. Historical reference reveals that the rich and powerful have often abandoned practicality in favour of flair.

SOURCES OF INSPIRATION
You might find one of these in your garden or in a museum of natural history. Snap a photo or do a quick sketch whenever you come upon something interesting.

The hard, parallel lines of the harp strings could be a problem; not only do strong diagonals draw the eye, but they can give the image a tilted appearance. To prevent this, the lines have been broken up, as though light were shining through the strings, making them difficult to see.

Highlights have been added only to points of interest; the heaviest are on King Toad's face.

Areas far away from the focal points have been given minimal detail; the tails of the cloak and the hanging shells are little more than outlines.

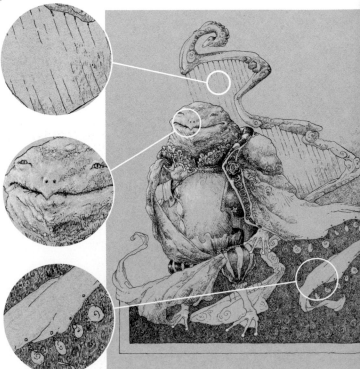

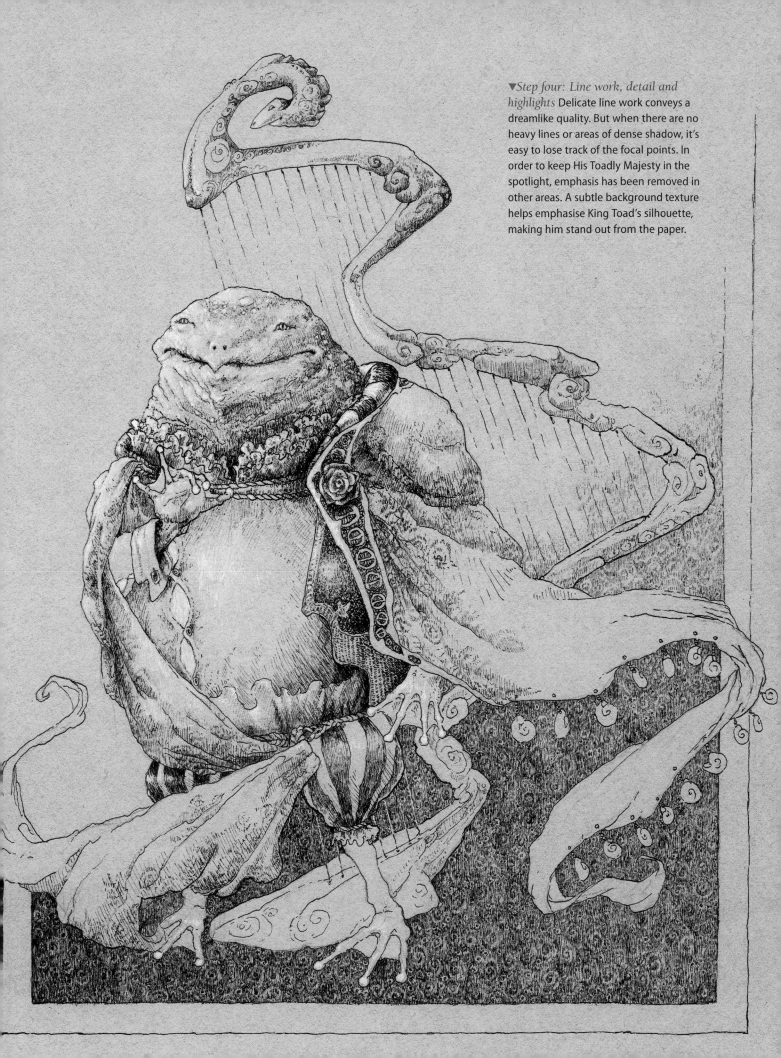

▼*Step four: Line work, detail and highlights* Delicate line work conveys a dreamlike quality. But when there are no heavy lines or areas of dense shadow, it's easy to lose track of the focal points. In order to keep His Toadly Majesty in the spotlight, emphasis has been removed in other areas. A subtle background texture helps emphasise King Toad's silhouette, making him stand out from the paper.

Dagmar the death card is miffed. Even with hundreds of years of fortunate predictions, no one's ever happy to see him. Sick of being shunned and reviled, he seeks to revamp his image.

REFRESHING A CONCEPT – How to tease out new meanings from traditional or ancient imagery.

Death card

The Major Arcana, or trumps, are a suit of 22 cards in the tarot pack. Death, the thirteenth card, is a harbinger of endings and beginnings; the closing of one door, so that another may open. He represents transitions and rites of passage and the stripping away of nonsense to find enlightenment. So, although drawing his card can mean sadness or death, it can also be a prediction of a wedding, a birth, a graduation or a bar mitzvah.

What if you discard the traditional imagery of pale horse and grinning death's head and instead concentrate on the fortunate predictions? What if Death is dressed in wedding finery and his horse is bridled in gold and festooned with red roses? How can you graft this new imagery on to the old to create a death card that is both traditional and surprisingly new?

◄ *Step one: Research* Look at a number of traditional death tarot cards. They typically feature a skeletal rider, trampling the dead and dying beneath his hooves. He carries a black flag with a white rose upon it, representing rebirth or the growth of new life from the decay of the old. Death himself is depicted as a drab and sombre character, draped and armoured in black. Consider which elements you want to include, exclude or subvert – and in what ways.

▶ *Step two: Thumbnails* Use thumbnails to explore the concept. Plain silhouettes, without descriptive detail, allow the arrangement of shapes to stand forth clearly. Thumbnails need not be large – a couple of inches are all you need. Make as many as you want. You'll probably end up using some ideas from one and some from another in your final sketch. Use those that work and discard those that don't. With the most important elements of the composition (horse, rider and costume) decided, it's time to place them within the picture plane.

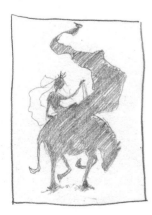

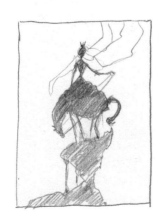

▶ *Step three: Experiment with details* Not sure what style of gown goes best on Death's bony frame? Try a few.

SOURCES OF INSPIRATION
Sometimes it's easier to refer to a drawing than to a photo. Here, the rose's complex form has already been converted to lines and shadows.

▶ Sketch Death wearing a wedding gown from front, back and side to see how he would look.

CONSIDER ALL ANGLES

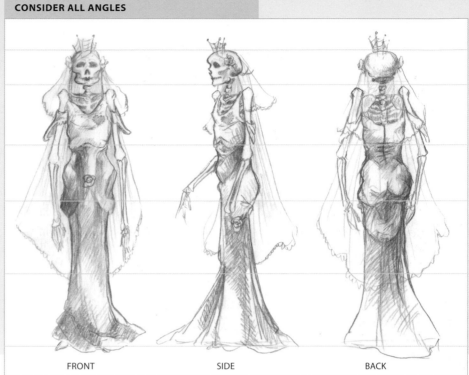

FRONT SIDE BACK

This dress was rejected, as it covers too much of Death's form.

This dress was not chosen, as it would never stay on.

This dress is the closest to the final dress. It has a fitted bodice, which draws attention to the fact that there's no flesh underneath, and a gathered skirt, which hangs pleasingly over the back of the horse.

▼ *Step four: Rendering* The sketch in step three has a simple arrangement of drapery, which conforms closely to the lines of Death's body. That's not a bad place to start, but the concept requires a more complicated costume. Although describing the complex drapery of Death's skirts might seem like a difficult task – there are a lot of folds to worry about, not to mention the forms underneath – it can be broken down into separate steps.

1. Start simple, with the underlying shapes and lines of tension. Look at the figure of Death. If cloth were to billow up around it, where would it bunch and where would it hang? Where would it sweep in swags and where would it pile up like clouds? If you're not sure, drape some cloth on a friend.

2. Shade and sketch in the cloth. Imagine fabric draping gently over the framework you've established. Where do the shadows fall (see Tips box on page 120)? A piece of tracing paper is useful for this stage to avoid the chore of erasing extraneous lines.

3. Add some ink. Hatching serves to darken shaded areas, draw attention to the directions of fall and pull on the cloth and emphasise contours.

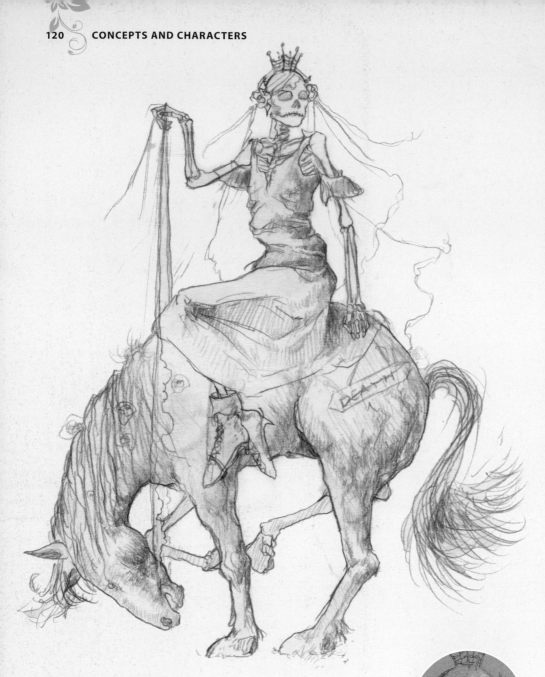

TIPS

- To get the placement of your shadows right, imagine a series of straight lines radiating out from your light source and hitting the cloth. Wherever the light would not hit (where something's in the way; where the object's turned away; where another object is casting a shadow), go heavy on the ink. Wherever the light would hit, go light. If you put all the highlights and shadows in the right places, the object you're drawing will look three-dimensional.
- For dimly lit edges, try using heavy, solid lines. For brightly lit edges, try lighter, broken lines.
- When you're hatching, remove your pen completely from the paper after every stroke. Avoid check marks and scribbles, unless you specifically want that type of texture.

The horse's far hind leg has sprouted a bulge that shouldn't be there, almost like an extra joint, just before it vanishes behind the near hind leg. This mistake should have been caught in the sketching stage of step five.

▲ *Step five: Working on the lines*
Now that a composition and a costume have been chosen, it's time to work on the line art. Examine your sketch with a critical eye. Where are the focal points? Is there anywhere the eye gets stuck in confusing details or finds nothing much to look at? Where's the light source? How's the anatomy working out? At this stage, nothing is set in stone. This is the time to get it exactly the way you want it.

Although Death has no lips, he seems to be smiling. Don't be afraid to take liberties with anatomy when they serve the idea, the composition or the style of the picture.

The long, flowing lines of the horse's mane and tail imply a very different texture from the complex hatching of Death's skirts, or the little scrubby lines of the horse's blankets, or the short, bristly strokes of its hair.

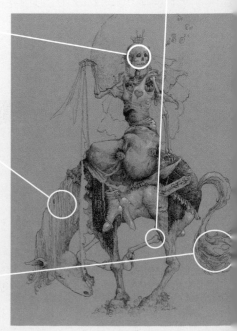

▶ *Step six: Assessing your image*
In the final image, some elements of the tarot card have been preserved: the skeletal rider, the white roses, contrasts between fertility and decay. The far legs of Death's horse are reduced to bones, although the side of the horse presented to the viewer is fully fleshed. At some point, Death has stolen the nameplate that normally adorns the bottom of the card, slung it over his horse's rear and crossed out his name. He rides forth, defiant, enjoying his new image. His horse seems a little less pleased. Its head droops, perhaps in embarrassment.

INSPIRATION FROM FOUND OBJECTS – Who would have thought that a dried-up old radish in the fridge could become a character?

Plant spirit

The idea for a fantasy character can be sparked off by the most unlikely objects. You know how they say, 'That's so rotten, it could walk out of the fridge on its own?' Well, this old radish really could. It might even be able to fly. And, although it's pretty enough to look at, with its crinkly foliage and bright red extremities, there's also something unpleasant about it. And so your imagination takes off. A fantasy artist is constantly looking at things and thinking 'what if…?'

The inspiration for this plant spirit was an abandoned daikon, found in the fridge:

This morning, at breakfast,
I found on the shelf
A daikon that made me
ashamed of myself:
Its root scarcely sampled,
just one sliver gone,
I must have forgotten it
there, and moved on.
Poor daikon, poor daikon,
I got you for stew –
I couldn't be bothered,
and now look at you!
You're withered and horrid,
too nasty to eat.
A shade or two browner,
and you'd be a beet.
Along with your corpse,
which I cast in the bin,
I thought I heard handfuls
of change clatter in.
I dug through the trash,
to retrieve what I'd tossed:
Though you were still
present, the money was lost.

SOURCES OF INSPIRATION
What's the essence of a daikon radish? How can you simplify it, in your drawing, so that its nature is understood, even when it's been bent and twisted into a humanoid form?

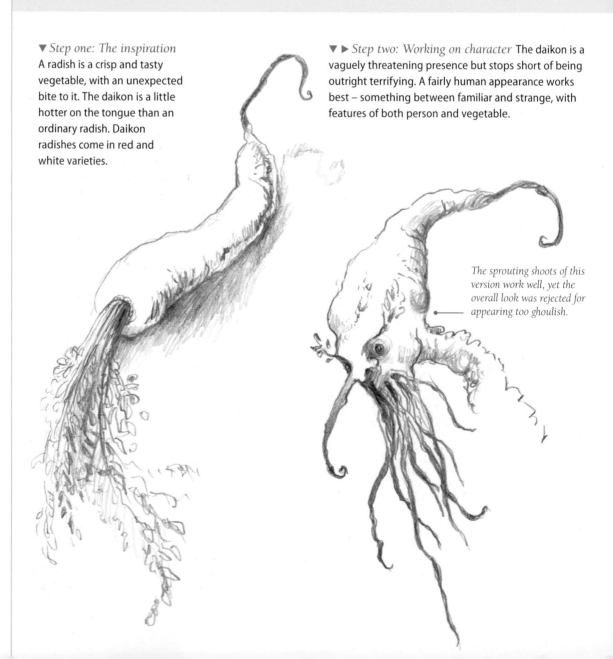

▼ *Step one: The inspiration*
A radish is a crisp and tasty vegetable, with an unexpected bite to it. The daikon is a little hotter on the tongue than an ordinary radish. Daikon radishes come in red and white varieties.

▼ ▶ *Step two: Working on character* The daikon is a vaguely threatening presence but stops short of being outright terrifying. A fairly human appearance works best – something between familiar and strange, with features of both person and vegetable.

The sprouting shoots of this version work well, yet the overall look was rejected for appearing too ghoulish.

► Explore your character from different angles, drawing out her character. Fragile as she seems, our little radish has some nasty claws.

SOURCES OF INSPIRATION
Talons are not the sole domain of birds of prey. These nasty hooks go just as well on the ends of our daikon spirit's fingers.

The more attractive appearance of this version is intended to lure the viewer in, then surprise them with the more dangerous details.

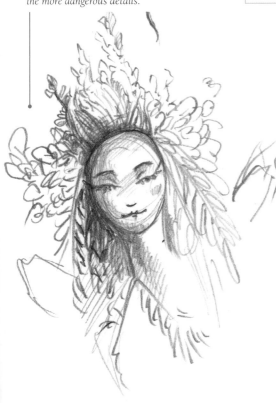

CONSIDER ALL ANGLES

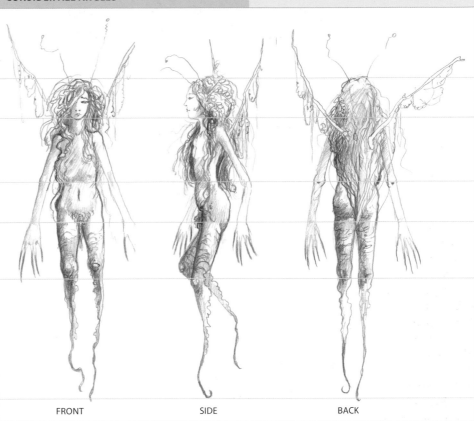

FRONT SIDE BACK

▼ *Step three: Thumbnails* Quick little sketches are the best way to try out different postures and moods. The more passive poses in the first and third thumbnails are most appropriate for a creature weakened by her protracted sojourn in the fridge.

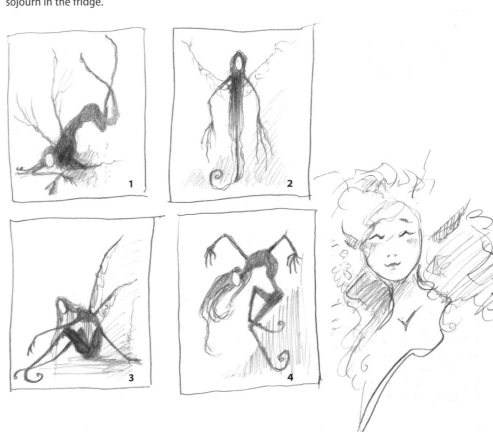

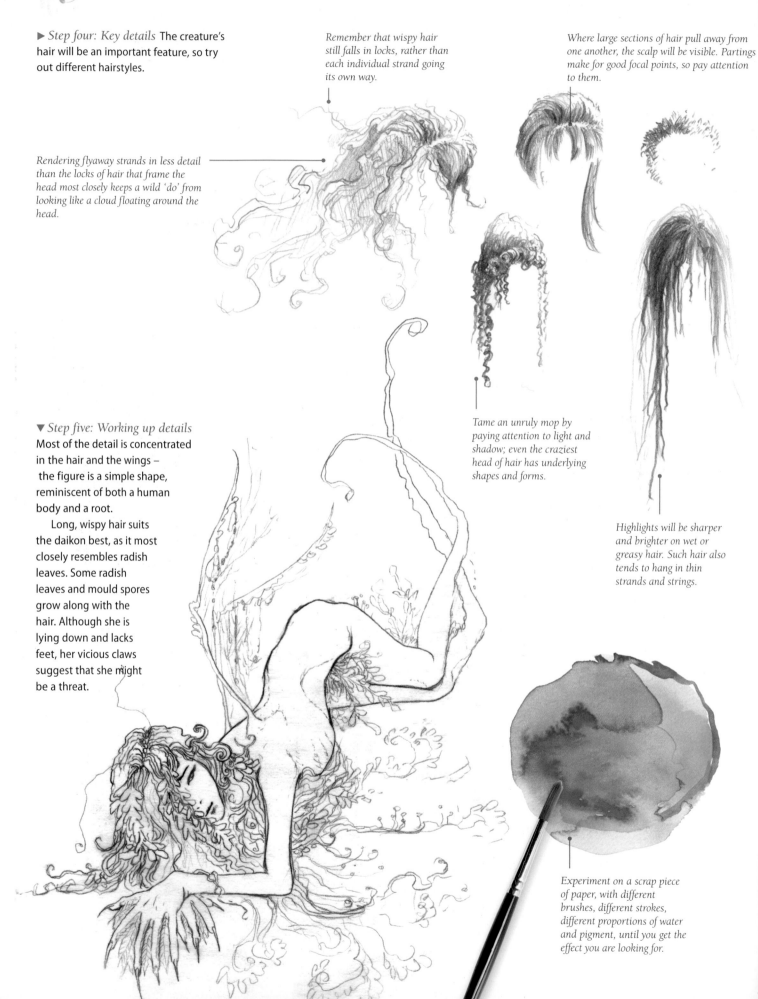

▶ *Step four: Key details* The creature's hair will be an important feature, so try out different hairstyles.

Rendering flyaway strands in less detail than the locks of hair that frame the head most closely keeps a wild 'do' from looking like a cloud floating around the head.

Remember that wispy hair still falls in locks, rather than each individual strand going its own way.

Where large sections of hair pull away from one another, the scalp will be visible. Partings make for good focal points, so pay attention to them.

▼ *Step five: Working up details*
Most of the detail is concentrated in the hair and the wings – the figure is a simple shape, reminiscent of both a human body and a root.

Long, wispy hair suits the daikon best, as it most closely resembles radish leaves. Some radish leaves and mould spores grow along with the hair. Although she is lying down and lacks feet, her vicious claws suggest that she might be a threat.

Tame an unruly mop by paying attention to light and shadow; even the craziest head of hair has underlying shapes and forms.

Highlights will be sharper and brighter on wet or greasy hair. Such hair also tends to hang in thin strands and strings.

Experiment on a scrap piece of paper, with different brushes, different strokes, different proportions of water and pigment, until you get the effect you are looking for.

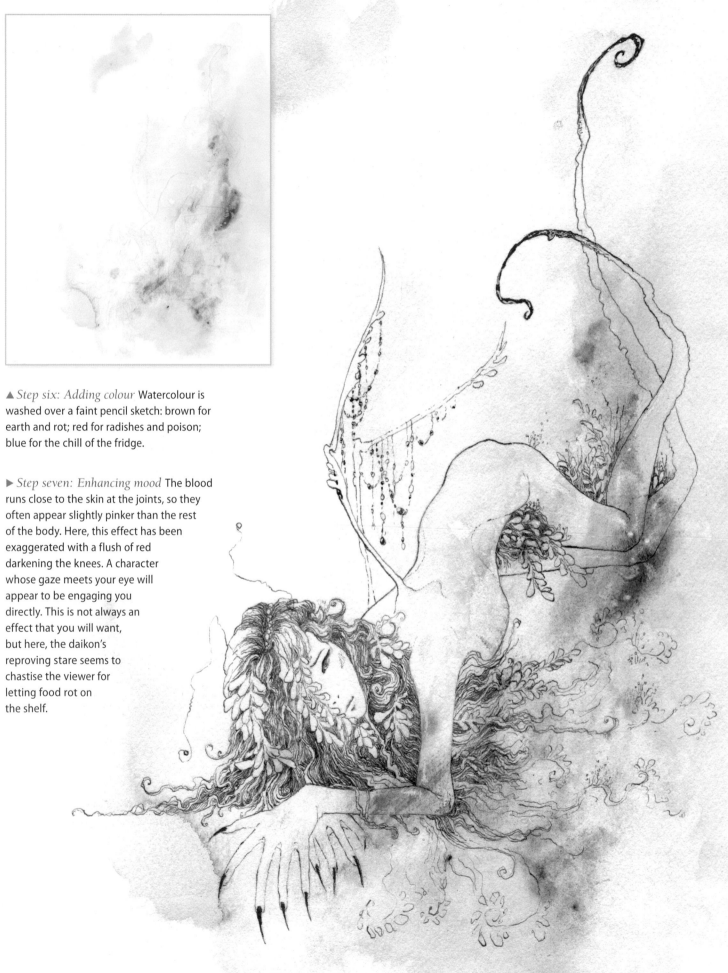

▲ *Step six: Adding colour* Watercolour is washed over a faint pencil sketch: brown for earth and rot; red for radishes and poison; blue for the chill of the fridge.

▶ *Step seven: Enhancing mood* The blood runs close to the skin at the joints, so they often appear slightly pinker than the rest of the body. Here, this effect has been exaggerated with a flush of red darkening the knees. A character whose gaze meets your eye will appear to be engaging you directly. This is not always an effect that you will want, but here, the daikon's reproving stare seems to chastise the viewer for letting food rot on the shelf.

Index

Credits

Quarto would like to thank the following artists for kindly supplying images for inclusion in this book:

Finlay Cowan 64, 65c and b, 66, 67b
Kevin Crossley www.kevcrossley.com
 p.12–13 (bugs), 14–15 (bugs), 16–17
 (bugs), 18–19 (bugs), 52–53, 61bl, 65t
Matt Dixon 77t
Dover Books p.28–29, 97b
EverQuest ® II: by Roel Jovellanos
 © 2004–2010 Sony Online
 Entertainment LLC p.30tl (EverQuest
 is a registered trademark of Sony
 Entertainment LCC in the US and/or
 other countries. Used with permission
 from Sony Online Entertainment LLC.
 All rights reserved.)
Slava Gerj/Shutterstock pp.10, 36, 43b, 60
Michael Hague www.michaelhague.com p.27
Abigail Harding p.71
Jon Hodgson p.32b
Vitor Ishimura vtishimura.deviantart.com 67t
Patricia Ann Lewis-MacDougall
 www.pat-ann.com p.73
LondonPhotos—Homer Sykes/Alamy p.34t

Lauren Mills laurenmillsart.com p.34b, 35,
 81br, 82, 85
Rex Features p.30br
Anne Stokes p.27
J.P. Taggart www.targetart.com p.89t
Cynthia Lund Torroll
 www.cynthialundtorroll.com p.47tr
Rafi Adrian Zulkarnain p.26

All other drawings are by Socar Myles.